Photoshop 3D for Animators

Rafiq Elmansy

Routledge
Taylor & Francis Group

LONDON AND NEW YORK

First published 2011 by Focal Press

Published 2018 by Routledge
2 Park Square, Milton Park, Abingdon, Oxon OX14 4RN
52 Vanderbilt Avenue, New York, NY 10017, USA

Routledge is an imprint of the Taylor & Francis Group, an informa business

Notices
Practitioners and researchers must always rely on their own experience and knowledge in evaluating
and using any information, methods, compounds, or experiments described herein. In using such
information or methods they should be mindful of their own safety and the safety of others, including
parties for whom they have a professional responsibility.

Product or corporate names may be trademarks or registered trademarks, and are used only for
identification and explanation without intent to infringe.

Library of Congress Cataloging-in-Publication Data
Elmansy, Rafiq.

Photoshop 3D for animators / Rafiq Elmansy.
p. cm.
Includes bibliographical references.
ISBN 978-0-240-81349-3
1. Computer animation. 2. Adobe Photoshop. 3. Three-dimensional display systems.
I. Title.
TR897.7.E356 2011
006.6'96—dc22

2010023146

British Library Cataloguing-in-Publication Data
A catalogue record for this book is available from the British
Library.

ISBN-13: 978-1-138-45624-2 (hbk)
ISBN-13: 978-0-240-81349-3 (pbk)

Dedication

This book is dedicated to my parents, who discovered my love of art and design; my beloved wife, who supported me in every step of my life and career; and my two daughters, for cheering my life.

Contents

Contents

Acknowledgments

This book started as a dream that became true through the collective effort and hard work of a great team, who took it from a draft idea to the final source of information in your hands. The members of this team are the real heroes behind this work, and I would like to thank everyone who worked to bring the idea for this book to life.

First of all, I would like to thank Chris Georgenes, Flash animator, expert, and author, for introducing me to the great team at Focal Press and for his help building a wonderful relationship with such an amazing team. Also, I would like to give special thanks to Katy Spencer, the product manager, who took care of the book proposal as a draft and turned it into real and useful material. She helped me so much during the production period of this book and worked to keep me focused on the content.

And a big thanks to Beth Millett. She took care not just of the copy editing, but also my concerns and questions during the production milestones and was always there to help. Beth has had an essential role in the success of this book regarding the content and the delivery.

Also, I was blessed to have Zorana Gee, Adobe Photoshop 3D product manager, help me with the technical editing for the book. Thanks to her for the great support she provided and the valuable information she added to the book. Without her, the book would never have reached this level of quality.

I would like to thank the Adobe Photoshop beta program team for the great opportunity of joining the prerelease program, especially Zorana Gee and Vinay K. Sharma. And I would like to thank Rachael Luxemburg, Adobe group manager, and Scott Valentine, Photoshop expert and author, for introducing me to Zorana.

The great book cover was designed by Russell Purdy, and I would like to take the chance to thank him for the amazing work that will be the first thing that readers see when they look at the book. Also, I would like to thank Laura Aberle, Focal Press Associate Project Manager, for her amazing support in finalizing the book.

The resource providers have helped me so much to complete this book and visualize the ideas behind it through the book's tutorials. I would like to thank Greg Smith from 3DVIA.com for providing many of the 3D models shown in the book and for providing great support through the site to make the examples so good. Also, I would like to thank Dosch Design for allowing me to use the models from 3DVIA.com.

Also, I would like to thank Sébastien Barré for allowing me to show the DICOM file examples from his web site, http://barre.nom.fr/medical/samples/.

And finally, I would like to give extraordinary thanks to my wife, Radwa, and my two children, Malk and Hala, for inspiring me and giving me the power to achieve my dream through this book.

Introduction

Adobe Photoshop has been widely used by graphic designers, web designers, photographers, Flash designers, animators, video specialists, and many others to accomplish design tasks ranging from the simple editing of personal photos to correct exposure, or make them more artistic, or even funnier in order to share with your friends online, to creating a whole professional web site, video resources, photo editing, cartoon backgrounds, and more. It's hard to imagine a design task that does not rely on Photoshop in one way or another.

After the merge of Adobe and Macromedia in 2005, Adobe Photoshop gained a big advantage: the integration between it and other Macromedia products in the family. This integration enables Adobe Photoshop users to move between the numerous former Macromedia products such as Flash, Dreamweaver, Illustrator, After Effects, and others. This makes it easier and faster to incorporate the features of those programs into Photoshop files.

Note: Throughout this book, we will be digging deeper into the Adobe Photoshop integration with other Adobe Creative Suite products for the benefit of the 3D and animation features in Photoshop. The Adobe CS products are shipped as one package and include full integration between the products inside the family.

With every release of Photoshop, new features are added for more power and enhancement. We will focus on two relatively new features added to Photoshop a couple of versions ago: the 3D capabilities and animation (Figure Intro.1).

About This Book

As a Photoshop user, do you need to spend hours or days learning another 3D software package just to be able to create simple 3D content for your web site or brochure? And as a 3D artist who is using Photoshop, are you sick of having to return to your 3D software to edit your 3D content and render it again and again?

The answer to these questions and the solution that will make your life easier is here. This book fills the gap between Photoshop and 3D. Many Photoshop users were having trouble creating 3D content or adding 3D content to Photoshop. The 3D tools in Photoshop extend your design capabilities and help you to work with 3D content more easily. Having 3D in Photoshop enables you to create 3D content from scratch and import 3D content from

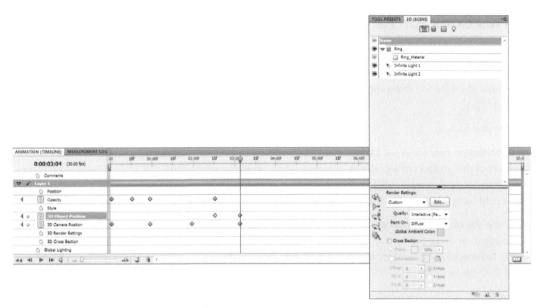

Figure Intro.1 The 3D panel and animation timeline in Photoshop.

3D software. Furthermore, you will be able to edit 3D content, such as when working with 3D object textures, meshes, and light, in addition to the other 3D features such as the ability to paint over 3D and control the 3D object's position, rotation, and perspective. And finally, you will be able to render 3D content or export it using a variety of options.

The other gap that this book fills is that of animation. The animation timeline was introduced in Photoshop CS3. In the old days of Photoshop, we counted on workaround methods or other tools such as Adobe Image Ready and After Effects to create animation. Now, you have your own independent timeline in Photoshop, which allows you to create animation directly in Photoshop and render the animation into video files or image sequences.

In the animation part of this book, I will discuss 3D animation to give you a better understanding of both the animation and 3D features. You will also learn how to extend your 3D knowledge by animating 3D content using the Photoshop timeline.

Toward the end of the book, we cover integration between Adobe Photoshop and other Adobe products such as Flash, Illustrator, and After Effects. The integration actually extends the benefits gained from 3D in Photoshop, and you will see how to use exported content as resources in the other products.

Is This Book for You?

Do you use Adobe Photoshop for any kind of work?

Do you like to learn about the real power of Photoshop for your work or to learn how to create fun things like web profile thumbnails and cool photo editing tricks?

This book is for you.

As a Photoshop user for years, I know that Photoshop was a perfect solution for most of design tasks in a project's workflow, and I never thought about an alternative tool to replace Photoshop because there simply was no tool that could compete with Photoshop, regardless of the design task at hand.

But I was still missing out on working with 3D and animation in Photoshop. Although there were third-party applications to do this, let's be honest, it's better to have all the necessary functions in one program instead of buying extra third-party tools!

We were not missing much regarding animation, because we depended on tools such as Adobe Image Ready to create animation. But Adobe Image Ready gave us more GIF animation creation than animation and video animation tools, as we will see later.

Animators and 3D artists, please do not misunderstand me. I do not claim that these new features will turn Photoshop into 3D or animation software. It will not give Photoshop wings to fly, either!

If you are a 3D artist, you will still depend on your main 3D tool. But you will find that when you get your work into Photoshop, you will have the ability to edit your model or 3D object instead of moving back and forth between Photoshop and another program to edit your 3D content and render it again and again.

The same goes for animation and video: you will still need your primary video editing or animation software. But for basic effects and tweaking elements and images that you have already created in or imported into Photoshop, you do not need other tools such as After Effects, Flash, and others to create your animation. You'll only need those heavy animation and specialized video editing tools for intensive animation effects.

Other Photoshop users and digital artists get to create 3D content and animation without as much effort as learning another whole 3D tool or an animation program to do simple 3D or animation content for your design or video content.

One last issue: do you know about Adobe integration? Do you ever think to take advantage of the integration between Adobe products? Now is the time to learn more about how to speed up your work and make your life much easier. At the end of this book, I cover the integration between Photoshop

and other Adobe tools and how to move your work between each product to get the most out of all of them.

The emphasis will be on integrating Photoshop 3D and animation with other Adobe tools, such as After Effects, Flash, and Illustrator.

How This Book Is Organized

The general approach of this book is the how-to approach or learning by example, as this is the best method to deliver ideas, especially when talking about topics that are brand-new for some of you.

The book is divided into two major topics: 3D and animation. Although this book is directed at designers and animators, it is important to understand the 3D capabilities in Photoshop to use it in the 3D Photoshop animation, as it will implement all the 3D-related features such as objects, textures, lights, cameras, and the final render process to export animation as videos or image sequences.

In addition, working with 3D in Photoshop is closely related to other software tools inside the Adobe Creative Suite and third-party 3D tools such as the DAZ Studio 3D, 3DVIA, and Strata 3D tools. The book will start by providing an introduction to the 3D world and the basic concepts for designers and animators that do not have experience with the 3D world and terminology, which we cover in the first and second chapters. In Chapter 3, I offer insight into how to organize files through the Adobe Bridge utility, which enables you to move your work between the various Adobe CS programs.

The early chapters provide an introduction to the 3D world and how to manage resources in Bridge. I then cover the different type of 3D objects in Photoshop and how to import external 3D resources into Photoshop, in Chapters 4, 6, and 7, where I also teach you about the new Repoussé feature that lets you create 3D objects from 2D content such as text.

Once you understand how to work with the 3D objects and models in Photoshop, we dig into working with these 3D models, including 3D texture, light, and cameras in Chapters 8, 9, and 10. Then you'll learn about creating 3D animation through the Photoshop timeline in Chapter 11.

In Chapters 12 and 13, I cover the final step in the 3D process: preparing the 3D objects and setting their quality to final output or export, either as video formats or image sequences of different formats.

This book also covers how to work with the 3D object and interact with other 3D programs to get your file into Photoshop, as well as how to get your files out of Photoshop, either by rendering them or exporting them as a resource to be used in any of the Adobe Creative Suite family of products.

Jumping outside the Photoshop boundaries, we will also see how Photoshop is integrated with other Adobe CS family products such as Flash and After Effects. I will walk you through the relationship between Photoshop and these applications. If you are looking for in-depth coverage of these applications, I suggest any of these great books:

- *How to Cheat in Adobe Flash CS5*, by Chris Georgenes (Focal, 2010)
- *Foundation Flash CS5 for Designers*, by Tom Green and Tiago Dias (Friends of Ed, 2010)
- *Adobe® Flash® Professional CS5 Classroom in a Book* (Adobe Press, 2010)
- *Creating Motion Graphics with After Effects*, by Chris Meyer and Trish Meyer (Focal, 2010)
- *Adobe® After Effects® CS5 Classroom in a Book* (Adobe Press, 2010)

Finally, I share some information about third-party software products that you can use to enhance your 3D work in Photoshop, such as DAZ Studio 3D, the Strata 3D tools, and 3DVIA. There are a lot of options out there!

Online Support

Photoshop3d.net is a companion web site to this book that provides readers with additional support and information about Photoshop and 3D technology. The site is frequently updated with the latest information, resources, and examples. Through this site, I will answer readers' questions related to 3D in Photoshop and the related topics in this book.

The site includes a user forum where you can add comments and get your questions answered, or search for already answered questions about Photoshop and 3D.

System Configuration and 3D in Photoshop CS5

The Adobe Photoshop application works closely with your computer's hardware profile to use its capabilities most efficiently. This smart relationship between Photoshop and the computer hardware ensures a better workflow for your Photoshop project. Many users who do not understand the relation between Photoshop and hardware—especially RAM—may face issues such as a slow workflow or lack of memory. A good understanding of this relation lets you configure Photoshop to meet your requirements on the one hand and your computer's capabilities on the other. In addition to the hardware relationship, you can configure your Photoshop workspace depending on your project needs and on which features in Photoshop you are using the most.

Let's start by helping you discover how to best configure Photoshop for ideal utilization of both hardware and the Photoshop workspace.

Are you a Mac person or a Windows person? We won't fight about which is better, and I am not even going to tell you what my own choice is. Photoshop works fine on both operating systems, so choose whichever best

Photoshop 3D for Animators. DOI: 10.1016/B978-0-240-81349-3.00001-1

fits your needs. Photoshop deals with both operating systems in the same way, so the only difference that you will notice is changes in shortcuts between keyboards for each operating system.

Note: The main difference between both operating system shortcuts is between two keys on your keyboard. The Command (CMD) key on the Mac is the same as the Control (CTRL) key in Windows, and the Option key on the Mac is the same as the ALT key in Windows. I will mention both shortcuts in tutorials and examples to avoid any confusion.

When I first learned Photoshop, I did not pay any attention to the hardware requirements, because my computer specifications are very robust. But I soon realized that I could get the best performance out of Photoshop by being a little bit smarter.

Actually, Photoshop is too smart when dealing with your hardware, and it works in a different way than other Adobe products do, so you have to really understand what your computer needs to work in the optimum way with Photoshop (especially the 3D features). In the Preferences dialog box, you will see a variety of options to specify how Photoshop deals with your system resources such as memory and storage.

But the following questions remain: What are the resources that you have to take into consideration when installing Photoshop? Which resources can be managed, and which ones require a hardware upgrade? You'll find the answers in this book.

Hardware Resources Utilization

There are resources in your computer to consider regardless of your type of Photoshop project, such as RAM, processing power, and hard drive storage space, and special consideration should be given to the graphics card, which will enable you to handle 3D content and render 3D projects in Photoshop. Along with other features such as Canvas Rotation, Scrubby Zoom, and so on—that is, GPU features, and there are a lot of them—the Painting feature also relies a bit on your graphics card. But before digging more into resources that you need to consider while working with Photoshop and how to optimize it for the best Photoshop 3D performance possible, I will mention the general system requirement to install Photoshop for both Mac and Windows.

Processor

Although Photoshop does not require a multiprocessor computer, having one will help many of Photoshop tools, filters, and 3D features work much faster than they do on a single-processor computer.

RAM

One of the resources that Photoshop loves and that affects your work in the application is the amount of *RAM (random-access memory)* on your machine. Although the recommended RAM to run Photoshop is 1 GB for both Windows and Mac, the amount of RAM necessary when working with Photoshop depends on your project. Photoshop's RAM usage heavily depends on the size of the files that you open in Photoshop, because each file you open in Photoshop uses RAM equal to about four times its size.

The more RAM your system is fueled by, the larger the files you will be able to handle in Photoshop. For example, if you are working with website images and images in low resolution, you will not feel that much pain when working with only a little RAM memory. But if you are working with files that must be printed, or 3D content or animation files with a lot of layers, you will definitely need a lot of RAM to be able to work easily.

The current Windows version, Vista, can load a maximum of 4 GB RAM, and Mac OS X can hold up to 8 GB RAM. So I always recommend buying as much RAM as you can afford, because RAM is the thin line between working in joy or pain in Photoshop.

Photoshop is a really smart application when dealing with memory: when you open Photoshop, it loads some of its files into the RAM, such as the fonts, presets, and others. Then it starts to use parts of the RAM for opening and working on your files. After using up the allocated RAM amount for Photoshop, it starts to take from the scratch disk. The *scratch disk* is a part of the hard disk that Photoshop uses as a virtual memory when it reaches the limit of the allocated files in the RAM. Let's focus on the RAM memory now, and dig deeper into the topic of scratch disk memory after.

Because it is smart, Photoshop enables you to customize how it deals with RAM and to set a limit for it to use from the memory and memory allocation; these settings are located in this Photoshop Preferences dialog box. I remember a very funny mistake of mine when I was learning Photoshop. I allocated all the memory to Photoshop—which left nothing for my operating system and other applications! Actually, it is a common mistake, but it will kill your computer, and you will never be able to work with other products properly, so be careful when setting the memory usage limit.

The default Photoshop RAM memory allocation depends on your operating system and the amount of RAM you have in your machine. Also, it depends on whether you run a 32-bit or 64-bit operating system. For example, if you are running Mac OS 10.4.11 or later, Photoshop will use up to 3.5 GB of the available RAM. In Windows, the Photoshop 32-bit version can use up to 1.7 GB in the 32-bit Windows version and 3.2 GB in 64-bit Windows, and the Photoshop 64-bit version, which runs only on 64-bit Windows, can get as much as your computer can afford. And Photoshop is supported by Windows

Figure 1.1 Performance options in the Preferences panel.

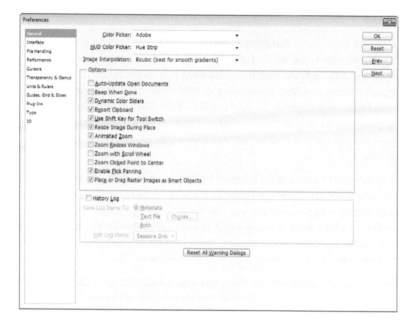

PX with Service Pack 3, Windows Vista with Service Pack 1 or 2, and Windows 7.

Shortcut: To open the Preferences panel, press CMD + K in Mac and CTRL + K in Windows.

The Photoshop performance settings are controlled through the Performance section in the Preference dialog box. You can find the Preferences dialog box via the menus Photoshop > Preferences (Mac OS) and Edit > Preferences (Windows). However, the Preference dialog box includes a separate section for the 3D settings, which provides full control over the 3D options in Photoshop. The 3D section lets you assign virtual RAM (VRAM) for the 3D projects. Also, you can set the properties of the Open GL, 3D resources guides colors, 3D ground plane, Ray Tracer options, and the loading 3D files option.

Note: The Preferences changes you make will not take effect until you restart Photoshop.

In the Performance dialog box, notice that Photoshop shows the available RAM that you can assign to Photoshop and the ideal range of RAM that Photoshop can use. You can set the RAM allocated to Photoshop using the input text box, or move the slider to the left or right or click the plus icon in the right of the slide bar or the minus icon in the right of the slide bar.

Scratch Disks

Another clever method to handle computer resources to get the most out of Photoshop performance process is the scratch disk, as mentioned previously. The scratch disk is actually virtual memory—Photoshop takes part of your hard disk and uses it as virtual memory to maximize the amount of memory

to handle files and tools, especially large files and memory-intensive Photoshop features, such as some of the filter and 3D tools. When your system is out of RAM allocated for Photoshop, it starts to use the assigned space on the hard disk as memory.

Photoshop requires 2 GB of hard disk space, but it appreciates more space for better performance and the ability to handle larger files. Therefore, the selected hard disk or disk volume that Photoshop will rely on as virtual memory should have plenty of space.

Because the memory is used to save your current work in Photoshop, it should be fast and able to handle Photoshop processes. This guideline applies to the scratch disk as well, so the scratch disk you rely on as virtual memory should be fast, well-defragged, and separate from the primary operating system disk or volume that is used for the operating system's virtual memory and paging. External hard disks and network hard disks are not recommended, because they will not be as fast as virtual memory.

Photoshop allows you to specify the volume that will be used as a scratch disk, with a total maximum space of 64 exabytes (1 exabyte equals 64 billion gigabytes). In the Performance dialog box, choose which volume to use as the scratch disk and arrange the volumes in order of your preferred usage sequence.

In the Scratch Disk preferences section, Photoshop lists the volumes that can be used as scratch disks. Check the box next to the volume that you would like to use as a scratch disk. You can change the order of the scratch disks by moving the selected Scratch Disk up and down in the list.

Note: Adobe Photoshop creates a temporary file on the scratch disk to save the current operations and history steps of the current file or files.

"Out of RAM" Errors

Because we are going to work with tools that consume a lot of operating system resources, especially virtual memory, you should know about an error message that may occur when you try to use a tool or a filter when its memory requirements exceed the available memory limit. Memory is consumed by other operations, tools, and filters that you use while working in your project, and at some point you may run out of free memory to execute the next process.

The solution to solve this problem is to free up some memory by closing the unwanted files and clear your history or limit the saved history steps. One of the most helpful things to do in order to free up Photoshop memory and therefore speed up your work is to purge the clipboard, undo list, and histories. Selecting Edit > Purge clears the various steps that Photoshop saves in memory, such as clipboard items, undo and history steps; this frees memory, which speeds up your work and gives you the ability to work with additional tools and filters—especially the memory-consuming tools.

When you open Purge from the Edit menu, you will have the option to delete the clipboard, the undo steps, the history steps, or all of them together. Keep in mind, however, that this will limit your ability to go back in your history to undo you work. You may want to save a copy of your working file at a particular state before you purge your history, just to be sure that you could get back to that version of the file if necessary.

As we're talking about memory and disk space, here are some facts about the file size and dimension limitations in Photoshop. The maximum file size for the PSD document is 2 GB, the TIFF maximum file size is 4 GB, and the maximum file size for the PDF document is 10 GB. When the PSD files cannot store large data files, you can save it using the PSB file format.

The file dimension limitations are 300,000×300,000 pixels for native PSD files and 30,000×30,000 pixels and 200×200 inches for PDF files. Keep in mind that large files may cause problems if you try to open them in an older version of Photoshop, such as version 7.

Getting the Most Out of the Photoshop Workspace

As I mentioned before, Photoshop is widely used in various types of tasks and professions, which means that it includes many panels, menus, and features to cover each field of interest's needs and requirements. Thus, some Photoshop users use specific panels or features more than others, depending on what they need to do and the nature of their Photoshop projects.

In old Photoshop versions, I was forced to keep many panels open and suffered as all these panels covered the actual work. The only working solution was to keep moving the panels around to reveal the design file under it. Another option was to open the panels when I needed them and then close them again, and to keep doing this every time I needed the panel. This approach was frustrating and time-consuming, especially with a large Photoshop project with many tasks.

Also, opening all the panels at the same time may be confusing and take up a lot of space, because some panels are used more than others or may not be used at all, even after implementing the docking panels layout. For example, if you are a photographer, you will need the panels that can help you edit photos and manage colors more than you will need panels like the 3D or animation panels.

The solution is to use the Photoshop workspace options to set the Photoshop panels' layout to meet your needs or even to create your personal favorite arrangement for the workspace. This makes life so much easier! In Photoshop, you can either choose from the default workspace options or create your own workspace and save it for further

Figure 1.2 Notice the Photoshop workspace in Photoshop 7 and Photoshop CS5 and how the docking panels help free space and arrange panels in a way that makes your work easier and faster.

Figure 1.3 Workspace options in Photoshop CS5.

use. One of the new features in the Photoshop CS5 is the new appearance of the workspace option at the top right of the Photoshop working environment.

The workspaces that already exist when you first install it are:

Note: The top Workspace bar is not the only method to access the workspace presets; you can also reach the workspace options from the top menu, via Window > Workspace.

- Essentials: This workspace option displays some of the essential panels that are commonly used by most of us, such as the Layers panel, Color panels, and Adjustments panel.
- Design: This workspace option shows the design-related panels, such as the Swatches panel, Styles panel, History panel, Character and Layer panel.
- Painting: This option activates the Brush and Color panels that are important when using Photoshop as a painting application, especially when using the new brushes and enhanced painting techniques.
- Photography: This option prepares the workspace for photographers who would like to edit photos in Photoshop. However, panels such as Histogram and Adjustments are activated in this mode.
- 3D: The 3D workspace activates the 3D panel, which is frequently used to edit the 3D scene or models. Also, the Layers panel becomes active so you can use it to navigate between 2D and 3D layers.
- Motion: This option sets the workspace to be ready for animation and video projects, which mainly activates one panel that allows you to animate both 2D and 3D objects: the Animation panel.
- New in CS5, this workspace displays the new features and panels in Photoshop CS5, such as the Mini Bridge, new brushes, 3D enhancements, Access CS Live, news, and the CS Review panel.

Create Your Own Workspace

You still have the option to create your own custom workspace to suit your project needs and display the panels used in your project. By default, not all the panels are displayed when you first install Photoshop. So you can choose from the workspace presets or create your own workspace. To display a panel, select it from the Window menu; you can arrange the panels in the workspace at either the right, left, or bottom of the workspace.

If you would like to keep some panels floating, no problem: just undock the panel by dragging it anywhere in the middle of the workspace, so you can keep the panel floating without putting it in a fixed place, in case you like to move the panel while working.

To change the position of the panel, click the panel header and drag it to any of the workspace edges mentioned previously. Photoshop guides you to the places that allow panel placement by showing a blue highlight line at the places between panels to add the new panel or a blue highlight around

Figure 1.4 Change panel placements in the Photoshop workspace.

the panel to group the new panel within existing panel groups (Figure 1.4). When you group a panel with other panel groups, it appears as a tab in the panel group.

The docking panels give you more space, but this may not be enough, so you still can free some more space by collapsing panels into icons. When you click on these icons, the panel appears. To collapse a panel, click the top right arrow, and then click the arrow again to expand it. When you need to collapse the whole panel sidebar, click the topmost right arrow and the whole panel will be displayed as icons, with the name of each panel next to it.

Move your mouse cursor over the sidebar's left edge, and it will turn to a double-sided arrow to indicate that you can resize the collapsed panel to hide the panels' names and show only the icons.

Save Workspace

After you've rearranged the panels and created your own Photoshop workspace, it is time to save this workspace and add it to the workspace list. To save the workspace, follow these steps:

1. Open the New Workspace dialog box via Window > Workspace.
2. In New Workspace dialog box, give your new workspace a name.
3. In the Capture area, you can opt to save the keyboard shortcuts and the menus modifications as well.
4. Click OK to save this customized workspace.

Delete Workspace

Adobe Photoshop allows you to delete the custom workspace. To delete a workspace, follow these steps:

1. Make sure that you are not currently using the workspace you would like to delete.
2. Select Window > Workspace > Delete Workspace.
3. Choose the Workspace you would like to delete from the drop-down menu and click OK.

Note: Adobe Photoshop provides auto saving for the changes you apply to the workspace without the need to save it again. This option lets you easily customize your own workspace and update it.

Customizing Keyboard Shortcuts

In the Keyboard Shortcuts and Menus dialog box, you can customize the Photoshop workspace even more and change the keyboard shortcuts for tools and commands and the menu setting (Figure 1.4).

Open the dialog box by selecting Window > Workspace > Keyboard Shortcuts and Menus. The Keyboard Shortcuts and Menus dialog box includes two tabs for keyboard shortcuts and menus settings. The first tab is the Keyboard Shortcuts, which allows you to change the shortcuts for existing tools and actions, save it, create new shortcuts, and customize existing shortcuts. You can also save your customized keyboard shortcuts as follows:

1. In the Set drop-down list, choose a keyboard set, save a set, delete a set, or duplicate a set.
2. Choose the category of the shortcuts from the Application, Tools, or Panel menus.
3. From the shortcuts list, select the shortcut you would like to add or change and type the new shortcut.
4. After setting the new shortcut, press the Accept button on the right to set it. You can also delete individual shortcuts by pressing the Delete Shortcut button in the right.

Note: When you choose a shortcut that is used for another command or tool, an alert message appears to show the current use of the shortcut and ask whether you would like to assign the shortcut to another command or tool.

Figure 1.5 The Keyboard Shortcuts and Menus dialog box in Photoshop.

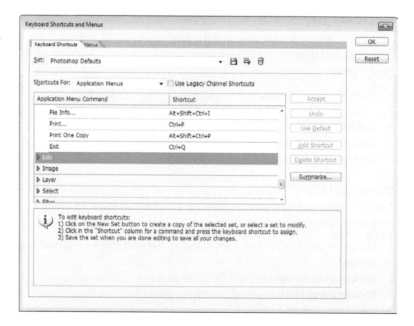

Customizing Menus

The second tab in the Keyboard Shortcuts and Menus dialog box is the Menus tab, which allows you to edit both the main application top menus and the panels' menus. The Menus tab includes the following functions, which allow you to customize the appearance of the menus commands:

1. In the Set drop-down list, you can save, delete, or duplicate a keyboard set.
2. Choose either the Application menu or the Panels menu from the Shortcut For drop-down menu.
3. From the list, browse the menu commands for which you would like to edit: visibility or change color.
4. Click the visibility column to toggle the visibility of the command on and off.
5. Click the color column to change the color of the command in the menu. You can either choose no coloring or select a color for the command from the drop-down color palette.

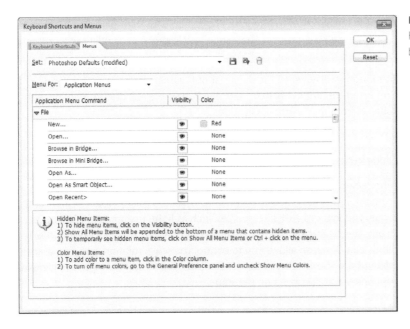

Figure 1.6 The Menus tab in the Keyboard Shortcuts and Menus dialog box in Photoshop.

The New 3D World in Photoshop

For some of you, 3D is a new field, and some are already familiar with 3D and bought this book to explore the 3D capabilities of Photoshop. The 3D feature in Photoshop was first introduced in version CS3 and was enhanced in version CS4.

I will introduce to you the 3D features in Photoshop, which are actually the points that I will talk about in detail in later chapters. If you find it difficult to understand some of the 3D terms at this stage, do not worry: I will focus on basic 3D terms and concepts later.

Because Adobe Photoshop CS5 includes some brand-new features and enhancements, I will mention these new features while talking about the other features.

Opening and Getting 3D Files into Photoshop

Adobe Photoshop supports the ability to import a wide range of 3D file extensions, which are .U3D, 3DS, .KMS, .OBJ, and Collada DAE files. These extensions are widely used in 3D programs such as Adobe Acrobat 3D, 3D Studio Max, Maya, and Google Earth.

You can also create 3D content from scratch in Photoshop by using the ready 3D models collection or by converting 2D layers into 3D content by applying 3D features such as the postcard effect or Repoussé.

You will see also how to integrate Photoshop with third-party applications to enhance the 3D process in Photoshop and improve your ability to work with 3D models.

Although I will cover all the details about working with 3D content and imported content in Chapters 4, 6, and 7, here we will discuss working with objects from third-party applications.

Working with 3D Content

Photoshop provides comprehensive tools and features to control your 3D content. It provides tools to edit the 3D objects' position, rotation, pan, and scale, and you can add 3D resources such as light, texture, and 3D camera work. The 3D Transform tools are represented with two main icons in the Tools bar: One icon allows you to control the scale, rotation, pan, roll, and slide of the 3D object, and the other allows you to edit the view and camera options of the 3D object on the stage.

3D Camera and Camera Views

Photoshop provides 3D camera options that allow you to navigate around the 3D object while keeping its position steady. The 3D camera allows you to roll, pan, orbit, walk, and zoom. You can choose from the existing 3D position presets or create your own camera view setting and save it. Chapter 10 covers the 3D camera and working with the camera in detail.

Figure 1.7 Adobe Photoshop provides comprehensive tools to control your 3D objects, such as transformation, rotation, panning, zooming, and sliding.

3D Lighting Effects

You can change the lighting effects of the 3D object through the unique light feature in the 3D panel that allows you to create light, delete light, or edit an existing light effect on the object. You can also choose the default light effect or import a light setting from an external file. And we will cover light and working with light in Photoshop in Chapter 9.

Materials

Photoshop allows you to use and edit object materials; you also have the ability to fully customize the materials inserted into the object and to edit its details and the relation between the object and its natural light and environment around it.

Photoshop CS5 includes a new material browser that lets you easily choose and apply materials with a mouse click. Furthermore, it has improved working with materials, for example, saving new custom materials—as you will see in Chapter 8.

3D Animation

Although the timeline in Photoshop is still simple, it can extend your capabilities by animating 3D objects, in both 2D and 3D space. When you animate a 3D layer in Photoshop, the Layer 3D properties appear to allow you to work with it and animate it.

3D Painting

Another amazing feature covered in this book is the ability to paint over 3D models using the Photoshop brushes: Photoshop senses the 3D object edges and paints over these edges in the 3D space. This feature was always on the wish list of digital painters and digital artists: the ability to paint over 3D models and smooth out artistic digital painting.

Wrapping 2D Layers over 3D Objects

You can also use 2D layers to wrap over 3D objects, such as labeling a
3D bottle with a 2D image, as you will learn about in Chapter 6. You can
also turn 2D layers into a 3D object's texture or apply it as a map to a
3D plane; this way, you can rotate and edit the layer's properties in
the 3D space.

Built-in 3D Shapes

Photoshop includes simple 3D shapes that can help you create simple
3D objects. Although this is a not real modeling tool, it provides you
with a few objects to use in your 3D project in Photoshop. However,
building your model using a 3D modeling application gives you more
capabilities. You can export your model as a Collada DAE file and import it
to Photoshop.

Rendering 3D Content

The rendering process is the last step in the 3D production to turn the 3D
project file or animation into a final product that the user can see, such as
a still image or animated video content. General users are not able to view
the 3D files, such as the 3DS or the DAE files. However, this step calculates
the 3D file's light, camera, and objects to produce a final product such
as a JPG image or AVI video. Although the default rendering method in
Photoshop is the solid render, Photoshop provides comprehensive rending
options that fit your rendering output requirements and artwork options.

The 3D render in Photoshop provides you with the following rendering
options that allow you to visualize your 3D object in different ways:

- Bounding box: Renders each part in the model as boxes around the
 edges of each component.
- Transparent: Allows you to display the model with transparency.
- Line illustration: Renders the model as a solid color with an outline.
- Solid outline: Renders the model as a simple outline.
- Wireframe/shaded wireframe: Displays the wireframes of the object with
 grayscale shades.
- Hidden wireframe: Displays the 3D object as a solid color without
 displaying wireframes.

Adobe Repoussé

Adobe Repoussé is an amazing new 3D tool in Photoshop CS5 that allows
you to convert 2D objects such as text, paths, selections, and masks into 3D
meshes with an extended ability to edit settings through the Repoussé
dialog box. Each 2D object—such as the text layer, selection, path, and

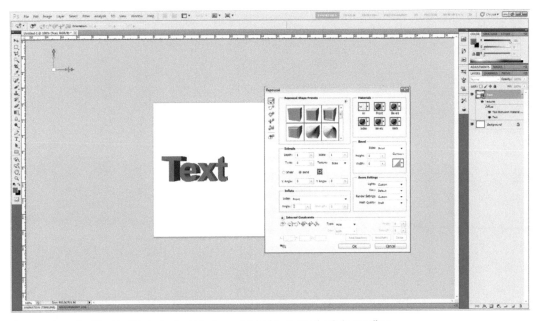

Figure 1.8 Converting 2D text to 3D text using the Adobe Repoussé dialog box associated with the text effects.

mask—has a separate command in the Repoussé submenu of the
3D menu.

Summary

In this chapter, we briefly reviewed the 3D features and objects that are
covered in this book. We will also cover 3D animation and the integration
between Photoshop and other Adobe products such as Adobe Flash and
After Effects. You will also learn how to use the 3D tools and resources in
Photoshop to easily edit and modify the 3D objects.

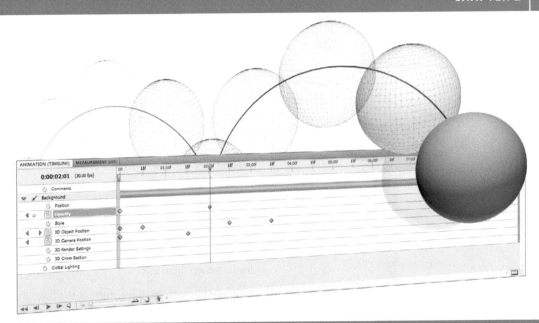

Getting into the 3D World

Long time ago, a friend of mine gave me a 3D Studio Max tutorial book. It was a very interesting book that taught you how to create amazing effects with 3D Studio Max. I started to read the book, and I can still remember the depression I fell into when it took me the whole day to get through the first couple of pages—it was my first attempt at 3D, and I did not know much about 3D terms and concepts. I had to read every term in the book carefully and try to understand it instead of focusing on understanding the book tutorials itself.

Now I realize that my big mistake was jumping into the 3D tutorials without knowing the basic concepts before digging into the book. Therefore, in this chapter I cover the basic concepts and terms you will see through the book in 3D or animation.

Many Photoshop users had been working with 2D still images for years before the new 3D and animation features finally merged with the new versions of Adobe Photoshop. If you are not familiar with the 3D and animation world, you might think 3D people are speaking another language—there are many different terms in the 3D world than there are in the 2D world.

In the first part of this chapter, I focus on the general 3D terms; in the second part, I discuss the basic concept of animation and extend this knowledge while discussing each feature throughout the book.

Photoshop 3D for Animators. DOI: 10.1016/B978-0-240-81349-3.00002-3

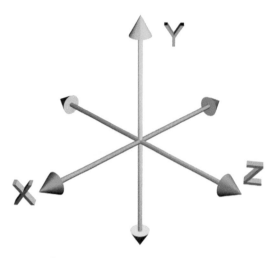

Figure 2.1 The three dimensions: X, Y, and Z.

3D Concepts and Terms

When you create graphic objects in the computer screen or on paper, you are limited to two dimensions, as both paper and computer screen are flat surfaces—that is, the X axis and the Y axis dimensions. But the real world is different—for every object in the world, there is a depth or volume, which is represented with the third dimension: the Z axis (Figure 2.1).

To give you a basic understanding of the difference between shapes and the dimensions used to draw these shapes, see the four types of shapes illustrated in Figure 2.2:

1. A zero-dimension shape, such as the dot, which does not have any width, height, or depth.
2. A one-dimension shape, such as the line, which has only length.
3. Two-dimensional shapes, such as any object that uses two of the X, Y, and Z axes, including the circle, rectangle, and triangle, among others. When a shape has the Z dimension as one of the two dimensions, it is known as a shape in the 3D space.
4. Three-dimensional shapes, which have all three dimensions, such as cube, sphere, and most of the objects we see in real life.

There are features that allow you to rotate the object in the 3D space, such as the 3D tool in Flash, the 3D layer in After Effects, and the Vanishing Point plug-in in Photoshop. In fact, these features only transform your object in the X, Y, and Z dimensions, without giving it volume and the 3D look. This happens because the object created actually does not include information about its other sides and the materials associated with it.

When you build a 3D object in 3D software and save it using 3D extensions such as 3DS and U3D, the object is built to include information about all its sides and the materials that will be included in each side. This type of object is called a *polygon*, which I describe later in this chapter.

However, the 3D feature in Photoshop allows you to read the information in the imported 3D extensions, such as the 3D Studio Max 3DS files, Collada DAE files, Ulead 3D U3D files, Google Earth KMZ files, and Wavefront OBJ files. Also, you can choose from built-in 3D objects with full 3D information.

As you will see in Chapter 6, the Collada DAE format is one of the most important formats for exchanging 3D files between 3D applications and Photoshop, and is recommended because it is the most compatible with Photoshop. In addition, Photoshop uses this format to read built-in 3D shapes.

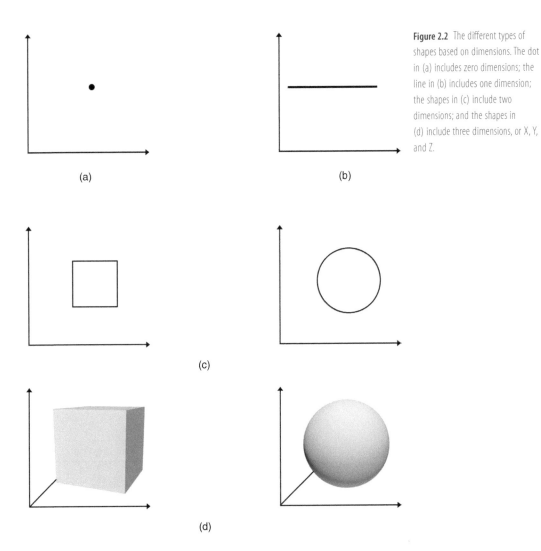

(a)

(b)

Figure 2.2 The different types of shapes based on dimensions. The dot in (a) includes zero dimensions; the line in (b) includes one dimension; the shapes in (c) include two dimensions; and the shapes in (d) include three dimensions, or X, Y, and Z.

(c)

(d)

Perspective

The concept of *perspective* is associated with how the eyes see things in the 3D space and the volume of the objects. When you look at objects and landscapes, you notice that the farther things are from you, the smaller they appear to the eye. For example, if you look at railroad tracks going through the landscape, you will notice that they look like the space between them is getting smaller, until it vanishes in the horizon (Figure 2.3).

This trick is known as the *vanishing point*—the point at which parallel lines converge or disappear. In the 3D world, when you view an object or create a camera to view an object, you can notice that the sides of the object are

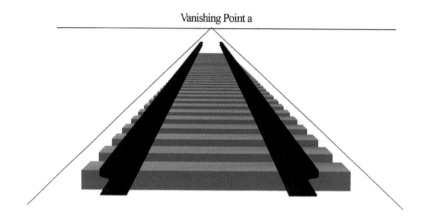

Vanishing Point a

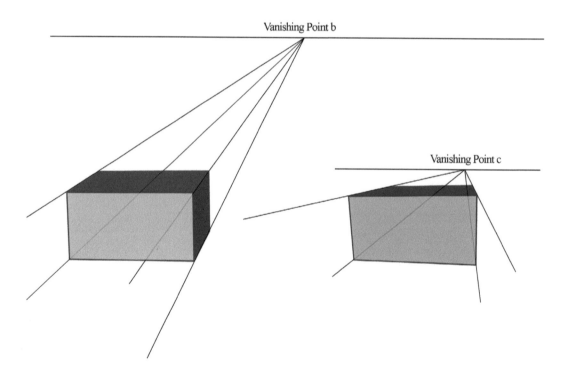

Vanishing Point b

Vanishing Point c

Figure 2.3 The perspective value affects the vanishing point of the 3D object, which consequently affects how a 3D object appears in 3D space.

getting smaller when the side or the part of the shape is farther from the camera based on the general perspective of the object.

The perspective value or angle affects the object feel of depth, and hence enhances the 3D look of the object; an increase in the object's perspective value produces more of a feel of depth, as the variation

between the part of the object close to the camera and the part farther away increases.

In Figure 2.3, notice that when the perspective value of the object changes, the vanishing point position changes. This change affects how the 3D object appears in the 3D space.

Modeling

In the 3D world, the 3D object is known as the *3D model*. The 3D model consists of one or more polygons. Understanding the anatomy of 3D models will give you a better idea of the 3D objects imported into Photoshop from different 3D programs. The 3D polygon consists of elements such as vertices, edges, and faces, as seen in Figure 2.4.

Also, I cover working with meshes and polygons in Photoshop CS5 in Chapter 4, where you will learn how to edit meshes in Photoshop in the 3D panel.

Vertex
The vertex is the smallest post in the model; it is a point in the 3D space that joins two lines or two edges.

Edge
The edge is the line that separates two polygons and connects two vertices.

Face
The face is a triangle area that consists of three points (vertices); each face is surrounded by three lines, which are defined as edges.

Polygon
A polygon consists of two or more faces gathered in a flat area of the model; increasing the number of polygons in the model increases the number of faces and vertices. The more faces the polygon includes, the smoother the polygon is when it is rendered.

Polygons with a low number of faces—known as *low polygons*—are used in systems with low graphic resources. They are not as smooth as polygons with a lot of faces, as you can see in old 3D games that depended on old hardware graphic resources.

Polygon Mesh
3D models are more complicated than just flat surfaces. However, the 3D model usually consists of many polygons arranged to form the final shape of the model. For instance, a fish model would consist of many polygons that are used to form the fish shape. This arrangement of polygons is defined as *mesh of polygons* or the *polygon mesh* of the object (see Figure 2.4).

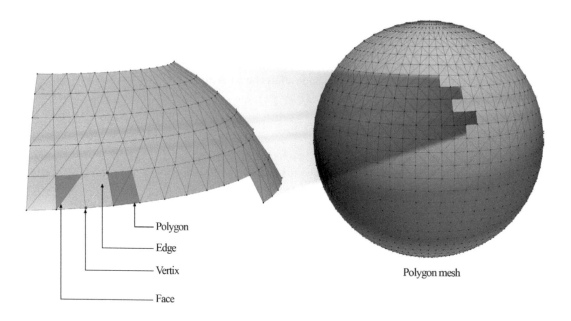

Polygon

Edge

Vertix

Polygon mesh

Face

Figure 2.4 The polygon consists of vertices, edges, and faces.

A 3D model can consist of one of more polygon meshes, depending on its complexity and details. Some complex models just can't be created based on one polygon mesh, so you need more than one polygon to form your model.

Cameras and Views

Looking at a 3D object is like a cameraman looking at a view. The best practice to understand the camera and camera views is to imagine yourself looking at the object through a camera lens rather than on a computer screen, thus putting in your hand all the real camera's capabilities and limitations. With the camera in hand, you can view the object from different views, zoom, pan through the object, rotate the view, and so on.

Although some 3D files may not include a camera to view scenes or models associated with it, 3D programs have a default camera. Creating a camera or group of cameras for the object gives you more capabilities to control the object's animation, as you do not have to change the position of the object or transform it; you need only to change the camera while preserving the object's properties. Also, you can create a camera for each view and easily switch between these camera while preserving each camera properties and type.

Basically, the 3D scene is like a studio. You have cameras in many places in the studio, and each of these cameras extends your ability to view the object from different views and angles. Though Photoshop supports only using one camera, when you import a 3D model that includes multiple cameras,

Photoshop can treat these cameras as different viewing angles for the model when you import the model to Photoshop as a 3DS file.

In Chapter 10, I talk about camera and views in 3D scenes, and we cover two issues: the views of the camera and the properties of the camera.

Camera Views

The camera views are like moving your camera to reveal unseen parts of the scene or model; these views can reveal only one side of the mode, when the camera is typically vertical to the model side, or multiple sides, when the camera views the model at a slope. You can set the camera view to show the top, bottom, right, left, front, or back view.

The camera views are like having presets for the different positions of the camera—without the need to move the camera manually to reach this position. For example, if you choose the top view, you would view only the parts of the model that can be seen from the top. This applies to the other views, such as the side, bottom, right, and left as well.

Camera Features

When you create a camera or choose a camera to view a 3D object, there are some features associated with the camera that let you control the camera. To get a better understanding of the camera features, compare it with the features and capabilities that you might have with a real camera; these features include the ability to zoom and to use the camera to navigate around the object, such as panning, walking around the object, and rotating the camera around the object, which is known as *orbiting*.

Light

Of all the 3D terms, light takes top billing, based on its importance on the 3D scene and for 3D models. The light makes us see objects; when light falls over an object, it reflects off it and to our eyes, to let us see things and feel the depth of the object.

Light affects a 3D scene or 3D object based on the light's properties, such as the softness, the intensity, and the type of the light. On the other hand, the light is affected by the object's material, color, type of texture, and details.

Light is critical to create a good design. However, it is essential not only in regard to the technical parameters assigned, but also its placement and how it affects the visual composition in total.

When you do not create a light source for a 3D scene or object, global light sources are created by default. These default lights are helpful in viewing the 3D object and in the final output for the project. But adding your own light

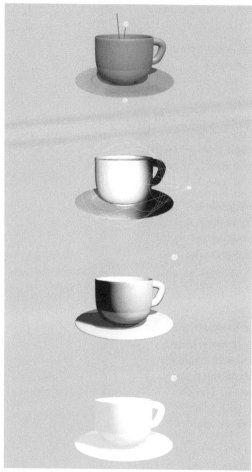

source to the object or the scene can make it more professional and create a better 3D experience.

The light can be either imported with the 3D object or created from scratch in Photoshop. When you create a light in Photoshop, you have four different choices of light sources to use, based on your needs and the nature of the project: point light, spot light, image-based light, and infinite light (see Figure 2.5).

Light types and intensity varies from one object to another, and even in the same object, based on the 3D scene or the effect applied to the object. This is why Photoshop and other 3D programs allow you to use multiple light types for the object to be able to add different light effects to an object's sides. However, it is a good practice to learn the best type of light to use with the object to create the required effect and expression.

Point Light

The point light works similar to a lightbulb; it shines on the whole object, based on its location around the object. The point light affects all of the object's sides. When you use a point light, consider that this type of light lights the whole object softly, but the light intensity increases in the areas the face the light more than other areas.

Spot Light

The spot light provides a light to the object on a

Figure 2.5 The different types of light in Photoshop. In the image, the lights are (from top): infinite, spot, point, and image-based light.

certain area; it is similar to a flashlight, as it focuses on certain areas in the object. This type of light gives you more of a sharp light effect on objects.

Image-based Light

This new light source in Photoshop CS5 allows you to create light based on an image source, and the light intensity is calculated based on the loaded image.

Infinite Light

When you create a 3D object, you may need to have to add a global light that does not have a spot light or a focus on a specific area of the object. The infinite light is like sunlight that does not focus on a specific area of the object, like the other light types. The object's sides that are directed to the light will still be brighter than the other sides, but it is similar to sunlight when it faces an object.

Mapping and Textures

Modeling is like working with clay; it does not give the object the materials that make it look real. Instead, the default created model is covered with solid colors only. Thus, materials are important to give the model its final appearance and details. The model can have a solid color as a material, or you can add a texture to it, such as adding a wood texture to a table to give it the look and feel of wood. When you add a texture to an object, you map the texture to fit the object's polygons or the polygon mesh.

Rendering

The 3D movies and images that we often see these days are not based on the actual 3D working file. You need to convert this working version to a final output image or video file for the user to be able to view it. This process is also useful for protecting the source files from being stolen. This final output is known as the *render output*.

The render concept is used in both 3D and video, to generate a final image output from the 3D source file. When you generate an image or video animation from a 3D source file, it creates a sequenced image animation, a video, and still image content.

Photoshop and other 3D applications provide different types of rendering options for the document; each rendering option is based on the model options, such as polygons, edges, and vertices.

In general, rendering is either general Open GL rendering or ray-traced rendering. The ray-trace rendering process is based on calculating the light and the shadows applied to the object and around it. However, it is more resource- and hardware-intensive, compared with the other rendering methods, which do not provide the same accuracy in rendering lights.

In the following discussion, I mention the rendering options that you will see in Adobe Photoshop; we will see the rendering in additional detail in Chapter 12.

Face Render Option
This is the default render option that renders the 3D object as it displays the polygon mesh with faces and texture. This option is the most commonly used option when working with 3D files.

Edge Render Option
This option is based on the edge part in the 3D model; when this option renders the 3D model, it shows only the edges on the model as wireframes.

Vertex Render Option

The edge render option shows the model edges and displays them as a wireframe; this option displays only the vertices of the object, and the object is displayed as points.

Stereo Render Option

This option renders the 3D object for views that will use red–blue eyeglasses or lenticular lens technology, which allows you to view images with a 3D effect, based on using magnified images together.

Volume Render Option

This option lets you render 2D layers as a volume (interpolation between layers). However, it is very important for DICOM files in the medical industry.

Animation

For years, Photoshop users worked with only one image project; therefore, more information and terms are associated with working with animation and video to help designers to understand the workflow of the animation and video production.

Animation in its most basic meaning is a sequence of images that follow each other in a short period of time. Remember the old game of drawing a shape on the edge of one sheet in a stack of paper and changing it slightly on each page, then flipping through the pages, so that the shape appeared to the eye to be moving? This is the basic idea behind animation.

This sequence of images creates the illusion of movement based on the concept of persistence of movement. This concept depends on that the last image our eye sees remains on the retina for around 0.25 of a second, which means that the eye does not notice the frame change or flip during this period of time. This causes our eye to see the sequence frames as if they were animated. The importance of understanding this concept is to be able to analyze how to animate the object and how to use the frame and effect to trick the audience's eyes.

Footage

The term *footage* refers to the video file that is used in the project as one of the project assets, such as using it in another video or importing video into a Photoshop file. In video applications such as Adobe After Effects, when you import video footage into a video project, it is saved in the project files until you add it to the video stage; this concept is similar to the library, where you save all the project files and insert them into the composition or workspace when needed.

Figure 2.6 Render options in Photoshop CS5.

a) Face render option

b) Edge render option

C) Vertex render option

Unfortunately, this concept is not available in Photoshop yet, although it is already in other video programs such as After Effects and Premier.

Frames

Based on the flipping pages concept mentioned earlier, there is a new drawing for the shape for each instance (like a sheet of paper), and these instances are the frames that we move to create the animation. However, there are two main types of frame in the animation: the keyframe and the in-between frames.

The *keyframe* is the frame where the object properties, such as size and position, change. For every animation, there are two keyframes: one for the start of the animation of the object and the other for the end of the animation of the object.

Figure 2.7 The anatomy of the animation in Photoshop and how the in-between frames work.

The frames between both keyframes are called the *in-between frames*; these frames show how the movement or animation transforms from the first keyframe to the end keyframe, and the more in-between frames, the smoother the animation.

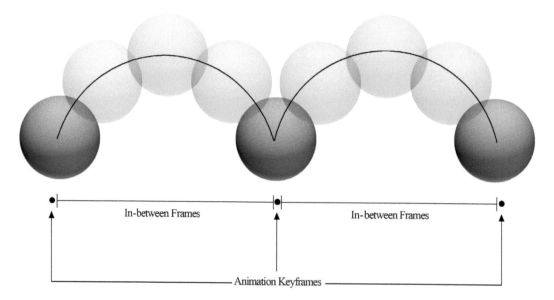

In-between Frames In-between Frames

Animation Keyframes

Frames per Second (fps)

The *frames per second (fps)* number refers to the number of frames the animation or the video displays every second to give the illusion of animation mentioned previously. The number of frames per second can vary quite a bit.

However, there are two main issues associated with an increase or decrease in fps rate. The first issue is the smoothness of the animation: the higher the

fps, the smoother the animation is, because the eye has much more of an image sequence to recognize, which gives a sense of a more realistic animation effect.

The second issue is the size of the file; with an increase in the number of frames per second, the size of the file increases, because of the increasing number of images that create the animation. Although these two factors are not the only factors that affect the animation, they are two of the most important concepts when considering high or low fps rates in the animation.

Another factor that affects the fps rate for the video animation is the output media. Video animation can be displayed in various types of media and devices; output media and devices vary in processing and requirements to display the video. This factor affects your choice for the fps rate of your video. It is obvious when producing video for TV broadcasting, as standards for the electronic signal vary from one country to another. The most commonly used standards worldwide for TV broadcasting are PAL and NTSC. The NTSC standard is commonly used in North and South America and has a 29.97 fps speed standard; the PAL standard is commonly used in other in other parts of the world, such as Europe and the Middle East, and has a 25 fps animation speed.

Another example that shows how the animation speed is affected by the output device is the production of video animation for mobile devices, as the mobile devices have low processing capabilities, which may limit their ability to display large, high-quality video content.

Producing video content for the web is mostly concerned with the size of the content and the bandwidth used to display this content. However, the second issue we mentioned regarding how the fps rate affects the video animation size should be kept in mind when creating video content for the web.

Dimensions

The output of the video animation corresponds to the width and height of the video file. Video file dimensions are different based on the type of file output. For instance, video files that will be broadcast to TV using the NTSC standard require the video file dimensions to be 720×486 pixels, and the PAL system requires the video dimensions to be 720×576 pixels.

Aspect Ratio
The *aspect ratio* is the ratio of the width and the height of the video file and concerns how it will display on monitors. Some monitors are square and others are widescreen. When you create a new video file, you can size it for either square screens or widescreens. The square aspect ratio is similar to the old computer monitors, which used to have resolutions of 800×600,

1024×768, and so on. The ratio of these dimensions are 4:3, which is the (nearly) square ratio. New TV widescreens and computer widescreen monitors have other dimensions, such as 1280×800; this wide aspect ratio is 16:9.

Figure 2.8 Adobe Photoshop CS5 video film presets in a drop-down menu.

Action and Title Video Safe Area

When you display video content on a TV, not all the content is displayed. The TV screen cuts part of the video image and makes it invisible. The TV screen cuts off around 10 percent of the video image edges, which is known as the *action safe area*, and 20 percent of the title, which is known as the *title safe area*.

Video Render and Compression

The *video render* is similar to the 3D render concept discussed in the 3D section of this chapter; the video render converts the video working files

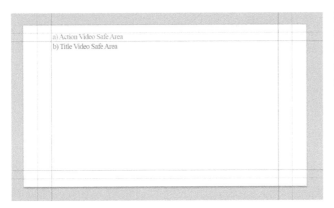

Figure 2.9 The action and title safe areas in video animation files. The light blue guide represents the action safe area. The light red guides represent the title safe area.

such as PSD (Photoshop), AEP (After Effect), and so on to a viewable video format such as AVI, MOV, FLV.

The saved or rendered video file comes with a large file size, which requires compressing the video content so that it can be easily handled by users. A huge file size and the need to compress video have made necessary a technology called the *codec*, which basically means to compress video content to get a smaller size. Actually, the quality and the compression works against each other: the more compressed the video is, the lower quality it has.

Summary

This brief overview of 3D and animation terms will help you to better understand the 3D and animation features in Photoshop as we cover these features and concepts in more detail.

Managing Resources Using Adobe Bridge

Most design ideas may require working with more than one application simultaneously; each of these applications has its own file format and setting. This necessitates being able to handle these different application formats easily and having a central location to handle project files. It has been a while since Adobe has applied the integration concept between its products; this concept makes it easy to work with multiple file formats in the project and transfer these files between different Adobe products. Along with the integration concept, Adobe introduced Adobe Bridge as a central point for you to view, arrange, and manage different Adobe files.

As a central point for communicating with all Adobe products, Adobe Bridge navigates files in your computer or network, and lets you search for files, arrange files, manage resources, and apply smart batch actions to files or folders; you can also easily open each file in its associated application just by double-clicking the files. Adobe Bridge can be accessed as a standalone application, or you can easily find the Browse Files command in any of the Adobe products, which allows you to open Adobe Bridge to browse files.

Photoshop 3D for Animators. DOI: 10.1016/B978-0-240-81349-3.00003-5

Adobe Bridge provides a better workflow by handling files such as viewing files, sharing files, organizing files, applying image processing commands in Photoshop directly from Bridge, and managing resources. In Bridge, you can do the following tasks with your files:

- Directly access Photoshop commands that allow loading images and applying batch processes on images directly from Bridge such as Images Processor, Batch, Lens Correction, Load Files to Photoshop Layers, Merge to HDR Pro, and Photomerge.
- View, search, label, rate, arrange, and sort images as well as open files in their associated applications.
- View files' metadata information for the images and edit them through the File Info command.
- Test your images for output on mobile devices (with Adobe Device Connect); you can also choose the device template that you would like to test your content on.
- Create PDF files from image files and edit the output PDF properties.
- Create a web gallery for your images and upload it to your website.

In this chapter, we will briefly navigate through the Adobe Bridge features and capabilities that you can use while working with Photoshop and other Adobe products. Bridge will be the main method for viewing and navigating both images and video files to use in our projects.

Adobe Bridge Anatomy

Let's start by exploring Adobe Bridge's anatomy and structure. As a central point for your workflow, Bridge is easy to use for file handling and navigation. The Bridge features and panels are arranged so you can easily reach each feature through a user-friendly interface. Adobe Bridge consists of six main parts; each of these parts includes a specific category of features.

Main Menus and Top Features Panel

The main menus, or the top menus, include most of the important commands in Adobe Bridge; some of these commands are represented within the panels, and others can be reached only through the main menu. Here are some of the important commands that you can find in the main top menus of Bridge:

- From the File menu, you can open files and test files on Device Central. Adobe Device Central allows you to test your content on mobile device profiles that simulate the real mobile environment to see how your project will look on specific mobile devices. It functions as a testing emulator before you test it on real mobile device. From the File menu, you can also get photos from a digital camera, move files, copy files, publish files, and place files in Adobe CS5 products.

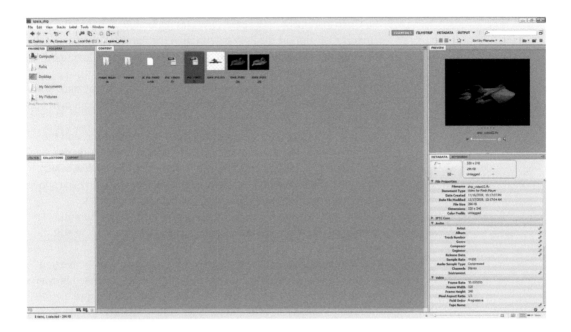

Figure 3.1 Adobe Bridge user interface.

- In the Edit menu, you can rotate images, edit the Camera RAW preferences, and edit the Bridge preferences.
- The View menu lets you set choose the appropriate view option for your files in Bridge.
- The Stack menu gives you the options to group images in stacks of images, such as related images or the images in one category.
- The Label menu allows you to rate and label images and folder content.
- In the Tools menu, you can apply batch actions such as Batch Rename or Photoshop Automation, and apply batch actions or the Image Processor. In the Tools menu, you can work with metadata profiles, such as creating a new metadata profile, editing a profile, and applying a profile to a current image.

The top panel is the essential panel in Bridge, as it includes features that can help you navigate and browse content:

- The navigation arrows are used to go forward and backward while navigating for images; you can click the drop-down menu next to the navigation arrow to see the folders in the opened path.
- The Reveal recent file or go to recent folder watch drop-down menu chooses the recent files opened in any of the installed Adobe products, such as Photoshop.
- You can also download photos directly from your camera using the Camera icon.
- The Refine icon lets you set the review mode for images, the batch rename, and the file information.

- The Open in Camera RAW opens RAW files generated with digital cameras that support the RAW extension in the Camera RAW dialog box.
- The Output icon opens the Output panel, which allows you to publish images as an image gallery or export them as PDF documents.
- On the right side of the panel are the workspace presets that allow you to set the workspace view as you prefer; you can also save your own custom workspace.
- Next to the workspace preset, you can search for content through the search field box. This searches the current folder for specific images.
- The Compact mode icon converts between the full Bridge view, which shows all the panels and functions, and the compact mode, which shows only the necessary content for you to navigate and open files.
- Under the navigation arrows is the navigation path of the current opened file. The new Adobe Bridge CS5 gives you the ability to edit the path or select it by clicking once on the path.
- Next to the path, you can find the image browsing options, where you can choose the quality of the images while browsing generated previews.
- The Rating Star icon lets you rate the content and label images.
- The rotation arrows let you rotate images either clockwise or counterclockwise.
- You can also open recent files, create a new folder, or delete images via the icons in the far right of the panel.
- Most of the main menu commands can be found in the top panel icons, so it is considered the most important panel to use while working with Adobe Bridge.

Folders and Favorites Panels

The Folder panel lets you easily access files in local drives by browsing to the desired resources folder and clicking it. You can also save an image or folder as a favorite resource to access it easily without having to browse for it again. Adding a resource or folder of resources to the Favorites panel is as easy as dragging it to the panel.

Both the Folders and Favorites panels are located in the top left in Bridge under the top properties. You can switch between both by choosing the panel tab.

Filter and Collections Panels

Under the navigation panels, you have other two useful panels that improve your ability to filter and organize your images for easy access and better organization: Filter and Collections.

The Filter panel lets you narrow your search by filtering the images in the viewed folder according to criteria format, resolution, modification date, aspect ratio, keywords, and so on. Bridge allows you to narrow your search

by clicking on any of these categories to show only the content that meets these criteria. You can also choose the criteria that you would like to display from the Filter panel context menu by toggling the category options.

The Collections panel is a great way to organize your images in specific folders. It enables you to create collections; each of these collections can include images from one folder or different folders. However, you can easily open these files by choosing a collection. The advantage of the collection feature is that files are still located in their original location, so you do not need to move your files or create another copy of them that would take up unnecessary space on your hard drive.

To create a new collection, click the New Collection icon in the bottom right of the Collections panel. You can also create a Smart Collection, which lets you choose criteria for the images that will be added to the collection; Bridge will look for the images that meet these criteria and add them to the collection. For instance, if you specify that a collection's images should include files that are less than 10,000 KB, add these criteria when creating a new Smart Collection from the New Smart Collection icon in the bottom of the Collections panel. The new smart collection looks for the images in the current folder and collects them. Also, when you import images that meet the smart collection criteria, they are automatically added to a smart collection.

Content Panel

In the Content panel, you can view files and thumbnails for images and video content. When you browse folders, you can view the content of each folder in the Content panel; only the supported formats will have a preview thumbnail.

When you click an image or video file, the image thumbnail or the video preview appears in the Preview panel in the right side of the Content panel. You can change the view of the Content panel and the size of the thumbnail through the bottom bar in Adobe Bridge. The bottom bar includes icons to provide more control over how to view content (see Figure 3.2).

Note: You can hit the spacebar in your keyboard to get a full screen view of the images, and you can navigate between images using the arrow keys.

- The thumbnail size slider allows you to resize the thumbnail in the Content panel; click the right icon in the slider or drag the arrow to the right to increase the thumbnail size or to the left to reduce the thumbnail size.
- By clicking the Lock Thumbnail grid icon, you can display the icons using grid lines between them.
- The View Content as Thumbnail icon displays the thumbnail with the default view of the content thumbnail arranged together.
- The View Content as Details icon shows the content as thumbnail and next to each one, detailed information about it as well as the color profile assigned to it.

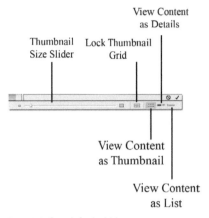

Thumbnail Size Slider

Lock Thumbnail Grid

View Content as Details

View Content as Thumbnail

View Content as List

Figure 3.2 Controls for the Adobe Bridge Content panel.

- The View Content as List icon displays the content in a list that includes small thumbnails for the content and information about the file size, format, and creation date.

When you right-click the images in the Content panel, you can view most commands related to this image, such as opening it in the appropriate program, testing it in Device Central, labeling an image, and sorting it.

Adobe Bridge provides a full-screen preview for specific image or group of images, you can show image in a full-screen preview by selecting the image and choosing View > Full Screen. You can also access the full-screen preview mode by choosing View > Preview Mode. The full-screen mode displays images in a slideshow presentation, where you can navigate between images by clicking on the image or using the navigation arrows.

Metadata and Keywords Panels

Shortcut: You can view image in full-screen mode by selecting the image, clicking the spacebar, and turning on Preview Mode (click CTRL+B in Windows, CMD+B on the Mac).

The Metadata and Keywords panels are associated with viewing and editing the metadata associated with the image files. The Metadata panel displays the file information saved in the file's XML data, such as the file format, creation date, camera information, audio information, video information, and so on.

The metadata is important in organizing the project, especially when working with multiple applications. The metadata is important for providing information about the file or image, such as the author of the image and the details of the camera that was used to take the image. Often, you might have multiple versions of an image and need to determine which image to select as best for a certain project. Metadata can help you organize your files.

On the other hand, the metadata is very important in arranging and sorting files, as you can sort files based on author, date created, resolution, color profile, date modified, and so on.

When you work with 3D files, you can create multiple options and formats for a model before importing it to Photoshop; formats and setting can vary in the imported results. However, you can use metadata to categorize these options for easily access for you and the project team as well.

Your usage for metadata and the amount of the data that you need to add depends on your project and the best way to archive your project files. It is good practice to add the basic metadata information, such as author and camera specifications. In video files, add information such as tape name and scene information.

Although the Metadata panel displays a lot of information, you can easily collapse or expand each type of data. You can directly edit the metadata

content by clicking the Pencil icon next to each data type and pressing the Correct icon in the bottom of the panel to apply changes or the Cancel icon to cancel the inserted information.

Through the Metadata panel context menu, you can use the following features:

- Create a new metadata template, edit the current template, append an existing template from another location, and replace an existing template. These commands are the same metadata commands located in the Tools top menu.
- Increase or decrease the font size for the panel.
- Edit the preferences of the panel to show or hide specific data information.

The Keyword panel lets you choose the appropriate keywords for a specific image or images. Each group of keywords is categorized in collapsible lists that allow you to choose a checkbox next to each keyword to add the image tag.

The Keyword panel's context menu includes the following commands to use when adding keywords to an image:

- Create a new keyboard or create a subkeyword of a parent keyword.
- Rename or delete existing keywords.
- Search and find specific content based on specific search criteria.
- Import keyword keywords from an external text file.

The icons at the bottom of the panel allow you to search for keywords, create new keywords or subkeywords, and delete keywords.

Similar to the metadata information, the keyword information provides an easy method to organize files and categorize files based on specific keywords; you can select specific keywords for each image and later arrange the files based on keywords by right-clicking the content area and choosing Sort > by Keyword.

The keywords are easier to attach to each image, as you just check a box next to the related keyword or keywords on the Keywords panel. You can use it for fast sorting. For example, you can categorize all the 3D files that include wood materials with the keyword "wood." Thus, you can find these files later by sorting based on the keyword "wood."

Though including many details in the metadata ensures better categorization and image identification, keywords should be narrow and unique to allow proper file management.

You can also view the file information via the File Info dialog box:

1. Right-click the file and choose File Info from the menu, or choose File Info from the File menu. (You can view the file info with CTRL+I for Win, CMD + I on the Mac.)

2. The File Info dialog box appears with tabs for each category of the metadata information. The tabs include information about the file description, camera data, audio data, video data, Mobile SWF data, and so on.

Note: The File Info command exists in all Adobe products, so you can easily find the metadata information for the image through the previous steps.

You can use Adobe Bridge to add or edit the metadata of an image or sequence of images exported from 3D animation through the Metadata panel:

1. Select an image or groups of images.
2. Right-click the image and choose File Info, or select File > File Info.
3. Edit the image's metadata.
4. Navigate to the edited metadata value in the Metadata panel.
5. If you need to add specific data that does not appear in the Metadata panel, you can add it by editing the Metadata preferences in the Preferences dialog box.
6. You can load, replace, or append existing metadata templates to an image from the Metadata panel context menu.

Figure 3.3 Edit image metadata through the File Info dialog box.

Compact Mode

The Compact mode (Figure 3.3) is a smaller version of the Bridge user interface that shortens features in the full view to just the panels necessary

for you to view resources, resources paths, and search for and rate resources. You can view the resources through the View panel and open the files by double-clicking it, or right-clicking to open in a specific application, or dragging and dropping it in the appropriate application.

You can switch to Compact mode by clicking the Switch to Compact Mode icon at the top right next to the search box. To switch to Full mode again, click the Full Mode icon at the top right in Compact mode.

There is an Ultra-Compact mode that shows only the resource paths and the recently visited folders. When you select any of the folders, the contents of the folder are displayed in Compact mode. To turn on Ultra-Compact mode, click the Ultra-Compact Mode icon on the top right of the Compact mode interface; you can Switch to Compact Mode icon in the same place to return to Compact mode.

Note: When you activate the Compact mode, it displays at the top of the screen even if you select another application.

Switch to Compact mode

Switch to Full mode

Figure 3.4 Adobe Bridge Compact mode.

Mini Bridge

Adobe Bridge CS5 comes with a new Mini Bridge version that allows you to use Bridge functions easily from within Adobe applications such as Photoshop. These features appear as a docking panel inside Photoshop—you don't have to open Adobe Bridge application separately. You can access both Bridge and Mini Bridge with these steps:

1. Open Photoshop.
2. In the top of the application next to the top menu are two icons. The first icon from the left opens Adobe Bridge.
3. The next icon opens Mini Bridge as a docking panel with the most commonly required Bridge features. You can also open Mini Bridge via Window > Extensions > Mini Bridge.

Mini Bridge is useful for users who depend on Bridge to navigate content and arrange files. It also saves time and resources as opposed to opening Bridge as a standalone application.

• The Mini Bridge panel is divided into main three sections: the top icons section, the browse files section, and the settings. Each of these sections includes some of the main Bridge functions. However, the top section icons from the left to right are the navigation arrows, the back icon, the

Figure 3.5 Mini Bridge in Photoshop CS5.

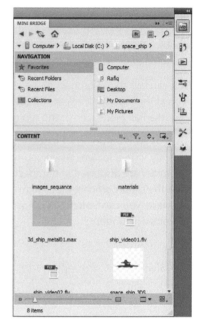

Figure 3.5 Mini Bridge in Photoshop CS5.

home icon, the Bridge launch icon, the Panel view icon (which lets you choose which parts are displayed and which are hidden), and the search icon (which lets you search in the folder for specific files and images).

- The files being browsed appear when you click the Browse Files icon, which lets you navigate and preview files and folders. It also includes functions similar to those of the content area in the Adobe Bridge, such as the Zoom Slider and sorting options.
- The Setting icon opens the Mini Bridge settings, such as the Bridge launch options and the Mini Bridge appearance options, such as the user interface brightness and image backdrop colors that appear behind the image.

Adobe Bridge Preferences

The Preferences dialog box (Figure 3.5) allows you to edit the Adobe Bridge program preferences; you can access the Preferences dialog box with Edit > Preferences or CTRL+K (CMD + K). The Preferences dialog box includes the following information:

- General information, which includes information about the appearance, program behavior, and default favorite folders.
- The Thumbnails section includes information about the maximum size of the processed files and the metadata associated with the thumbnail. While working with 3D files and resources, you can handle large files,

whose thumbnails take a long time to generate. However, you can specify a maximum size for files to get a thumbnail in Bridge.

- The Playback section is responsible for the audio and video playback settings. You can adjust these settings to allow you to preview 3D video and animation content and audio associated with it. For example, you can navigate and preview video footage that you can use in a Photoshop 3D project.
- The Metadata section lets you configure the information that will appear in the Metadata panel. For example, some metadata is not required in the 3D projects, such as GPS information, so you can remove such unrelated metadata from the Metadata panel. On the other hand, you can activate information such as the DICOM file information, which can be used to add information for the medical DICOM files, which we can use in Photoshop to create a 3D volume of medical scan images (see Chapter 4).
- In the Keyword section, you can set the keywords settings, such as the Parent Keywords.
- The Labels section lets you configure the label settings so that you can easily mark a file or group of files with a specific color and associate a special shortcut with each label.
- The File Association section lets you specify the associated program for each of the file extensions in Adobe Bridge.
- In the Cache section, you can configure the caching setting that is responsible for caching information about image thumbnails; better caching performance produces a better-quality thumbnail preview. These options can improve your preview process in Bridge.
- The Startup Scripts section configures the scripts that will be loaded when you open Adobe Bridge. These scripts ensure communication between Bridge and other Adobe products such as Photoshop. For faster loading, you can activate only the Photoshop CS5 script to communicate with Photoshop and exchange files between both and improve the loading time for Bridge.
- The Advanced section shows other settings such as generating monitor-size previews.
- The Output section lets you set the output file settings and embedding color profiles.

Batch Rename

One of the common tasks when exporting a 3D animation into a sequence of images is renaming it. It is not good practice to rename files manually or export the files again with the new name. Thus, Adobe Bridge allows you to rename files through the Batch Rename dialog box, which is a flexible tool to rename images in sequence, as in the following example.

Figure 3.6 Adobe Bridge preferences.

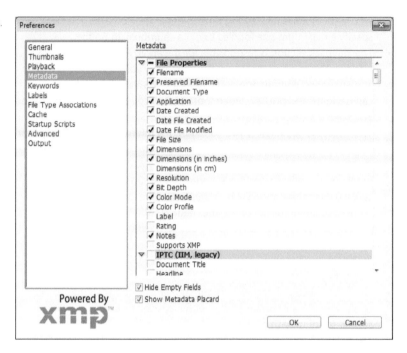

The following example shows how to batch rename group of sequenced images that can be a 3D animation sequence:

1. Select the images, right-click, and choose Batch Rename (or choose Batch Rename from the Tools menu).
2. The Batch Rename dialog box appears to add the renaming conditions (discussed in the following subsection).
3. Click OK to start the rename.

The Batch Rename dialog box (Figure 3.7) maximizes your ability to rename files according to specific criteria, as described in the following sections.

Presets

The Presets drop-down menu lets you choose from three options for batch file renaming:

* The Last Used option lets you use the last setting you applied in batch renaming.
* Default contains basic settings for batch renaming options.
* String Substitution lets you choose to replace only a specific string in the name with another name.

The Presets section allows you to save a preset setting through the Save button or delete it with the Delete button next to the drop-down menu.

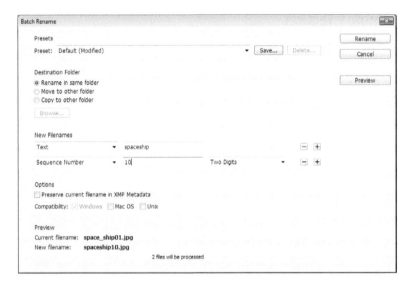

Figure 3.7 Batch Rename Dialog box

Destination

The Destination section lets you choose to either rename files in the same folder, move the renamed files to another folder, or copy the renamed files to another folder.

New Filenames

The New Filenames section lets you change the file's name based on specific criteria from the drop-down list:

- The Text option replaces the image names with text that you specify in the text field.
- New Extension lets you change the file's extension to another image extension. This option is a great way to bulk change not only file names but also their extensions.
- Current Filename lets you edit the current file name, such as choosing to show only numbers, only text, or remove the name.
- Preserved Name is similar to the previous option.
- Sequence Number renames the images to include a sequence of numbers and sets the number of digits the name will include.
- Sequence Letters changes the file names to a sequence of letters, which can be either upper- or lowercase.
- Date Time changes the file's specific date, such as the creation date or the modified date.
- Metadata lets you choose to rename the files based on specific metadata information such as the width, height, and resolution.
- Folder Name renames the files by including the folder name.
- String Substitution replaces a specific part of the name as mentioned earlier.

Options Section

The Options section allows you to save the current image name in metadata for further reference and to have the files made compatible with other operating systems such as Windows, Mac OS, and Unix.

Preview Section

The Preview section is a very helpful section—it gives you a live preview of how what the renamed files will look like. You can also preview how all the images will be renamed by clicking the Preview button.

Stacking Files

The Stack section gathers the images in one group, which is helpful when gathering similar files or a sequence of images when you are in the same folder. You can convert images to a stack of images by selecting the images, right-clicking, and choosing Stack > Group to Stack. The images in the stack appear as one thumbnail. You can change the display of the thumbnail to show a slideshow of all the images by using the controller that appears when you maximize the thumbnail preview through the bottom review slider in the Adobe Bridge bottom sidebar. This feature is very useful for saving screen space for folders that include many Photoshop files, and makes selecting images easy for multiple-image processing, such as Merge to HDR Pro. Also, you can auto-stack similar images together. You can change the frame rate of the slideshow presentation by right-clicking the stack and choosing the frame rate from Stack > Frame Rate.

You also can make the stack thumbnail transparent to show other images' thumbnails in the stack by choosing Enable Onion Skin: right-click the stack and choose Stack > Enable Onion Skin.

When you roll over the images stack, you can preview the images using the small arrow on the top of the stack thumbnail or the slider on the top right. You can also click the number to extract the stack or click on it again to restack it.

Save Images as PDF and Web Gallery

You can save the images as PDF pages through Output to PDF or the Web icon on the top bar. When you click the Output icon, the Output panel appears with two choices (Figure 3.8). The PDF option allows you to output the images as a PDF file, and the Web Gallery option allows you to output the files as an interactive web gallery.

When you select an image or multiple images and click the PDF tab in the Output panel, the PDF output setting displays to let you edit the properties of the output PDF file. Through the PDF tab, you can edit document

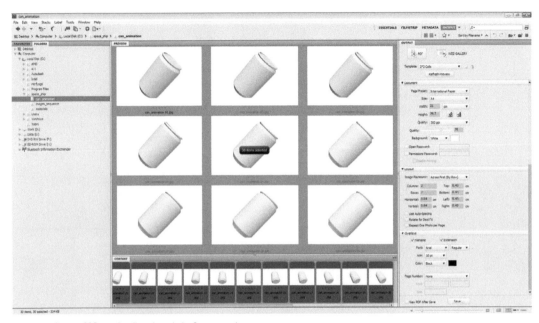

Figure 3.8 Create a PDF or web gallery through the Output panel.

properties such as the PDF template and how the images are arranged, the document setting, the layout of the PDF, the header and footer, the playback for slide presentations, and the watermark section.

The Web Gallery tab lets you output the images as a web slideshow; you can set gallery properties such as template and style. Bridge provides you with a variety of templates for the web gallery and number of styles for each template. Click the Refresh Preview to create a preview for the web gallery or Preview in Browser to see how the web gallery will appear in the web browser.

The Web Gallery tab also includes different settings for the gallery, such as the site information, the colors palette for the site, the appearance of the images, the save location, and FTP upload information.

Summary

Adobe Bridge is an key tool for arranging your 3D project by navigating your resources and arranging your files, such as the 3D models, materials, and textures. Also, it improves your work process by letting you categorize images and label resources for faster and more reliable file access.

Unlike many image viewers, Bridge lets you preview 3D files thumbnails and resources before sending them to Photoshop.

Working with 3D Files

The 3D industry is very extended, with many specialized fields and applications; every tool has its own specialization that makes it different than other tools. For example, the Mudbox is a 3D application that specializes in 3D modeling and 3D sculpture. And 3D Studio Max provides a complete solution for building 3D content and animation. Some 3D applications provide extended capabilities in specific 3D areas, such as fur modeling and clothing.

Each of these applications has its own associated file extension. These extensions do not allow the files to be opened in multiple applications. However, there are some 3D file formats that do allow the exchange of files and resources, such as the DAE format.

Adobe Photoshop provides various methods to use 3D resources and models in Photoshop. For example, you can use the imported 3D models, models from the Photoshop 3D shapes, and create 3D models based on 2D layers. However, the Collada DAE format is the recommended format for importing 3D models and objects to Photoshop, as it is also Photoshop's interchange format and many third-party applications directly support import and export of this format (sometimes through plug-ins).

However, Adobe Photoshop supports the import of commonly used 3D file formats that can be exported from different 3D programs and exchanged with different applications as well. The supported formats that can be imported to Photoshop are DAE, OBJ, 3DS, KMZ, and U3D. Some of these formats are common formats that can be used and exported from different 3D applications, such as the DAE and OBJ formats. Other formats are related to specific applications, such as KMZ, which is a Google 3D format, as we will cover later in this chapter.

Photoshop 3D for Animators. DOI: 10.1016/B978-0-240-81349-3.00004-7

49

Controlling the 3D models is different than controlling the 2D objects that we used to work with inside Photoshop, because the 3D models have X, Y, and Z dimension information, such as the different sides of the models, including the hidden sides. However, the 3D tools let you control or edit the model based on this information. For example, you can rotate the model to reveal the hidden sides of the model in the 3D space.

In this chapter, we will start by introducing the 3D objects that you can import to Photoshop from external resources. In the following chapters, we will cover how to work with these 3D models using the comprehensive 3D tools and commands. We will also cover the DICOM medical files that are produced by medical devices and can be imported into Photoshop. Photoshop can read the frames inside these files and convert them to 3D volume images.

3D File Formats

Importing the external 3D files is easy using the New Layer from 3D File command in the 3D top menu. This command imports the 3D file in any of the previously mentioned formats.

When you import the 3D file, Photoshop adds it in a new 3D layer. This layer allows you to control the 3D models using the 3D control tools in Photoshop. These tools enable you to move, rotate, scale, and pan 3D objects in the 3D space. Let's start with an overview of each format and its properties.

3DS

This is one of the most common and oldest 3D formats, created by Autodesk. Although it works across many 3D applications that allow you to export your files in the 3DS format, it cannot be edited directly and is not the preferred format for importing into Photoshop. Although you can import 3D models to Photoshop using this format, Photoshop does not provide a method to export the 3D content to this format.

OBJ

Similar to the 3DS format, the OBJ format is a simple 3D format that can be exported from different 3D applications and allows you to export the object with a small file size. You can use this format for both importing 3D files and exporting the 3D files from Photoshop. Although you can directly edit this format, it does not support animation, lights, or cameras.

DAE

The Collada file format or DAE is one of the most important 3D file exchange file formats because it is used to import and export 3D models in Photoshop.

It is a cross-3D file exchange format. Many major applications support the Collada format and allow files to be exchanged with this format.

You can export 3D models as the DAE format from 3D applications such as 3D Studio Max, Maya, Cinema 4D, Poser, Blender, and Google SketchUp. This format is also used in developing 3D games and game models.

The Collada DAE file format is also important because it is used in the built-in 3D shapes in Photoshop. One of the new assets in Photoshop is the ability to create 3D shapes from 2D layers. In this case, Photoshop uses the 2D layer as a texture map for the 3D shapes, such as the 3D cube, sphere, pyramid, 3D hat, 3D can, and so on.

Adobe Photoshop can read this format as and lists it in the 3D shapes in the 3D menu. This format is one of the recommended formats for integrating your 3D models and objects with a Photoshop project.

When you work with 3D in Photoshop and build your project, you can output the final result as a 3D file by exporting it as a 3D Collada DAE file.

U3D

The Universal 3D format (U3D) is another standard format that is widely used in the 3D CAD industry. U3D is the accepted format for Adobe Acrobat, where you can embed 3D content into a PDF file and control it with the 3D control tools in Adobe Acrobat.

However, you can use 3D models and scenes created or modified in Photoshop by exporting them in the U3D format and embedding them in Adobe Acrobat to have 3D content in the final Adobe PDF file. You can easily navigate the final files through the 3D control tools in Adobe Acrobat Reader, which support 3D content display.

KMZ

This format is a compressed version of the KML Google Earth files. You can also use this format when working with Google SketchUp modeling, as you can export your SketchUp models in the KMZ format and import them to Photoshop. KMZ is fundamentally a Collada file format and is a wrapper for the DAE format.

Importing 3D Objects

As seen previously, most of the formats are binary formats that allow the easy exchange of 3D files between applications. Thus most of these formats are available in many 3D applications, such as 3ds Max, which allows you to export 3D models in the OBJ and DAE formats.

However, choosing a format depends on your source application and how the 3D application will export the model. For example, exporting the 3D models from 3ds Max as OBJ does not preserve the cameras applied to the 3D model or the 3D scene. However, it is not recommended to use the OBJ format when exporting 3D content with camera information attached to it.

On the other hand, you can preserve the 3D animation of the model by export it in specific formats. For example, if you created a 3D animation for the model created in a 3D application such as 3ds Max, you can preserve the animation by exporting the animated 3D model in DAE or 3DS formats. However, the imported animation information cannot be directly edited in Photoshop.

On the other hand, when you export the files in this format, some information is incorrectly read—especially the information related to the object itself, such as the textures applied to it, and its properties, such as the reflections on the object surface. Thus, it is a good practice to review the 3D model properties after importing it to Photoshop.

> Note: When you import 3D models to Photoshop, make sure to review the paths of the applied textures and make sure they are correct and are referenced to the applied texture correctly. In most cases, you will need to reload the textures from its paths. However, in the following examples in this chapter, I try to reload the textures from its paths. I don't mention this detail in the tutorials, but this issue will be covered in detail in Chapter 8.

Let's start with an example that demonstrates how to import 3D objects into Photoshop and view the imported 3D object information:

1. Open a new Photoshop document.
2. From the 3D top menu, choose "New layer from 3D files" (Figure 4.1).
3. Navigate to 3dplanet.3ds and open it.

Photoshop then imports the new 3D model in a new layer.

The ordinary Photoshop layers are mostly 2D layers and do not support the 3D properties. However, when you import a 3D file into Photoshop, it is placed in a new 3D layer. The 3D layer allows you to edit or modify the object using the 3D control tools in Photoshop.

Note: Next to each texture sublayer, the Eye icon lets you show or hide a specific layer.

Notice that the 3D layer is different than the 2D layer, as the 3D layer includes sublayers that show the different textures applied to the object. And when you add new textures to the object, the new added textures appear as new texture layers in the 3D layer.

As mentioned in an earlier chapter, a 3D model can consist of one or more meshes, depending on its complexity. Each mesh includes the faces that form the final surface of the object and its details. Although you cannot visually identify how many meshes are in the model, you can review these by

getting information about the object and its meshes through the 3D panel, as we will show later.

Figure 4.1 Importing 3D files into Photoshop.

When you import the 3D model into Photoshop from external sources, it is imported with its mesh structure preserved. Furthermore, you can edit any of the meshes separately through the Mesh section in the 3D panel.

Preserving the 3D model mesh depends on the format used to import the 3D object. Some formats, such as OBJ, convert all the 3D model meshes into one compiled mesh. However, you cannot edit each of the models meshes separately. In Figure 4.2, you can see the difference between one model imported as an OBJ format and another in the 3DS format. Notice that the structure of the OBJ file consists of one mesh, but the 3DS imported file preserved the source model structure.

You can view the 3D model information and properties by selecting the 3D layer and opening the 3D panel. If the 3D panel is not appearing in the Photoshop workspace, you can display it by choosing 3D from the Window top menu.

When the 3D panel opens, it displays the whole scene information (Figure 4.3). This information appears in a layered structure, with layers linked to each other based on its related meshes. So each mesh appears as a main layer and the textures applied to it appear under it in a sublayer.

Along with the meshes that appear in the scene structure, the light sources and the camera that is applied to the 3D model appear in the structure as main layers separate from the meshes.

Figure 4.2 The imported mesh with different import formats.

Note: You can show or hide any of the scene resources such as the meshes, lights, and camera by toggling the Eye icon on next to each layer. However, the textures applied to each mesh cannot be hidden or shown.

You can display only the meshes of the 3D object by clicking the Filter by Mesh icon on the top of the 3D panel. When you click this icon, only the mesh layers are displayed in the 3D scene display in the 3D panel.

The Filter by Meshes section in the 3D panel is divided into two sections: the mesh layers section and the mesh properties section. In this section, you can control the shadows on each mesh in the 3D model separately, as we explain shortly.

3D File Loading Limitations

When you import 3D files into Photoshop, you can set limits for the maximum light sources and Diffuse textures that will be imported into Photoshop from the Preferences dialog box.

Figure 4.3 The 3D panel.

The 3D section of the Preferences panel includes the 3D file loading limitations. In this section, you can limit the Active Light Source that Photoshop can import, which can help importing files more quickly, especially when the source file includes too many light sources.

You can also limit the Default Diffuse Texture Limit to control the maximum number of textures that can be imported into Photoshop.

Working with the Mesh Shadows

When you render the 3D models using the Ray Trace, which is one of the high-quality rendering options that relies on calculating the shadows and light applied on the object to create better rendering results, you can display shadows on the object or the object's shadow on the ground. In the Mesh

Note: The shadows' values apply to each mesh in the model separately. However, you have to set the shadows' values for each mesh in the object.

section of the 3D panel, you can edit the properties of the shadows that are applied to the object (Figure 4.4):

1. The Catch Shadows option lets the mesh display shadows from itself. For example, an object that includes many details can have shadows appear from its own mesh over other parts in the mesh.
2. The Cast Shadows option allows the mesh to display the shadows applied to it from other meshes and objects around it.
3. The Shadow Opacity value ranges from 0–100% and controls the visibility of the shadows that appear on the mesh. The shadow opacity is also affected by the global ambient color. So if you have a 50% grey global illumination set, your shadows will start at 50% (with the Opacity set at 100%).

In the natural scenes around us, the light doesn't just affect the object and create a shadow for it; it also creates shadows for the object details on itself, and the object is affected by the other objects around it and gets shadows from them on its surface. However, the Catch and Cast Shadows options are important to give the 3D model a realistic look and feel and a unified style with the objects around it.

In the following example, you will see how the Cast and Catch Shadows options affect the mesh of the model and the environment around it:

Figure 4.4 The 3D File Loading Limitation in the Preferences panel.

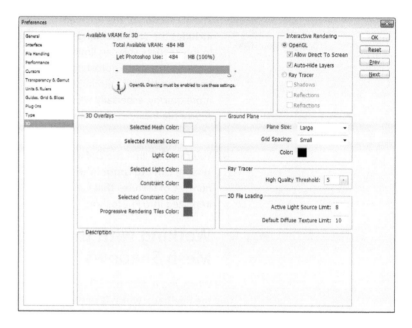

Figure 4.5 The 3D mesh properties in the 3D panel.

1. Open a new Photoshop document.
2. Choose New Layer from 3D File command in the 3D menu.
3. Import the file 3dchair.3ds as a new 3D layer.
4. Open the 3D panel and click Filter by Mesh; this will display only the meshes that are included in the 3D model (Figure 4.6).
5. Click on the first chair in front of the viewer; check the Catch Shadows and Cast Shadows boxes.
6. Set the Shadow Opacity to 100%.
7. Select the second chair mesh and set the Opacity value to 50%.
8. In the 3D panel scene section, make sure to set the quality of the rendering to be Ray Traced.
9. From the top 3D menu, choose Ground Plane Shadow Catcher to render the shadow of the objects on the ground.

Notice how these shadows create a relation between the 3D objects in the scene and each other (Figure 4.8). Try to follow the above steps without checking the Catch and Cast Shadows options.

Under the shadow properties is brief information about the mesh, such as the number of materials applied to it, textures, vertices, and faces. This information is useful to give you an idea of the 3D model and its complexity.

For example, in the previous example, the chair mesh includes one material, one texture, 274 vertices, and 272 faces.

Figure 4.6 Importing a 3D model to Photoshop.

Editing the 3D Model Meshes

On the left side of the second section in the 3D panel, the 3D control tools let you easily control and edit the model parts properties, such as position, rotation, pan, rotation, and scale. Each set of icons in the 3D panel lets you control one of the model resources:

Figure 4.7 The Catch and Cast Shadows properties.

1. The Object 3D tools let you control the 3D model or object in the 3D layer. However, if the model contains multiple meshes, all the meshes will be affected by using these 3D tools.
2. The Camera 3D tool controls only the cameras on the scene.
3. The Mesh 3D tools controls the individual meshes that are included in the object.
4. The Light 3D tools control the lights applied to the object.
5. Return to the Initial Mesh Position to reset the changes you created in the mesh and revert to the original position. You can use this tool to reset any changes you create in the mesh if you want to go back to the first model shape.
6. The Repoussé icon is related to the paths and the text that is converted to 3D object using the Repoussé feature, which we will cover later.

When you click and hold the 3D mesh control tools, the related 3D control tools appear to let you choose the 3D tool to rotate, roll, pan, slide, and scale (Figure 4.9). We discuss in this chapter objects that you can import to Photoshop and how to work with it and its structure, and we cover how to use the 3D tools in more detail in Chapter 5.

In the following example, you will see how to use the 3D mesh tools in Photoshop to control an imported 3D model's mesh. In this example, we will

Note: You have to make sure that the correct layer of the mesh, camera, or light is selected to be able to edit the properties of these specific parts.

Figure 4.8 The 3D model with and without shadows applied.

import a 3D gift box with multiple meshes applied to it and change its status by editing the position of the top box cover using the 3D mesh tools:

1. Open a new Photoshop document.
2. Create a new layer from the Layer panel.
3. Choose New Layer from 3D File.
4. Select the file 3d_giftbox.3ds; the new 3D model is imported in a new 3D layer (Figure 4.10).
5. Open the 3D panel and choose Filter by Meshes to reveal only the meshes.
6. Click the Cover mesh layer.
7. Click and hold on the 3D Mesh tool in the bottom meshes section in the 3D panel and choose the Drag tool.
8. Drag the box cover top away from the box.
9. Choose the 3D mesh rotate tool.
10. Rotate the box to replace the top beside the box (Figure 4.11).
11. In the 3D panel main window, choose Ray Traced as the rendering option.
12. Make sure that both Catch and Cast Shadows are selected.
13. In the 3D panel, choose Ground Plane Shadow Catcher to display the 3D box shadow.

Figure 4.9 The 3D mesh control tools in the 3D panel.

You can apply the same concept of this tutorial to other imported 3D models instead of opening them in a 3D application for just a small change in the meshes structure or to edit its position.

Figure 4.10 The 3D gift box in Photoshop.

Figure 4.11 The 3D gift box in Photoshop with the shadows applied to it.

DICOM Files

The Digital Images Communication in Medicine (DICOM) format is the standard format for medical images that are produced through scanning equipment. Scanned images may be in DC3, DIC, or DCM or may not include a format.

DICOM can either contain one frame or multiple frames; thus Photoshop is able to import both one frame or multiple frame types of the DICOM files and arrange the frame either in layers or separate files or use them to create a 3D volume image that you can view from different positions.

Also, Photoshop supports 8-, 10-, 12-, and 16-bit DICOM files, and when you open a 10- or 12-bit file, Photoshop converts it to a 16-bit file.

When you open any DICOM files with the Open command, the DICOM dialog box appears with the settings and option available to handle the DICOM files inside Photoshop. In the following example, we import a DICOM file that supports multiple frames into Photoshop. The left side of the DICOM dialog box displays the frame included in the DICOM file. You can select one frame to display its properties on the right side or you can select all the frames using the Select All button.

In the middle of the dialog box, the preview windows display a large preview for each frame, and you can change the frame zooming and navigate

through frames using the Next and Previous arrows at the bottom right. You can change the frame options in the Windowing section; you can also adjust the frame brightness and darkness with the Window Level and the frame width through the Window Width. The Window presets include some radiology default views such as Lung, Bone, Abdomen, and Full. Also, you can reverse the look of the frame using the Revert Image checkbox.

Figure 4.12 The DICOM dialog box.

The right section of the DICOM dialog box includes information and options regarding importing a frame or group of frames as well as information about each frame, as we will explain shortly.

Frame Import Option

At the top of the right side of the DICOM dialog box, the frame import option gives you three options to import the DICOM file into Photoshop:

1. The "Import frames as layers" option imports the DICOM frames as layers.
2. The N-Up Configuration option converts the frame to an aligned grid; you can specify the number of rows and columns in the grid in the values in the Import Options section.
3. The "Import as volume" option converts the frame into a 3D volume model. This setting will cause Photoshop to read the header information

Note: Some compressed DICOM files or the files with changed DICOM settings cannot be imported as a 3D volume, such as files that are compressed with the JPEG format.

to determine how far apart to set each frame and therefore how much interpolation there is between the frames. You can also just import frames as layers and then select all layers (frames) and choose New Volume from Layers from the 3D menu. You can then manually change the Z distance in the dialog that pops up.

DICOM Dataset Options

These options affect the information attached to the DICOM files. The Anonymize option overwrites (to protect patient confidentiality) the information attached to the frames; the Show Overlays display information such as the curves and annotations.

Export Options

In this section, you can choose the imported frames' prefix name that will be added before the numbering of the frames. You can use the Export Presentation JPEG function to export the frames as a JPEG sequence.

Header

Figure 4.13 Importing DICOM files as a 3D volume. (Image courtesy of barre.nom.fr/medical/samples.)

This section includes information about the DICOM files such as the manufacturer, equipments, and format. In our example, open the file US-MONO2-8-8x-execho, select all the file frames, select Display as 3D Volume, and click Open. The DICOM frames convert to one 3D volume layer in a new PSD file. You can change the render setting from the 3D panel.

Summary

In this chapter, we covered Photoshop's ability to import external 3D files from different 3D common formats and explored the structure of the imported 3D models through the 3D panel. We also covered how to edit the 3D mesh properties in the model using the 3D mesh tools. Also, we saw how shadows can affect the final result of 3D model rendering and how we can control the shadows from the mesh section in the 3D panel.

At the end of the chapter, we covered the DICOM medical format, which can be imported into Photoshop and converted from a 2D frame to a 3D volume model.

Working with 3D Tools in Photoshop

The existing Photoshop tools provide you with control over 2D content and objects. The 3D objects contain extended information about their meshes on the other sides in the 3D space, which do not face the viewer. However, it is important to consider all three dimensions when these sides are revealed. Although the 3D tools give you the ability to control the 3D object and its position, the 2D tools have power over the final look of the 3D object, such as painting over the model; this is another benefit of the using the 3D features in Photoshop, because you can use both 2D and 3D tools with the 3D objects.

You can access easily the tools to control a 3D object through the toolbar and the 3D panel, which allows you to control the 3D object itself as well as the camera that views the object. Thus, the 3D control tools in Photoshop are divided into two main categories represented with two icon sets in the bottom of the toolbar above the Zoom tool:

1. The 3D object control tools control the 3D object itself, including rotate, roll, drag, slide, and scale.
2. The 3D camera control tools control the virtual camera that is used to view the object.

Photoshop 3D for Animators. DOI: 10.1016/B978-0-240-81349-3.00005-9

Although the 3D tools allow you to control the object directly from the work area, you can control the object more precisely through the Properties toolbar and the 3D-Axis tool, which is the easiest to use, and includes all the 3D control tools in one place.

In this chapter, I cover how to work with the both 2D and 3D tools to view and edit 3D objects in Photoshop. I also cover how to use these tools directly in the workspace, via the Properties toolbar and the 3D-Axis tools. Although there are three locations from which you can control the 3D objects, I prefer to start with the 3D-Axis method because it is the easiest, most efficient, and fastest method. Furthermore, it includes access to all the 3D model controllers in one place. But before we dig into this essential tool, I'll give you an overview of the 3D tools in Photoshop and the concepts behind them.

An understanding of these tools will give you the basic knowledge to animate a 3D object in Photoshop; 3D animation in Photoshop depends on control of the 3D object and the camera position in the 3D space.

Using the 3D Object Control

As mentioned previously, the Photoshop tools can control the 3D object in the X and Y dimensions. To change a 3D object's position, rotation, or scale over the third axis, use the 3D control tool in the toolbar or the 3D-Axis tool.

Shortcut: To reach the 3D object control tools, press K.

The 3D object control tools set includes the 3D Rotate, 3D Roll, 3D Pan, 3D Slide, and 3D Scale tools (Figure 5.1). I'll teach you how to work with each tool. You can extend the 3D object control icons by clicking the small arrow at the bottom right of the 3D tool or click and hold over the tool. This will extend the icons to let you choose from the different available icons in the toolbar.

3D Rotate Tool

The 3D Rotate tool lets you rotate the object in 3D space. Although you can simply rotate the object by dragging your mouse over the workspace, this is not the most accurate method. For instance, you can get more accuracy by rotating the 3D object using specific values, or you can create a rotation animation for the object in the 3D space based on specific rotation values.

However, the most accurate method for rotating an object is using the numerical values that are at the top of the Properties bar:

1. Select the 3D Rotate tool.
2. From the top Properties bar, change the orientation X, Y, and Z values of the object to start rotating it in any direction. For example, change the X value to 150 to rotate the object clockwise in the X axis 150 degrees.

Figure 5.1 The 3D object control tools.

You can rotate the object using the 3D-Axis control arrows. The 3D control arrows appear when you select any of the 3D tools to let you control the 3D object itself, as well as the 3D camera, lights, and mesh. To change the object rotation using the arrows, follow these steps:

1. Select the 3D Rotate tools or any 3D camera, light, or mesh tools, based on what you want to control in the 3D model. In this example, we will rotate the model.
2. The 3D control arrows appear on the working space; the blue arrow represents the Y dimension, the green arrow represents the X dimension, and the red arrow represents the Z dimension.
3. Roll over the little arc in any of the arrows to choose to rotate the object in the associated dimension with each arrow. When you choose an arc of any arrow, a yellow cycle identifies rotation direction of the object. Start rotating the object by dragging the mouse to rotate the yellow cycle, which is an indicator of the object rotation.
4. Click the Home icon at the left of the Properties bar to reset the position of the object to its original position before rotation.

When you use any of these methods to rotate the object, the object position values change to reflect the new position.

Although this example shows how to use the 3D-Axis to rotate the 3D model, later in this chapter, I cover the 3D-Axis in more detail. It changes based on the 3D tool you choose.

Note: You have to have OpenGL enabled under Edit > Preferences > Performance to be able to display the 3D-Axis tool.

Because the 3D object's information allows you to view it from different sides in the 3D space, Photoshop allows you to choose the view position of the 3D object through the Position drop-down list. You can choose from the default saved positions of the object, such as the Left, Right, Top, Bottom, Back, and Front views. Once you rotate, scale, or change the object position, a new custom position is created with the new position values. You can save the new position in the drop-down list for further use by clicking the Save icon next to the Position drop-down list.

The New 3D View dialog box lets you rename the custom position and save it. You can delete any of the custom views by clicking the Delete icon next to the Position drop-down list.

Note: When you right-click the 3D Rotate tool, it switches to the 3D Pan tool or vice versa.

3D Roll Tool

The 3D Roll tool lets you rotate the object around its Z axis. However, when you choose to roll the object, you can roll it by dragging over the object horizontally. You can drag to the right to roll the object to the right direction, and to the left to roll to the left side.

The following example shows how the 3D Roll tool works by trying to roll a 3D car model:

Note: You can switch between the 3D Roll tool and the 3D Slide tool by right-clicking the object when you choose any of them (or by Option-clicking on the Mac).

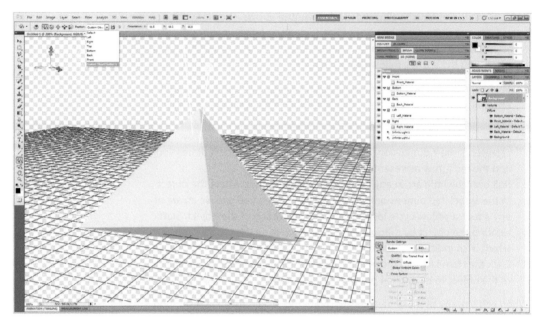

Figure 5.2 3D object Position drop-down menu.

Figure 5.3 3D roll direction for the 3D airplane.

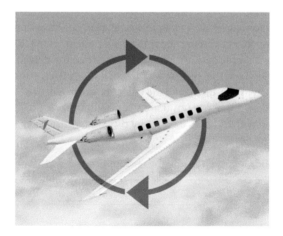

1. Open the file 3Dairplane.psd.
2. From the 3D tool bar, select the 3D Roll tool in the 3D object tools.
3. Start by dragging the model to the right and the left.

Notice that the object is rolling on just one axis to the right and left. However, this tool is useful when you would like to rotate the object in 2D without affecting the third dimension.

3D Pan Tool

There are two 3D Pan tools in Photoshop: the first one is in the 3D object control tools, which lets you pan the view of the object around its axes. This tool actually moves the object, not the camera, to change the view. The other panning tool is the 3D Camera Pan tool, which pans the view of the object by moving the camera, not the object. I discuss this tool in the next section.

When you activate the Pan tool, the values change in the top Properties bar to let you set the object's position instead of the orientation values. Thus, there are three methods to control the object panning. The first pan method is through the workspace by dragging the mouse:

1. Open 3Dairplane.psd.
2. Select the object, and from the 3D tools, select the 3D Pan tool.
3. Drag the object in the 3D space to start panning the object.

The second method is to pan the object through the 3D Control arrows:

1. Select the object.
2. Roll over the top parts of the 3D Control X, Y, and Z arrows; notice that the active direction is highlighted. The cursor will change to show you the direction that the object will pan in. For example, when you click and hold the top of the Y blue arrow, the mouse change to indicate that you will pan the object in vertical direction.
3. Click the arrow and hold, and move the mouse to pan the object in any of the three directions.

The final method to change the object's pan view is with the numerical values in the Position field of the top Properties bar:

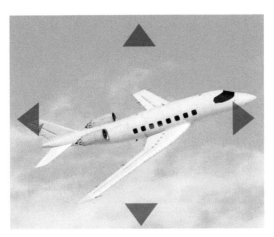

Figure 5.4 3D pan directions for the 3D airplane.

1. Select the object.
2. In the top numerical values for Position, change the Z value to 100 to move the object in the Z value away from you toward the depth of the work area. You can change this value to −100 to move it closer the camera.
3. You can change multiple values to change the position of the object in the 3D space. For example, change the X value to 100, Y to 50, and Z to 100.
4. Click the Save icon next to the Position drop-down list to save your custom position for the object for future use.

3D Slide Tool

The 3D Slide tool slides the 3D object closer to or farther away from the camera view, depending on the how you drag the object on the screen. You can also slide the object through two or three dimensions (Figure 5.5) by applying the tool to the airplane example:

1. Select the Object and choose the 3D Slide tool.
2. Click and drag over the object horizontally to slide the object over the X axis.
3. Click and drag over the object vertically to slide over the object in the Z dimension, so the object moves closer to or farther from the camera view.
4. Click and drag over the object from the top right to the bottom left side of the screen to move the object over both the X and Z dimensions.
5. Click and drag over the object from the top-left to the bottom-right side of the screen to move the object over the X and Z dimensions in the opposite way.

Figure 5.5 3D slide directions for the 3D airplane.

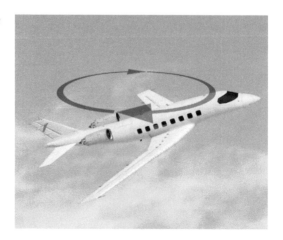

3D Scale Tool

The 3D Scale tool changes the scale of the 3D object either equally in all dimensions, in one specific dimension, or in two specific dimensions. When you activate the 3D Scale tool, the top properties change to reflect the values that you use to change the object dimensions. Thus, you can change the object scale from the top Properties bar, 3D Control arrows, and dragging over the 3D object.

The first method is via the Properties bar values, which let you change the scale of the object more precisely and accurately:

1. Select the 3D airplane object.
2. Change the top values to change the scale of the object on any or all of the X, Y, or Z dimensions.

The second method is via the 3D Control arrows:

1. Select the 3D object. Each of the 3D control arrows now has a cube under the rotation arc in the top of each arrow; this cube control the scale of the object on this dimension.
2. Select the cube in the red arrow to scale the object in the Z dimension.
3. Select the blue arrow cube to scale the object in the Y dimension.
4. Select the green arrow cube to scale the object in the X dimension.

Note: You can change the scale of the object in all dimensions equally by holding and dragging over the cube in the middle of the 3D control arrows. When you roll over the cube, it turns yellow. Move your mouse up to increase the size of the 3D object and down to reduce the size of the 3D object.

The third method to change the 3D object's scale is via the numerical values in the Properties bar. When you select the 3D Scale tool, the numerical values in the Properties bar let you change the scale of the object in any of the 3D dimensions.

When you enter a value in the X, Y, or Z Scale fields in the Properties bar, the value represents a percentage of the original object, as the following example:

1. Select the 3D object.
2. Choose the 3D Scale tool.
3. In the Scale values in the Properties bar, change the X value to 2 to double the size of the object in the X direction.

To scale the 3D object in the 3D dimensions with the same proportions, just add the same scale value to all the three dimension values.

Note: You can change values in the Properties bar by pointing with your mouse to the value name. Dragging and moving right or left increases or decreases the value.

The 3D Camera Control Tools

The 3D camera tools (Figure 5.6) let you control the camera, not the object. It may be bit confusing because some results are typically the same and it is hard to figure out whether the results are based on any of them. But it is important to know that the 3D camera tools control only the camera that views the object to be able to see the difference between these tools and the 3D object control tools. Using the 3D Camera tools including the object as part of a scene. So it changes the object's properties, such as position and rotation, in addition to changing the 3D ground plane for the object.

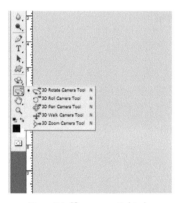

When you click and hold your mouse over the 3D Camera tools, the hidden tools are revealed: these include the 3D Orbit, 3D Roll, 3D Pan, 3D Walk, and 3D Zoom tools. These are briefly described in the following sections; I will cover them in more detail in Chapter 10, in the coverage of the 3D camera in Photoshop.

Figure 5.6 3D camera control tools.

3D Orbit Tool

The 3D Orbit tool rotates the camera around the object in any of the three dimensions; you can change the camera orbit using the 3D controls the same way I described previously for the 3D Rotation tool. You can also change the 3D orbit of the camera through the numerical values as well.

3D Roll Tool

The 3D Roll tool rotates the camera over the Z direction similar to the 3D Roll tool mentioned earlier.

3D Pan Tool

The 3D Pan tool works similar to the 3D Pan tool. The only difference is that when you pan the camera in one direction, the object moves to the other to indicate that the camera is what is moving (not the object). This tool can be used in animation to create a pan animation with the camera moving across the object either horizontally or vertically.

3D Walk Tool

The 3D Walk View tool is used to move the camera toward or away from the object. It is useful in animation when you would like to walk through a scene and give the viewer the impression of walking to or away from the 3D model.

3D Zoom Tool

Although the 3D Zoom tool works the same as the 3D Scale tool, it is functionally like working with a real camera zoom feature, as is covered in more detail in Chapter 10.

Working with the 3D-Axis Tool

The 3D-Axis tool lets you to do all the functions of the previously mentioned tools—in one place. As mentioned in the previous examples, you can control the 3D tools through three main methods: the Properties bar, dragging over the workspace, and with the 3D control arrows. The 3D control arrows allow you to do most of the work that was done thus far with the 3D tools.

The 3D control arrows consist of three arrows that represent the X, Y, and Z dimensions. The green arrow represents the X dimension, the blue arrow represents the Y dimension, and the red arrow represents the Z dimension (Figure 5.7).

Note: The 3D control arrows are available only when the Enable OpenGL Drawing option is checked in Preferences > Performance.

Note: When you roll over any of the active part in the 3D control arrows, the active part is highlighted with yellow color to indicate that it is selected.

Figure 5.7 The 3D control arrows enable you to modify your 3D objects by dragging on the various controls.

3D Drag on Y and X axes

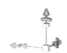

3D Scale on Y axis

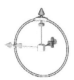

3D Rotate on Y axis

3D Drag on Y axis

3D Scale

The 3D control arrows appear in a transparent panel on the top left of the workspace by default. When you roll over the arrows with the mouse, the panel header appears at the top of the 3D arrows, and includes the following features:

1. You can move the arrows around the screen for more flexibility by clicking and dragging the arrows' gray header.
2. The arrows' top left icon lets you minimize the arrows so that they appear as three links to represent the three dimensions. You can maximize the arrows again by clicking on the minimized arrows.
3. At the top right of the arrows' header, the zoom icon allows you to change the size of the arrows.

Once you select any of the 3D tools, all the control features in the arrows become available. Each of the three arrows includes the following controllers to control the 3D objects.

Moving

You can use the arrow tip to move the object over specific directions. When you roll over the arrow tip, it turns to yellow to indicate that it is activated. When you scroll between any of the arrows near the center cube, a yellow square shows that you can move the 3D object along only the two directions surrounding this yellow square.

Let's use the 3D-Axis tool to change the position of the 3D car model:

1. Open 3car.psd.
2. Select the 3D Object tool; the 3D-Axis tool appears on the workspace.
3. Roll over the green arrow tip; it will change to yellow to indicate that it is activated.
4. Drag up and down to move the car model.

You can follow these steps with the other arrows as well.

Rotating

When you roll over the small rotation curve under the arrow tip, a yellow circle indicates the orbit that the object will rotate around. Start rotating the object by dragging the rotation part of the arrow around the circle. You will notice that the whole arrow rotates with the mouse movement, as well as the object. Apply the previous steps on the 3D car model to rotate it:

1. Open 3car.psd.
2. Select the 3D Object tool; the 3D-Axis tool appears on the workspace.

3. Roll over the small arc under the green arrow tip; it will change to yellow to indicate that it is activated, and a yellow circle appears to show the direction of the model rotation.
4. Drag over the model to rotate it.

You can follow these steps with the other arrows as well.

Figure 5.8 Moving the 3D object using the 3D-Axis tool.

Scaling

The scale cube in the middle of the 3D-Axis tool allows you to scale the object in all directions with the same proportions. Thus, when you drag over any cube for any of the directions, the 3D object is scaled in this direction only. Following is an example of how to scale the 3D car model:

1. Open 3car.psd.
2. Select the 3D Object tool; the 3D-Axis tool appears on the workspace.
3. Roll over the small square under the green arrow tip; it will change to yellow to indicate that you can scale the object in this direction.
4. Drag over the model to rescale it.

You can follow these steps with the other arrows as well. You can scale the 3D car model by the same proportion in all axes by dragging over the big square in the middle of the 3D-Axis tool.

Figure 5.9 Rotating the 3D object using the 3D-Axis tool.

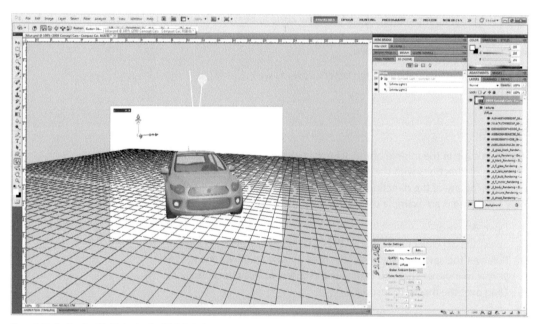

Figure 5.10 Scaling the 3D object using the 3D-Axis tool.

Rotate View Tool

When we used to draw or create artwork on paper, we could rotate the page to have more accuracy and hand control over the artwork. For a long time, this was not an option while working in computer graphics. However, the new Photoshop CS5 comes with a new feature—the Rotate View tool—which allows you to rotate the whole workspace.

When you activate the Rotate View tool, you have more control over drawing or working with the 3D object, especially when it comes to 3D painting, in which you might like to change the document rotation to get more control out of the drawing tools. When you activate the Rotate View tool, you can change the work area's rotation by dragging over the work area. The following example shows how to use the Rotate View tool:

1. Open the file 3Dcar.psd and make sure that OpenGL is enabled from Edit > Preferences > Performance.
2. Click and hold on the Hand tool in the toolbar and select the Rotate View tool.
3. Drag on the stage to rotate it.

You can also adjust the work area rotation using the Properties bar, which allows you to enter the rotation value of the object in the Rotation field or drag the Rotation cycle next to the Rotation field. In the Properties bar, you can set the following for the Rotation View tool:

1. Reset View button: This button resets the view of the work area to its original view. You can also double-click the Canvas Rotation tool to reset it.
2. Rotate All Windows: This option rotates all the opened windows in Photoshop.

Note: The Rotate View tool requires OpenGL to be activated; otherwise, you will get a warning message when you try to use it. In CS5, you can also now turn this off in Preferences > Interface > Enable Gestures.

As mentioned previously, the 3D tools are located not only in the 3D toolbar but also in the 3D panel. The 3D panel includes some extra 3D control tools that control the model's mesh, lights, and texture.

In the bottom right of the 3D panel are five sets of 3D tools, which are the 3D Object tools, the 3D Camera tools, the 3D Mesh tools, the 3D Light tools, and the 3D Materials tool. The first two sets of tools are the same as the two object and camera tools in the toolbar. Here, we will briefly cover the other sets of tools—we will dig into more detail about them in their relevant chapters.

Note: When you select any of the 3D tools in the 3D panel, the 3D-Axis tool appears with the associated function for to these features. Make sure to activate the material or the light that you would like to edit to make the 3D-Axis tool appear.

3D Mesh Tools

When the model includes multiple meshes, this set of tools lets you control specific meshes or part of the model and using the 3D Mesh Rotate, Roll, Pan, Slide, and Scale tools. When you select any of the 3D mesh tools, the 3D-Axis tool becomes active and lets you control the selected mesh through

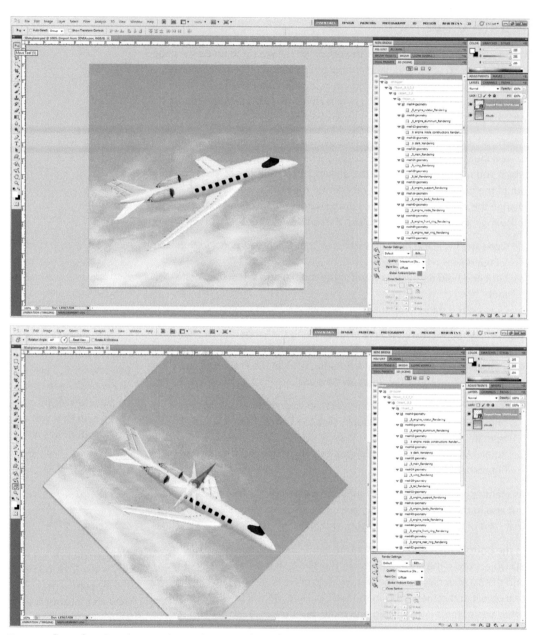

Figure 5.11 The top figure shows the stage in its original position; the bottom figure shows the stage after rotation.

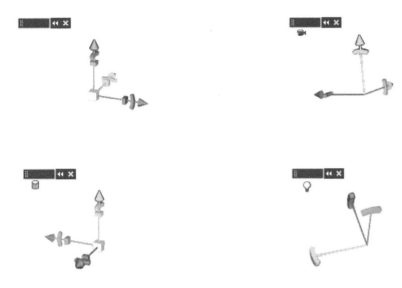

it. I will talk more about working with the 3D objects and its meshes in Chapter 6.

3D Light Tools

This set of tools lets you control the rotation, pan, and slide for the light sources applied to the model, which is covered in detail in Chapter 9.

3D Materials Tools

The 3D materials tools include the 3D Materials Drop tool and the 3D Select Material tool. The 3D Material Drop tool lets you apply selected materials directly to the object by clicking on the object. You can also copy materials from a specific part on the model and apply them to another path, as you will see in the textures and materials section in Chapter 8. You can also use the 3D Select Material tool to select a specific material directly by clicking on it in the model.

Editing 3D Objects Using the 2D Tools

The 3D tools are not the only tools that allow you to edit and work with the 3D object in Photoshop. Some 2D tools that we used to use with 2D layers can edit the 3D object. As many of us are already familiar with Adobe drawing tools, I will focus in this section on how these tools work with 3D objects.

Object Selection Tools

The selection tools include the Rectangle Marquee, Elliptical Marquee, Single Row Marquee, and Single Column Marquee on one side and the Lasso tool, Polygon Lasso tool, Magic Wand tool, Quick Select tool, and Magnetic Lasso tool on the other.

When working with the selected tool with the 3D object, to copy the selected part as a 2D object without preserving the 3D properties of the 3D objects:

1. Open a new Photoshop document.
2. From the 3D menu, choose New Shape from Layer > Cube.
3. Select the Rectangle Marquee tool.
4. Select part of the 3D cube, then copy this part by pressing CTRL+C (CMD + C on the Mac).
5. Paste the copied part by pressing CTRL + V (CMD + V on the Mac).
6. The 3D object is pasted in a new layer as a 2D object.

You might be wondering why you would use a selection for the 3D object or part of it. Actually, there are many usages in the real-life work for such a selection over 3D models. For example, you can select an area to show or hide its meshes, or you can select an area for selective rendering, as demonstrated in the following example:

Figure 5.13 The 3D car model.

1. Open 3Dcar.psd.
2. Select the Polygon Lasso tool.
3. Rotate the 3D car to view the front part of the car using the 3D Rotate Camera tool.
4. Select the front part of the car.
5. From the 3D menu, choose Hide Nearest Surface; this command will remove the front mesh and display the inside part of the car.

You can use these steps to reveal the inside of the model.

Figure 5.14 The 3D car model after hiding the polygon parts closest to the camera, in order to reveal the interior parts of the car.

Magic Wand and Quick Selection Tools

The Magic Wand tool selects a part in the layer with similar colors. Also, it can select the colors next to the main color and tolerance with it. This tolerance depends on the Tolerance value option in the tool's options. The Quick Selection tool selects similar color areas while you move the mouse over the object.

Both the Magic Wand and Quick Selection tools work similar to the selection tools. When you select a color range in the 3D object, the Magic Wand tool detects the 3D sides of the object and selects the colors in the visible edges.

3D Painting

You can use the Photoshop painting and drawing tools to directly paint over the 3D model in the 3D space. However, your paint or drawing will be

applied directly to the model. I cover this feature in more detail, along with using textures, in Chapter 8.

Eraser Tool

The Eraser tool and its neighbor tools act in a special way with a 3D object. The concept behind using the Eraser tool is that its does not erase the object itself; instead, it erases the texture applied to the object or the layer that is used as a texture for the object. Here's how to use the Magic Eraser tool to optimize the 3D object layer:

1. Open the Photoshop document Label.psd.
2. From the 3D top menu, choose New Shape from Layer > Soda Can.
3. The label layer will form the texture of the soda can. Now we need to remove the white background of the layer to show the object's main diffusion color.
4. Select the Magic Eraser tool and then click the space outside the main label. This will erase the white area around the object.

Along the same lines, most of the 2D tools affect only the texture of the 3D object or the layer that is used to create the 3D object. However, the mesh of the 3D object itself is not affected with these tools.

Figure 5.15 The label layer.

Free Transform

The Free Transform tool cannot interact directly with the 3D object or the 3D layer. However, the 3D object needs to be changed into a smart object so that you can easily edit it:

1. Select a 3D layer in Photoshop.
2. Select Edit > Free Transform or press CTRL+T (CMD + T on the Mac).
3. A warning message appears to tell you that you can not free transform the current 3D object and that you need to convert it to a smart object.
4. Click OK to convert the 3D object to a smart object or Smart Object > Convert to Smart Object from the Layer menu.
5. The Free Transform control appears to let you edit the smart object.

Summary

Working with the 3D models in Photoshop depends on your understanding of the 3D tools and methods. There are many methods to control your object via the 3D tools, numerical values, and the 3D-Axis tool, which is the most efficient and easy-to-use approach. However, this chapter provided details on each of the available 3D tools and their usage.

3D Objects in Photoshop

As you saw in Chapter 4, you can import 3D objects and models from different 3D applications with a wide variety of formats, such as the 3DS, U3D, KMZ, and OBJ formats. But you are not limited to importing 3D objects: Photoshop includes built-in 3D shapes that you can use in your project. The built-in 3D presets in Photoshop are extendable to let you add additional 3D objects as Photoshop presets. Furthermore, Photoshop gives you multiple methods to create 3D shapes based on 2D layers or objects.

Generally, there are six methods to create 3D objects in Photoshop:

- 3D Postcard
- New Shape from Layer
- New Mesh from Gray Scale
- New Volume of Layers
- Repoussé
- A 3D volume that is created from a DICOM file

Each method has its own appropriate use and features. In this chapter, I will discuss the differences between the methods and how to use each to create 3D objects in Photoshop, along with an example or two for each tool.

Working with DICOM files, including for medical use, is covered in depth in Chapter 4, as it differs from the other graphic formats. Repoussé is covered in more detail in Chapter 7. In in this chapter, you'll learn about the anatomy of the 3D Mesh tab in the 3D panel.

3D Postcard

You can give a 2D layer 3D properties such as rotation, positioning, and scale. You can also give your 2D layer the ability to use other 3D different

Photoshop 3D for Animators. DOI: 10.1016/B978-0-240-81349-3.00006-0

options, such as panning and sliding in the 3D space, by converting it to a 3D postcard. The 3D postcard object is actually a two-sided 3D mesh that has the 2D layer image applied to it as a texture map for both sides (a.k.a. diffuse maps).

Here's how to create a 3D postcard out of a 2D layer and change its 3D properties. This example demonstrates an easy method for creating a 3D chessboard with the 3D postcard method:

1. Create a new Photoshop file with the dimensions 200px × 200px.
2. Create a square selection using the Selection tool at the top left of the screen. Set the size of the selection to 100px × 100px from the Properties bar. Set the Style to Fixed Size and type in 100px in the Width field and 100px in the Height field.
3. Fill the selection with white.
4. While the Selection tool is active, move the selection to the right to the edge of the white square to create another square and fill it with a brown color.
5. Repeat this with the other two squares under them with reversed colors.
6. Select the whole object with CTRL + A (CMD + A on the Mac).
7. Define your selection as a pattern by choosing Edit > Define as Pattern.
8. Create a new Photoshop file sized at 800px × 800px.
9. Choose Edit > Fill and specify the fill option Pattern from the Use menu, selecting the squares pattern.
10. Select the chessboard layer, and from the 3D menu, choose New Postcard from Layer. This will convert the 2D layer to 3D, and the chessboard fill will be used as a texture map for the 3D object.

Figure 6.1 The first four squares of the chessboard.

11. Rotate the chessboard in the X dimension to have depth in the 3D space. (See Figure 6.2.)

Figure 6.2 Create the chessboard using the 3D postcard feature.

Notice that the texture in the 3D has moved to be a diffuse sublayer of the main 3D layer.

3D Shapes

Photoshop includes a library of 3D shapes that you can use as built-in models. The library includes basic shapes, such as the cone, cube, cylinder, sphere, donut, and pyramid, as well as more complicated models such as the hat, wine bottle, soda can, ring, and spherical panorama (Figure 6.3).

Similar to creating the 3D postcard, when you create a 3D shape out of a 2D layer, the 2D layer content is used as a (diffuse) texture map for the 3D model. When the layer does not include any content, the model is created without any texture applied to it and uses the default color for the meshes.

The 3D models in the 3D shapes menu are extendable, similar to other Adobe Photoshop resources such as brushes, actions, and colors. The built-in 3D models in Photoshop are 3D Collada DAE format files and are saved in the following path: Local Machine\Program Files\PhotoshopCS5\Presets\Meshes. You can add more 3D models to the meshes library by copying your DAE format models to this folder. When you restart Photoshop, it will read the new 3D shapes in the shapes menu.

87

Figure 6.3 The 3D shapes in Photoshop.

Although Photoshop has limited capability to edit the 3D model, the extendable capabilities in Photoshop allow you to add new models and work with these models, which can automatically inherit the 2D Photoshop layers as textures or maps.

In the following steps, we will copy into the Meshes folder a Collada file for a chess rook created in 3D Max. You will see how this 3D shape will convert a 2D layer to a texture for this shape. We will also add this shape to the 3D chessboard layer (scene) we created earlier in this chapter. Follow these steps:

1. Copy the DAE Collada file Rook.dae for the chess rook, from chapter six in the DVD, to the folder PhotoshopCS5\Presets\Meshes and name it Rook.
2. Restart Photoshop so that the new files are available.
3. Create a new Photoshop file.
4. Add the wood_texture.jpg image as a new layer (Figure 6.4).
5. Select New Shape from 2D Layer > Rook in the 3D menu. The rook model is created on the stage with the wood texture applied to it (Figure 6.5).

Note: In some cases the texture map does not appear on the model properly or needs further modifications for some other reason, so I discuss how to edit the texture map of the model in Chapter 8.

Here is another example where we will use the existing 3D soda can model in Photoshop and add a label over it using a 2D layer as a texture map:

Figure 6.4 The wood texture in the Photoshop file.

1. Open the file Photoshoplogo.psd from the Chapter 6 files on the DVD; this file includes the Adobe Photoshop logo label that we will use to cover the 3D soda can.
2. From the 3D menu, choose Soda Can. The soda can 3D model appears and the 2D layer is converted to a diffuse texture map for the side mesh of the soda can (Figure 6.6).

Figure 6.5 The wood texture applied to the inserted 3D Collada model in Photoshop.

Spherical Panorama

3D panoramas are one of the commonly used shapes to create a global environment in a 3D scene. The 3D panorama consists of a sphere; the panoramic image also works as a texture for this sphere, which surrounds

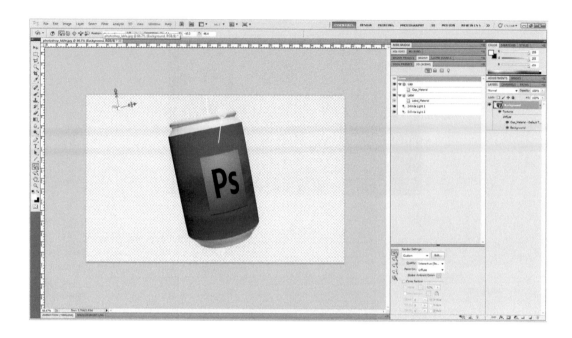

Figure 6.6 The soda can model with the Photoshop label applied to it.

the 3D scene as an environment. The Spherical Panorama tool converts the 2D layer to a 3D sphere that surrounds the 3D scene. You can rotate, pan, or use the 3D tools to navigate around the 3D sphere.

To give you a better understanding of spherical panoramas, the following example converts a space image to a panoramic space that you can then navigate using the 3D tools in Photoshop:

1. Open the file panorama.jpg. This is an image for a city background (see Figure 6.7). We will convert this image to a spherical panorama that you can navigate through with your 3D tools mimicking a real environment.
2. From the 3D menu, choose New Shape from Layer > Spherical Panorama.
3. The image layer is converted to a 3D layer that includes the city background image as a (diffuse) texture for the inside side of the sphere (Figure 6.8).
4. Select the 3D Camera Rotate tool from the 3D camera tools and drag over the panorama image to navigate through the image. Notice that the spherical panorama gives you the effect of being inside the environment.
5. Use the 3D Camera Zoom tool to zoom in and out inside the panorama.

3D Meshes from 2D Grayscale Layers

I consider this method one of the greatest 3D resources in Photoshop, as it gives you the ability to translate the depth of a grayscale layer or image into a 3D mesh. Photoshop translates the depth in the image to this mesh.

Figure 6.7 The panorama image before applying the spherical panorama object.

The 3D meshes from the grayscale option allow you to use a grayscale image as a map that forms your 3D shape. The map image is used as a texture for the object and a bump map to give your object the required depth. The idea behind this concept is that Photoshop reads the different gray degrees in the image as depths for your 3D surface. For example, the white areas are the highest areas in the model and the black areas indicate that there are no mesh areas in this part of the model.

Note: Although the file should be a grayscale to make sure that all the file content is converted to grayscale, you can use this feature with RGB or CMYK files whose colors are white, black, and gray.

Figure 6.8 The spherical panorama object applied to the city background.

The 3D meshes have four main types; which one to use depends on the final shape that will be created out of the grayscale layer. The four types of the meshes are:

- Plane: This option converts the grayscale layer to a plane with 3D properties such as position and rotation in the 3D space.
- Two-sided plan: This plan creates two sides, each of the which includes the same details of the grayscale layer.
- Cylinder: This option creates a cylinder that includes depth in its surface.
- Sphere: This option creates a sphere shape and modifies the depth of the surface based on the 2D grayscale layer color variation.

The following examples show you how to use the grayscale layer to create 3D shapes without the need to use any 3D tool, inside or outside Photoshop.

In the first example, we will create a curtain based on a layer with a gray gradient and convert this gradient to a depth with the curtain style.

Figure 6.9 The results of applying the different meshes on a gradient layer to create a 3D mesh based on the grayscale layer.

Plane-based mesh

Two-sided plane-based mesh

Cylinder-based mesh

Sphere-based mesh

Note: You will get smoother meshes if you use a 16- or 32-bit depth for your document. When possible, try to keep at least one dimension of the document to a power of 2 (512, 1024, 2048). The document information gets scaled during the conversion to prevent a huge poly count, which can cause chunky results. Documents with dimensions of less than 512 pixels get scaled in half. Documents with dimensions greater than 512 pixels get scaled to 512 pixels.

1. Open a New Photoshop file.
2. Create a new white background.
3. Click on the style icon in the Layers panel and choose Gradient Overlay.
4. Change the angle of the gradient to zero degrees.
5. Click the gradient bar to open the Gradient Editor.
6. In the gradient bar, create a gradient similar to that of Figure 6.10.
7. Set the Gradient Opacity to 10%.
8. From the New Mesh from 2D Grayscale Layer in the 3D menu, choose the Plane shape.
9. The 2D layer is converted to a 3D plane and the layer content into a texture map and bump texture using the grayscale of the gradient (Figure 6.11).

In the next example, we will use the same idea with the brush painting to create a bump texture, which will give a 3D plane a hilly surface. The idea behind this example is that the whiter the circle becomes, the higher the mountains are—similar to contour maps. Here's how to create this effect:

Figure 6.10 The curtain gradient in the Gradient Editor.

Figure 6.11 Creating the curtain effect based on the plane shape.

Shortcut: You can use SHIFT + [to decrease the brush size and SHIFT +] to increase the brush size.

1. Create a new Photoshop document with a dark gray background.
2. Change the color of the foreground in the toolbar to white.
3. Select the Brush tool and change its opacity to 15% in the Properties bar.
4. Make the brush size large enough to create the first stage in the hill.
5. Reduce the size of the brush by pressing the [key on your keyboard and create a smaller circle inside the first one to create a brighter area.
6. Repeat the following steps in different areas in the file to create different hill contours and different heights based on how the brightness of the circles' centers (Figure 6.12).
7. From the 3D > New Mesh from 2D Grayscale Layer menu, choose the Plane shape.

Just as the Plane and Two-Sided Plane options create a 3D plane shape, the Cylinder and Sphere shapes create full 3D shapes out of the grayscale layer. In an earlier example, we created a chess rook based on a model created in Collada 3D. In this example, we will use the grayscale layer to create a chess pawn from scratch in Photoshop. The gradient we will use will identify the height and depth that will form the chess pawn model. Here's how:

1. Create a new Photoshop file.
2. Create a new layer with a white background.
3. From the Styles icon in the Layers panel, select the gradient overlay.

Figure 6.12 The bump texture identifies the areas of depth and height in the 3D plane shape.

4. The Gradient dialog box appears. Click the gradient bar to open the Gradient Editor.
5. Create a gradient similar to the one in Figure 6.13.
6. Select the layer. From the 3D menu, choose New Mesh from 2D Grayscale Layer > Cylinder.
7. The 2D layer with the gradient is converted to a bump texture for the cylinder 3D shape (Figure 6.14).
8. Open the Chessboard file. Choose Window > Arrange > Tile to arrange the two files next to each other.
9. Drag the chess pawn to the chessboard document.
10. Place the chess pawn on the board (Figure 6.15).

Note: You can combine 3D layers in the Photoshop file with by simply dragging and dropping the 3D layers over each other and using the Merge 3D Layer command from the 3D menu. The objects in both 3D layers are merged into one 3D layer, and each layer has its own 3D properties, such as rotation, scale, and pan. Also, each 3D layer has its own camera view properties.

You can also create a 3D mesh from the grayscale layer using the 3D panel:

1. Select the 2D layer.
2. In the 3D panel, check the 3D Mesh from Grayscale.
3. From the drop-down list, choose Cylinder.

Figure 6.13 The chess pawn gradient map in the Gradient Editor.

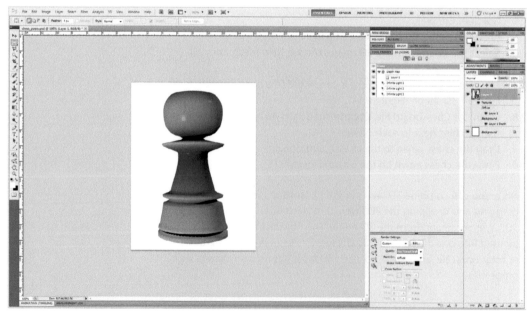

Figure 6.14 The chess pawn created with the mesh cylinder object.

The previous example shows you how to form a new shape from the cylinder using a grayscale gradient; the following example will use a 2D layer to create a bumpy planet surface. We will create a texture layer to function as the contour map for the planet. This texture layer will different degrees of light gray and white that will create bumps on the sphere's surface, creating the effect of a real planet. (In Chapter 8, we will discuss adding a texture map in more detail.)

Figure 6.15 The chess pawn on the 3D chessboard.

1. Open a new Photoshop file.
2. Create a new layer and fill it with a very light gray color, such as #f7f7f7. This will create a global change in the sphere surface (by making it a little deeper).
3. Use the Brush tool with a slightly darker gray color and the brush opacity set to 15%. Click in the areas where you would like depth, and repeat your clicks to get a darker gray, which will translate to more of a dip in the surface.
4. Change the brush color to white, and click on the areas that you would like to be higher on the planet's surface.
5. Instead of the brush, you can use the Pencil tool (with sharper edges) to create sudden changes in the surface. The brush edges fade softly, which will create a gradual change in the surface.
6. Make sure that the layer is selected, and in the 3D panel, choose 3D Mesh from Grayscale in the Create New 3D Object section.
7. Choose Sphere from the drop-down list.

Figure 6.16 The planet created with the Sphere object.

The result is a sphere with an irregular surface of more depth and height, as seen in Figure 6.16.

New Volume from Layers

Here is another option that lets you convert a group of 2D layers to a 3D object by compiling them. The difference is that the created 3D layer has a transparent volume. We used to do have to create this effect manually, but now we are able not only to create this effect automatically, but also give it a 3D volume effect that allows you to animate it through the timeline in the 3D dimensions.

The following example will give you a better idea of the volume method and how to use it to create a volume effect for a 2D text layer:

1. Create a new Photoshop file.
2. Using the gradient methods, create a new gradient with the same Photoshop logo color scheme.
3. In the Gradient Editor, set the first color on the right to #0551b9, and the first color on the left to be #063370.
4. Use the Gradient tool to apply the gradient by dragging over the document from bottom right to top left.
5. Use the text tool to create the first text layer. Type in the text "Photoshop" in white (Figure 6.17).
6. Duplicate the text layer twice (drag the layer to the New Layer icon at the bottom of the Layers panel or click CTRL + J [CMD + J on the Mac]).

Figure 6.17 The Photoshop gradient and the text applied to it.

7. Select the top two layers.
8. In the 3D panel, check 3D volume from the Create New 3D Object section, and click Create.
9. The Convert to Volume dialog box appears so that you can set the X, Y, and Z values for the new 3D volume object. Click OK. The new layer contains the text in 3D depth.
10. From the 3D tools, choose the 3D Zoom tool and set its property perspective camera from the Properties toolbar.
11. Using the Z axis in the 3D control arrows, drag the 3D layer to zoom through the stage as in Figure 6.18.
12. Use the rotation part of the Y axis to rotate the 3D layer a little, in order to display the different volume levels for the 3D model.
13. Return to the first text layer. Reduce the opacity of the layer to 25% with the Opacity value in the Layers panel.
14. Add some style effects to the layer:
 - Add a strike effect with white and 1px width.
 - Add an inner glow effect with white.
 - Add an outer glow effect with white.

3D Meshes

The 3D models can contain single or multiple meshes. You can navigate the polygon meshes and control each of the polygon meshes by using rotate, scale, position, roll, drag, and/or slide on each of the polygon meshes via the 3D Mesh tab in the 3D panel.

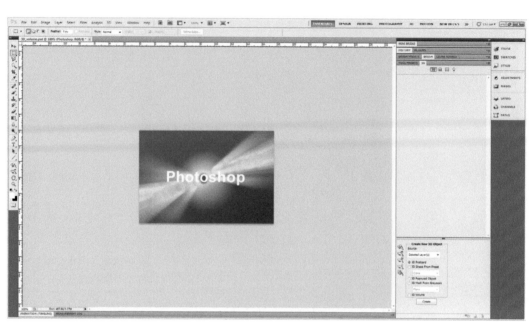

Figure 6.18 The 3D layer of the text with the 3D zoom applied to it.

Figure 6.19 The final text effect after applying the text style and rotating the 3D text layer.

The 3D panel provides various tools for your 3D scene properties, such as meshes, lights, and materials. The 3D Scene tab includes the scene graph, which shows you a list of meshes, lights, and materials. It also includes global settings for the 3D scene. The 3D Mesh tab includes only methods to navigate and control your model polygons and meshes and adjust the 3D object shadow opacity.

The anatomy of the 3D Mesh tab is as follows:

1. The top area displays the structure of polygon meshes separated in layers, which you can display or hide using the Eye icon next to each layer.
2. The preview area displays the selected model. When you select one of the model meshes from the meshes in the scene graph, notice that Photoshop draws a bounding box around the targeted mesh.
3. In the left of the preview area, the 3D navigation tools allow you to control each of the meshes separately without affecting the whole model. The top home icon resets the properties of the mesh to the original properties.
4. The right part under the preview area displays information about the 3D model, such as the number of materials, textures, vertices, and faces.
5. On the left side of the information area are three checkboxes that let you set the following options:
 - Catch Shadow specifies whether the mesh will display shadows on its surface that are cast from other meshes.
 - Cast Shadow specifies whether the mesh will cast a shadow onto the surface of other polygons.
 - Invisible hides the mesh itself and displays only its shadow effects.
6. The bottom icons are global icons in the 3D panel. However, some of them are disabled in the 3D Mesh tab. The only active icons in this view of the panel are:
 - The Toggle Lights icon, which lets you display or hide the light guides applied to the object.
 - The Toggle Ground Plan icon, which shows or hides the ground in the stage.

Note: Shadows are dependent on the Ray Tracer.

Note: These overlays are dependent on OpenGL support. You must have a supported video card in order to see these guides.

In the next example, we use the 3D Mesh tab features by loading a 3D object with multiple 3D meshes, such as the cube in the 3D menu's objects:

1. Create a new Photoshop file.
2. From the 3D menu, choose New Shape from Layer > Pyramid. The current layer is converted to a 3D pyramid layer (Figure 6.20).
3. Open the 3D panel from Window > 3D.
4. Click the 3D Mesh icon from the top of the 3D panel; it is the second icon from the left.
5. Notice that the 3D object includes five meshes. Select any of the meshes from the meshes list.
6. Select the 3D Mesh Rotate icon on the left of the mesh shadow information area.

Figure 6.20 The 3D pyramid object.

Figure 6.21 Modifying the 3D pyramid mesh using the 3D Mesh Rotate tool in the 3D panel.

7. Drag with the mouse on the stage to rotate only this face on the pyramid without affecting the rest of the polygon.
8. Click the Return to the Initial Mesh Position icon to reset the mesh position.

Summary

In this chapter, you learned how to work with different 3D objects inside Photoshop. You also saw how to create 3D objects from grayscale images, as well as how to create volumes from 2D layers. Although creating basic 3D objects in Photoshop is simple, the examples in this chapter show that you can use these features to create a lot of advanced effects.

Challenge yourself by using the exercises in this chapter as a basis for creating your own projects with cool 3D effects and designs.

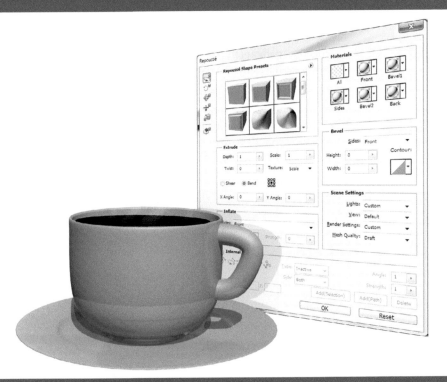

Working with Repoussé

Many questions have been asked since the last version of Photoshop with regard to creating 3D text. Many design tasks include 3D text or 3D text animation. However, designers hoped to create 3D text in Photoshop. Adobe added the Repoussé feature in Photoshop CS5, which allows you to create not only 3D text but also 3D content based on 2D paths, selections, and masks.

The new Repoussé feature provides full control over the created meshes through the Repoussé dialog box, as explained in this chapter. Because of the importance of this feature and the extended capabilities that the Repoussé dialog box can provide, I've given it its own chapter. You'll discover the features available in the 3D Repoussé feature and, through the examples, how to use these features and their different options.

At first, it was strange for me to see a French word in Photoshop when working in the English version! So I searched for the word "repoussé" and found that it refers to a type of artwork that uses metal to create an extrusion of 2D drawing lines. It makes sense, because the Repoussé feature turns 2D paths, selections, text layers, and layer masks to extruded 3D content with different styles of bevels, materials, and shape presets and

Photoshop 3D for Animators. DOI: 10.1016/B978-0-240-81349-3.00007-2

individual parameters. The Repoussé options can be reached through the 3D menu, as well as the 3D panel when you have a 2D layer selected.

By going through the different options in the Repoussé feature (Figure 7.1), you will discover how powerful this feature is and how much power it can provide for your 3D work in Photoshop. This is a powerful tool that can not only turn your 2D path into 3D extruded content, but also apply, extrude, and bevel different settings and styles.

Figure 7.1 The Repoussé dialog box.

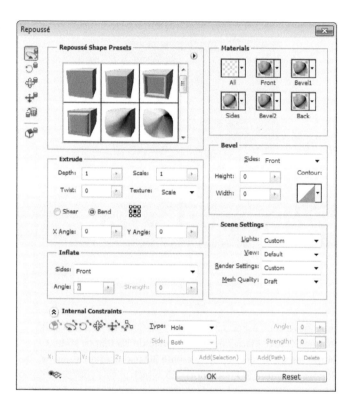

The Repoussé is applied to paths; there are four types of paths and selections that you can use to apply the 3D extrusion through the Repoussé feature: the Text Layer, the Layer Mask, the Selected Path, and the Current Selection. The Text Layer option lets you apply the 3D extrude over a text layer, but you first need to rasterize the text layer:

1. Open a new Photoshop file.
2. Select the Text tool.
3. Click on the stage and type the word "Photoshop."
4. From the 3D menu, choose Repoussé > Text Layer. The text extrudes and the Repoussé dialog box displays for you to set the options of the Repoussé effect.

5. An alert message appears to ask you to rasterize the text layer to be able to apply the Repoussé effect. Click OK to convert it. This is done because it would be computationally expensive to keep the text layer as editable; if a user ever went to edit it, you would essentially be working with a different mesh geometry. Imagine deleting the whole string and changing it—how would we reapply all the settings to accomplish the same look?

Figure 7.2 Repoussé applied to a text layer.

I will discuss the Repoussé dialog box later in more detail.

When you apply a mask to a layer using the Layer Mask option, you can extrude the masked area of the layer and covert it to 3D object:

1. Create a new layer in Photoshop.
2. Fill it with a color.
3. Create a selection over the layer.
4. Select the mask by clicking the Mask icon in the bottom left in the Layer panel.
5. While the mask layer is selected, choose Layer Mask from the Repoussé section of the 3D menu.

Using the Selected Path option, when you create a path that is over an object or filled with color, you can create a Repoussé using this path:

1. Create a new layer in Photoshop.
2. Choose the Custom tool.
3. Select a shape from the custom shapes.

Note: For sharper lines and better results, use the selection-based Repoussé instead of the mask-based option.

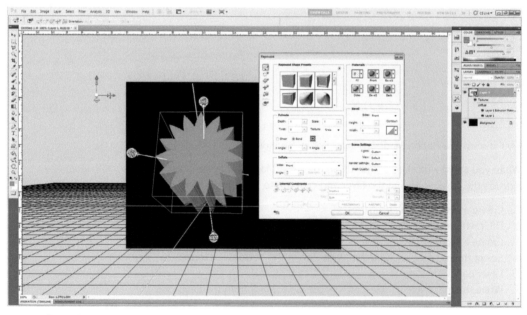

Figure 7.3 Repoussé applied to the mask layer.

4. From the Properties panel, click the Shape Layer icon.
5. Draw the object over the stage.
6. Select Selected Path via 3D > Repoussé.

Paths are not the only method to create a Repoussé 3D object. You can use the current selection of a layer to create the extrusion effect. This option is

Figure 7.4 Repoussé applied to a path.

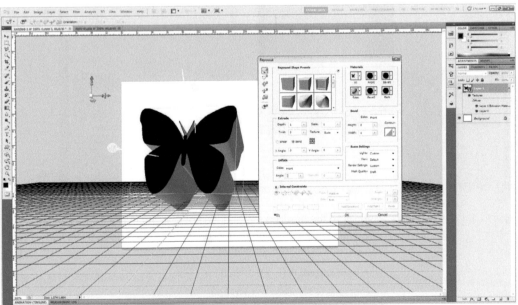

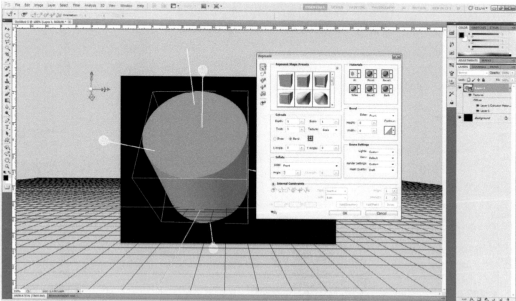

Figure 7.5 Repoussé applied to a selection.

similar to the previous method, except that you create a selection and Repoussé hides the content outside the selection and converts the content inside it as 3D extruded content.

Note: Do not worry if you apply the Repoussé incorrectly, because an alert message will appear to help you.

The Repoussé Dialog Box

After reviewing the resources that we can use to create the Repoussé 3D content, let's discuss the Repoussé dialog box and see some examples of how to use it. The Repoussé dialog box consists of eight parts, discussed in the following subsections.

The Navigation Tools

These tools let you navigate through the object by rotating, scaling, rolling, panning, and resetting the object to the original position.

Repoussé Shape Presets

In my opinion, the Presets section is the easiest way to see the many capabilities you can get from the Repoussé feature. The presets show existing styles that you can use directly without the need to edit any of the values in the Repoussé dialog box.

The Repoussé presets include 18 different presets, as you can see in Figure 7.6. You can also create and save your own presets if you want to use the same parameters later for different objects.

At the top right of the Presets section, the presets context menu gives you more options for the Presets section, including the following commonly used ones:

- New Repoussé Preset: Saves your custom Repoussé setting as a preset for later use.
- Rename Repoussé Preset: Renames an existing preset.
- Delete Repoussé Preset: Removes the preset from the Presets section.
- Delete All Repoussé Presets: Removes all the presets from the Presets Preview section.
- Reset Repoussé Presets: Returns to the default presets.
- Load Repoussé Presets: Loads presets. The Repoussé presets are saved in P3E format.
- Save Repoussé Presets: Saves current presets in an external P3E presets file.
- Replace Repoussé Presets: Replaces the current presets with another presets file.

You can apply any of the presets by clicking on it; it will be applied directly to the 3D object. It provides an easy way to preview each of the presets.

When you select any of the default presets, its values automatically appear in each section's values. So you are free to edit these values and save your customized settings as a new preset.

Figure 7.6 Repoussé shape preset examples.

Materials

The default mesh that is created by applying the Repoussé contains five parts. The materials are divided into five parts, plus one for the overall Repoussé mesh. Each of the six material parts has presets of materials, and you can load external materials. Though you have more control over materials through the 3D panel, you can still choose from the material presets list attached to each part of the polygon.

The polygon is divided into six parts where you can apply material presets to the whole model. These include the All Materials list, Front, Bevel1, Sides, Bevel2, and Back. When you click the material presets for each part, you will

Figure 7.7 The Repoussé materials options.

find the different built-in materials, such as wood, chessboard, marble, and so on.

You can apply any of the listed materials by selecting it; it will be applied to the model or a specific part according from the part selected when you chose the material. When you select a material under All, it is applied to the whole model.

Each part's material list includes a context menu with more commands related to the Repoussé materials. The context menu includes the following commands:

- New Materials: Although you cannot create new materials from the Repoussé dialog box, you can create material and control it through the 3D panel.
- Delete All Materials: Removes the Material Presets.
- Reset Presets: Return to the default setting of the Material Presets list.
- Load Materials: Loads materials from an external location; the materials are loaded in the P3M format.
- Save Materials: Saves the materials as the P3M Photoshop materials format.

113

- Replace Materials: Loads external materials and replaces the current materials.
- Default: Loads the materials that do not support ray trace quality.

Note: As we mentioned in Chapter 8, in addition to the existing material presets, you can download extra materials via 3D > Browse 3D Content Online, which takes you to the Adobe 3D resources site, from which you can download extra materials as ZXP files. Double-click the file once downloaded to install it in Photoshop CS5 through Adobe Extension Manager CS5. Follow the installation guidelines and restart Photoshop to finish installing these materials.

Extrude

The Repoussé feature actually extrudes the path or selection area to give it the three-dimensional effect. The Extrude section controls the extrusion settings for the 3D Repoussé objects. The Extrude section includes the following settings:

- Depth: Increases or decreases the dimensions of the object in the Z axis and gives it more perspective. The depth value ranges from 0 to 10.
- Scale: When you create the extrude effect over an object, the object extends in the Z axis and the back side is actually a duplicate of side of the model facing you. However, the scale value changes the scale of the back side of the extruded object. The scale value ranges from 0 to 10.
- Twist: Twists the 3D object either clockwise or counterclockwise. The range of the twist value ranges from +3600 to −3600.
- Texture: Sets how the texture will be applied to the object. The Texture option includes Fill, Tile, or Scale options. The Fill option adds the texture to the object; the Tile option repeats the texture if it is smaller than the area; and the Scale option makes resizes the texture to fill the entire surface of the object.

In addition to these settings, two options are affected by the registration point and the X and Y angle. The Shear option changes the direction of the extrusion around the basic 2D face that is used to create the 3D object. Similar to a 2D shear, this option slides the parallel planes relative to each other. The Bend option bends the extruded object.

When you select either of these two options, you can change the center point of the effect by clicking on any of the small squares that represent the object registration points that represent the center point for the shear or bend. However, this option is similar to the Transform tool, in which you can drag the center point to any of the sides. Here, you can click on any of the points to use it as an end point.

The X and Y angles let you change the shear or bending angles of the object. The following simple example shows the difference between changing the X and Y bending values:

1. Open a new Photoshop file, and use the Text tool to type the word "Photoshop" in the stage.
2. Select the text layer and choose 3D > Repoussé > Text Layer.
3. An alert message will appear to let you know that the text layer will be rasterized and will not be editable; click the OK button.
4. In the Repoussé dialog box, increase the Extrude value to 3 and 3D rotate the model to reveal the extruded part in the model.
5. In the Extrude section, select Bend and move the X and Y values by dragging the slider or changing the values directly to see how the X and Y values affect the extrude of the 3D model.

Bevel

The bevel is an extension that is added to the 3D object's front and back and allows you to adjust different settings that affect the appearance of the beveled areas. You can apply the bevel to either the front, back, or both sides via the Sides option. The Bevel section includes the following settings:

* The Height value sets the length of the increasing area that is added to the main 3D object to create the bevel.
* The Width value sets the width of the new face that is created after applying the bevel effect.
* The Contour presets let you specify how the beveled area will look according to the contour curve. You can use the context menu to load external contours, replace contours, or save contours as presets.

Inflate

The Inflate option changes the flatness of 3D object face by adding the bump curve in the middle of the face. You can apply these settings to front, back, or both sides. You can set the angle and the strength of the Inflate effect:

* The Angle value changes the curviness of the inflated area and the angle varies from −180 to +180.
* The Strength value changes the height of the applied Inflate effect.

Scene Settings

This part lets you set the general Repoussé object settings in the scene; these settings can depend on the selections you choose from the drop-down lists or just inherit the global settings in the 3D panel. The Scene Settings includes the following options:

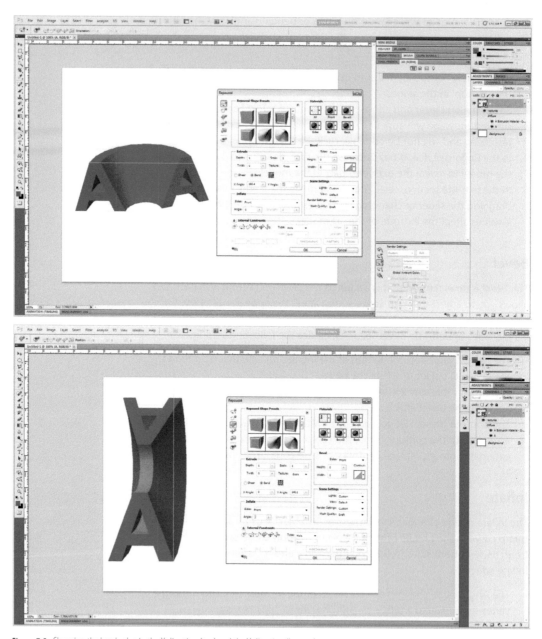

Figure 7.8 Changing the bend value in the X direction (top) and the Y direction (bottom).

- The Lights options include different types of lights presets from which you can choose based on your scene. Options like Fire, Dawn, Cold, Lush, and Default colors can give your scene a more dramatic look and feel.
- The View options include different view angles for the Repoussé model.
- In the Rendering Settings drop-down list, you can choose rendering options for the 3D Repoussé object.
- The Mesh Quality sets the quality of the 3D Repoussé polygon quality. By default, this is set to Draft. It is acceptable for simple extrusions. If you are adding more bevels, twists, or constraints, I recommend bumping the quality up to Best.

Internal Constraints

The internal constraints are selected parts (selections or paths) inside the 3D Repoussé face that allow you to set the areas that are excluded from the extrude effect. The selected areas can be filled with the Repoussé object meshes or turned into a hole in the object or just left inactive. It is important to have an inactive setting in case you bring in a path that has many subpaths, some of which you don't want to make active and to which you don't plan to apply any additional extrusion parameters. This will make your geometry less complex and computationally faster upon interaction.

The Internal Constraints option is used when you need to create unfilled parts in the Repoussé, as the Repoussé detects only the outer selections and paths and the internal selections are detected as constraints for the 3D extrude.

The Internal Constraints section includes the following features:

- The Constraints navigation tools let you rotate, roll, pan, slide, and scale the constraints selection.
- The Type drop-down list lets you specify how the Repoussé interacts with the constraints. The types of the constraints are:
 - Active: Separates part of the meshes and their properties from the rest of the polygon. You can change its angle depth and height without affecting the main polygon meshes.
 - Inactive: Fills the selected area with the extrude polygon. Notice that it does not have the main shape materials.
 - Hole: Hides the constraint area and leaves it empty, or punches out a hole.
- The Sides option applies the constraints on one or both sides.
- The Angle value affects the curve of the constraints and can give it a curved effect on the main polygon mesh.
- The X, Y, and Z values affect the dimensions of the constraints.
- The Add Selection button creates a constraint from the current selection.
- The Add Path button creates a constraint from the current path.
- The Delete button deletes the constraints.

Figure 7.9 Internal Constraints examples.

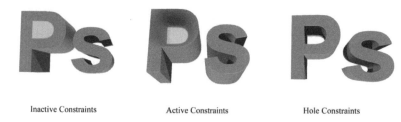

Inactive Constraints Active Constraints Hole Constraints

Note: You can convert the selection or path to constraints either through the Repoussé dialog box or by choosing 3D > Repoussé > Create Constraints from Selection or Create Repoussé from Path. These choices will become active if you add a selection or path on the Repoussé 3D mesh from outside the dialog box. You can then add the subpath/selection as a constraint from the 3D menu or directly from this section in the dialog box.

When you apply the Repoussé effect on a selection, text object, or path, you can edit it by choosing 3D > Repoussé > Edit Repoussé.

The following example helps you understand the Repoussé option better by trying it out. In this example, we will create a 3D smoke/steam effect coming out of a 3D cup using the Repoussé options:

1. Open the file teacup.psd; this file includes a 3D model of a teacup.
2. Create a new layer and fill it with gray.
3. Select the Ellipse tool. Make sure that the Path option is selected from the top left icons in the Properties bar and draw a small circular path on the gray layer.
4. Choose 3D > Repoussé > Selected Path.
5. A new 3D object is created based on the path, and the Repoussé dialog box appears. You can rotate the 3D object using the 3D Rotate tool to reveal its sides.
6. In the Presets section, choose Twist 3 to create a twisted cylinder.
7. Increase the extrude depth to 10.
8. Set the Scale value to 0. This will reduce the size of the face side.
9. Set the Twist value to 750 to create the swirl effect of the steam rising out of the teacup.
10. Flip the 3D object upside down to get the narrow part on the top.
11. In the material presets, make sure that the Default (Ray Tracer) is selected from the context menu to be able to view the ray-traced-quality materials. Choose the Glass effect.
12. Click OK to exist the Repoussé.
13. Open the 3D panel and go to the Material section.
14. Set the opacity of the five materials to 15%.

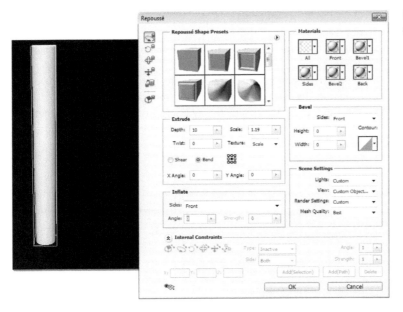

Figure 7.10 Create a Repoussé based on a selected path.

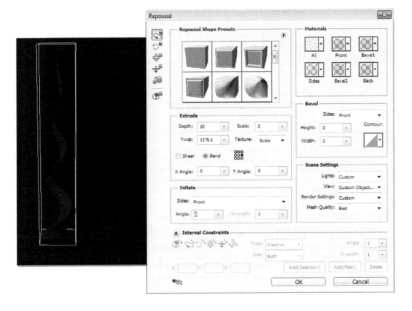

Figure 7.11 The 3D smoke/steam object.

15. Move the 3D steam effect so that it appears as if it were rising out of the hot teacup.
16. You can fade the top part of the smoke line by applying a mask over the 3D layer.
17. Set the mask gradient to black and white or transparent.
18. Drag over the 3D layer to make it fade from bottom to top.
19. Make sure to set the quality to Ray Traced from the 3D scene panel. It is a best practice to make this step the final step after you finish setting up the model.

Figure 7.12 The 3D smoke/steam effect: final results.

Summary

Adobe Photoshop includes different methods to create 3D content and interact with different 3D formats, and provides the ability to convert 2D content to 3D objects. In this chapter, I covered how to create 3D content from 2D resources using the Repoussé feature, which allows us to create 3D content based on selections, paths, and text layers.

The Repoussé feature includes the ability to modify and edit the 3D created content easily through the Repoussé dialog box, which includes many settings. The Repoussé feature is one of the most important resources in Photoshop to create 3D content, as it can be used in many ways, such as creating 3D text for design and animation. You can also extrude a 2D design and convert your design to 3D.

Textures and 3D Painting

Texturing and painting the 3D model is the second step after creating the model itself. Although the 3D polygon mesh has one solid color, in real life most models have texture and map effects applied to them, which helps create more realistic effects and higher rendering quality.

In the previous chapters, I covered how to import 3D content into Photoshop and how to create 3D content from scratch using 2D layers or built-in 3D content. When you create 3D content based on a 2D layer—such as postcards, built-in 3D objects, and 2D grayscale layers—the 3D model created uses the 2D layer as a texture or map for the created object.

You can also create 3D content based on a blank layer; in this case, there will be no texture applied to the 3D layer, as Photoshop does not have anything to use as a texture reference. The texturing and mapping extends to cover not only materials added to the object, but also the object's polygon by bumping areas and affecting the light texture, as we will see in this chapter.

Photoshop provides additional tools to enhance your model's look and texture by allowing you to paint and draw over the 3D model. The same tools that you used to paint and draw over the 2D layers are now able to

Photoshop 3D for Animators. DOI: 10.1016/B978-0-240-81349-3.00008-4

affect the 3D model, including the Brush tool, the Pencil tool, the Eraser tool, the Gradient tool, and so on.

In this chapter, I will discuss how to work with texture, painting, and drawing tools with the 3D object, and how to apply them to 3D model examples from 3Dvia.com.

Texture

Textures are 2D layers or images that are applied to an object to give it a realistic look and feel. When the model consists of many meshes, you can select each mesh individually and apply the texture to it separately from other meshes in the model.

When you create a 3D layer, notice the textures applied to each mesh in the model through the sublayers to the 3D layer in the Layer menu. When you expand the arrow next to the 3D layer, the sublayers appear to show the materials applied to each polygon in the model mesh.

In addition to navigating the 3D layer materials and polygons, you can show or hide the Eye icons next to each material layer to give you more control over the model meshes.

Before you try applying a texture to a model, let's start with the different texture options located in the Materials section of the 3D panel. When you select a 3D layer, you can view its options and details in the 3D panel.

Figure 8.1 3D Materials in the 3D panel.

When you open the 3D panel, the scene shows the whole structure of the model, including the meshes, materials, and light applied to it. When you click Filter > Materials, only the materials and polygons applied to this object are displayed (Figure 8.1).

Generally, associating the texture with the object is related to different types of materials that can affect the object, such as texture of the object itself, the reflection on the object, and the overall environmental effect from outside objects. Following are definitions for the types of materials and the settings that affect the object—you can edit these options in the 3D panel, as shown later in this chapter:

- Diffuse: The diffuse color is the basic material that applies to the object. The diffusion materials can be a solid color or 2D texture image that covers the polygon. When you load an external texture as the diffuse materials for the object, Photoshop has a reference for this material and applies it to the object.
- Opacity: This value determines the transparency value of the object, ranging from 0–100%. When you apply a texture as an opacity reference, Photoshop identifies the grayscale values of the texture image and applies it as different opacity values on the object.

- Bump: The default appearance of the polygon surface is a flat surface, but you can create a surface with raised and lowered areas by modifying the polygon itself. This option creates a bump effect on the model surface. When you apply an image as a bumping texture, the lighter colors resample high areas in the polygon surface, and the darker areas resample lower areas in the model surface, based on the degrees between the light and dark areas.
- Normal: Just as the bumping option affects the polygon surface based on the grayscale of the used texture image, the normal option uses the RGB channels as a reference to change the polygon surface. The normal effect is sharper than the bumping texture and is used to flatten the surface for low-polygons model.
- Environment: This material creates a reflection for the environment around the 3D object; this environmental material is created using a loaded texture image. Photoshop converts the loaded texture image to a spherical panorama and reflects it on the global object texture.
- Reflection: The reflection value controls the opacity of the reflection on the polygon. The reflection can come from either the objects around or the environment texture applied in the Environment texture map. The Reflection value ranges from 0–100. When you load a texture image as a reflection, it overlays the current environment texture.
- Illumination: This texture creates an internal light based on a solid color or loaded 2D texture. When you apply the Illumination effect on the object, the loaded images' colors appear as light that comes out of the object.
- Gloss: This option specifies the number of colors that are absorbed or the colors that are reflected when a light source fall on the object surface. The glossiness of the object depends on the amount of reflected and absorbed light. When you apply a texture as glossiness texture, the colors' values in the image determine the glossiness of the object. Light colors create more glossy areas and dark colors create less glossy areas.
- Shine: The Shine value also affects how the light will be reflected based on the Gloss value. The Shine value controls the dispersion of the light and how much it is focused. For example, when the Shine value is set to 0, the light will be focused and there is no dispersion for the light. When the Shine value is set to 100, all the light will disperse. The Gloss and Shine values work together to set the options of the reflected light and absorbed light of the object.
- Specular: This color defines the global light when applying the either the Shine or the Gloss values on the object. Double-click the color thumbnail to change the color.
- Ambient: This color sets the global light color applied to the object when applying the reflection texture. This value interacts with the total global light around the object.

- Refraction: This value is applied when you choose the Ray Traced option in the render setting, and it is apparent when two objects intersect that have a different refraction value.

The Materials section in the 3D panel includes a number of material presets in the Material Picker, which lets you choose from different ready materials. When you click the arrow next to the Material Picker, a list of the available material presets appear; choose any of the materials by just clicking on them.

The Materials Picker context menu provides the following additional commands to control the material presets or add new materials:

- The New Materials command lets you create new materials and save them for later use.
- Delete All Materials removes the current materials from the presets list.
- Reset Materials reverts the material list to the default materials.
- Load Materials opens material files, which are saved in the P3M format.
- Save Material saves the current custom material in the P3M format.
- Replace Materials replaces the current materials in the Material Picker with other materials in the P3M format.

In addition to the materials listed as Material Picker presets, you can download extra materials from the Photos 3D resources site via 3D > Browse 3D Content Online. This command opens the Photoshop 3D resources page in your browser, from which you can download 3D resources and extra materials that you can then load into the Material Picker list. These include a variety of materials such as Wood, Metal, Rock, Plastic, and others.

After you download the extra materials in the ZXP format, double-click to import them into Photoshop through the Adobe Extension Manager CS5. You can add them to the current materials in the Material Picker list by choosing the material type you would like to append from the Material Picker context menu. To add the extra materials to the Material Picker list, follow these steps:

1. Open the Material Picker in the 3D panel.
2. In the context menu, select the material type you would like to load.
3. An alert message appears, allowing you to choose either to replace the current materials in the Material Picker or append the new materials to the old one. Choose Append to keep both type of materials available.

You can apply any of the materials to the 3D model by selecting the 3D layer of the model and clicking the material.

In addition to the previously listed commands, you can choose to display either the default materials or the Ray Traced materials. The Default materials list is heavily dependent on the Ray Trace rendering. It can include some light information, but the Ray Traced materials are still a better choice for better quality and light effects.

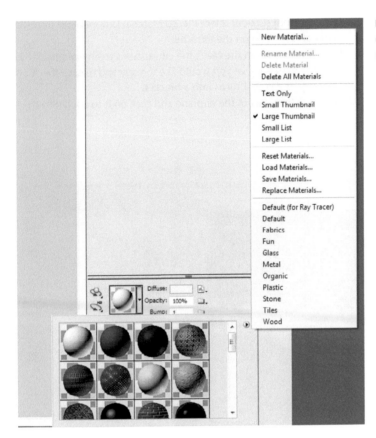

The different material options extend your work with the 3D models in Photoshop and allow you to create realistic models that mimic natural textures and reflection.

3D Material Tools

The 3D panel includes two very useful tools that let you easily handle 3D model materials, especially for objects that have multiple materials applied. The 3D materials tools include the 3D Material Drop tool and the 3D Select Material tool.

The 3D Material Drop tool lets you easily select materials and apply them to another part of the model:

1. Open the Photoshop file Airplane.psd, which contains an airplane model from 3Dvia.com.
2. Open the 3D panel and go to the Material section.

3. In the bottom section, select the 3D Material Dropper tool from the 3D Materials tool icon on the left side.

4. Press Alt (Option on the Mac); the curser turns to an eyedropper icon. Click the material that you would like to copy and release the Alt (Option Mac) key. The cursor turns into a bracket.

Figure 8.3 Using the 3D Material Dropper to copy a material and apply it to other parts of the model.

5. Go to another part of the airplane and click on it to apply the copied materials.

Note: When you roll over any of the materials using one of the 3D Material tools, the material is highlighted with a white outline to indicate the material that is selected.

The 3D Select Material tool gives you an easy method to edit a material by selecting it from the 3D model. In previous versions of Photoshop, it was hard to identify the materials associated with the object. This tool provides a visual way to choose the material that is associated with each part of the model with a simple click.

The following examples shed light on how to use the materials in Photoshop for realistic effects on 3D objects, sometimes with special tips and tricks. In the first exercise, we added new texture to a 3D couch. Here, you will learn how to load an external texture as an image and how to use the materials preset from the 3D Material Dropper in the 3D panel:

Figure 8.4 The 3D couch file includes a 3D couch model.

1. Open the file 3Dcouch.psd, which includes a 3D model of a couch.
2. In the 3D panel, select the 3D Select Material tool and then select the couch's seat cushion.
3. In the Diffuse option, right-click the icon next to the Color Picker. This submenu handles imported textures, and includes the following commands:
 - New Texture opens a new Photoshop file to create a new texture for the material; once it is saved, the material will apply to the object.
 - Load Texture loads a 2D image as a texture map for the object.
 - Edit Texture edits the size and offset of the texture as shown later in this example.
 - Remove Texture removes the texture applied to the object.
4. Choose Load Texture and navigate to the image Wood.jpg in this chapter's folder on the DVD.
5. Set the Gloss value to 50% to increase the surface reflection of light.
6. Set the Shine value to 100%.

When you apply an image as a texture on the 3D object, you can edit its properties such as position and scale through the Edit Texture options:

- Target: This drop-down list shows the target layer that will receive the texture modification. Generally, when you apply the texture, it is applied to the current mesh in the 3D layer. The texture name and thumbnail show the name of the edited texture and preview for the texture.

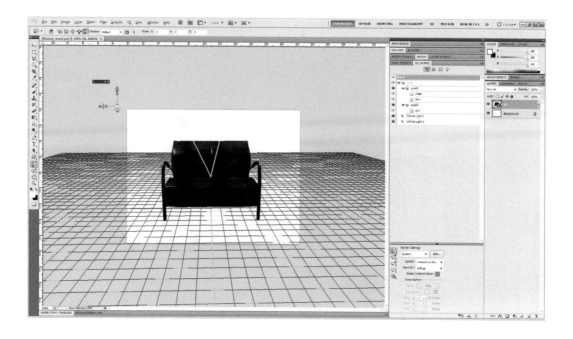

Figure 8.5 The 3D couch with the loaded Wood texture applied.

- U Scale and V Scale: When the texture does not properly fit the object, you can edit its vertical and horizontal scale by dragging over the title or use slide, for values that range from 0 to 10.
- U Offset and V Offset: These two values edit the position of the texture on the mesh on both the vertical and horizontal axes of the mesh. The default offset is set to 0 and ranges from −1 to 1.

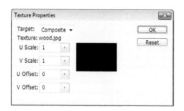

Figure 8.6 The Edit Texture Properties dialog box.

You can apply the same material to the couch arms using the 3D Material Dropper:

1. Select the 3D Material Dropper from the 3D panel.
2. Holding the Alt (Option on the Mac) key, click the Wood texture in the model.
3. Release the key; the mouse cursor changes to the bracket icon.
4. Click the couch arm; it will be highlighted with white outline when you roll over it with the mouse to indicate that you can paste the material to this area.
5. Click the couch arms to apply the texture to them.

Next we will change the couch material to a fabric material from the Material Dropper's extra materials collection. Make sure that you've already installed the extra materials mentioned earlier, and then follow these steps:

1. Open the file 3Dcouch.psd.
2. In the 3D panel, select the 3D Select Material tool and the couch's seat cushion.

3. Click the Material Dropper to reveal the materials list.
4. Click the context menu on the top right of the list.
5. Select the Fabrics option to load the fabric materials.
6. An alert message appears with a choice to append the new materials to the current materials or replace the current materials. Choose the Append option.
7. Choose the Fabric Wool option.

Figure 8.7 The 3D couch with the Fabric Wool material applied to it.

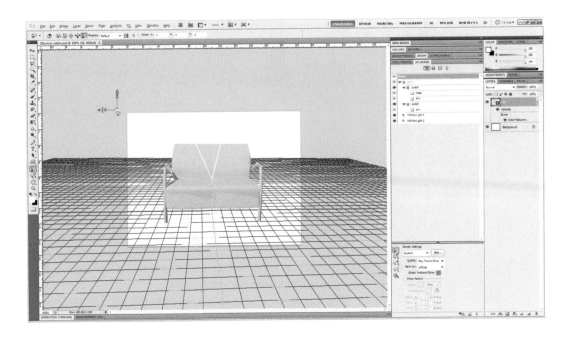

Let's take this example a little further by adding the couch inside a room:

1. Drag the image Room.jpg to the couch file and make it fit on the page; put the room layer behind the 3D couch.
2. Select the 3D Camera tool and start fitting the couch on the room as the figure below.
3. Make sure the 3D model quality of the couch is set to Ray Traced Draft or Final
4. From the 3D menu, choose Ground Plane Shadow Catcher to create a shadow for the couch on the floor.

In the above example, we covered the basic steps to add a texture to a 3D model by either loading external texture images or using the materials presets. In the following example, we will see how to apply an environment texture over a 3D airplane that reflects the clouds around it.

1. Open the Photoshop file Airplane.psd.
2. In the 3D panel, open the 3D Materials section.

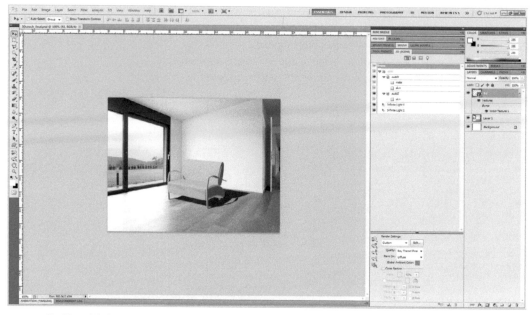

Figure 8.8 The 3D couch final scene inside the room.

3. In the Environment option, click the menu next to it and choose Load Texture.
4. Navigate the chapter folders on the website (http://www.photoshop3d. net/downloads/) for Clouds.jpg and click OK.
5. In the Reflection value, set it to 50 to have more reflection for the cloud on the airplane.
6. Set the Gloss value to 100% to show the plane body as full glossy.
7. Add the clouds image as a new layer behind the airplane. However, it provide more realistic look as the plane flies through the cloudy sky.
8. In the 3D panel, make sure to set the quality to Ray Traced draft or final to get the highest quality possible.

In a previous chapter, we covered creating 3D objects in Photoshop and created a chess rook. In this chapter, we will add a wood texture on the rook and try to edit the texture to fit on the rook model as below:

1. Open the file 3Dchess_rook.psd.
2. Go to Filter by Materials in the 3D panel.
3. Click the Material Dropper to reveal the materials list.
4. Click the context menu on the top right of the list.
5. Select the Fabrics option to load the Wood materials.
6. An alert message appears to choose either to append the new materials to the current materials or replace the current materials. Choose the Append option.
7. Choose the Red Wood material from the Material Dropper.

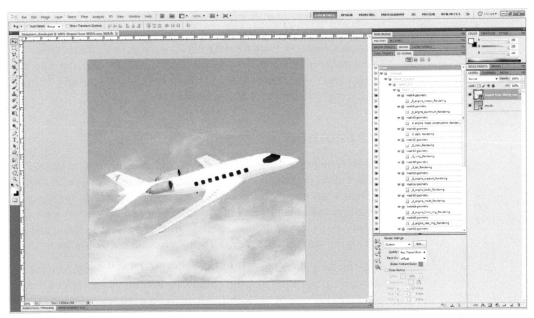

Figure 8.9 3D airplane with the clouds reflection.

Figure 8.10 The 3D Rook with Wood texture applied to it.

Using the texture materials and its different options depends on the object mesh, lighting, and the global environment you would like to have around the object. However, there are not fixed values to use with the materials. Understanding the materials options is important for knowing the different usage of each value, but practicing is the best method for learning how to use the materials with your 3D model or scene.

3D Painting

The 3D texturing and materials are not enough in many cases to provide the realistic effect or the impression that meets with your needs. The 3D painting concept extends your ability by giving you the option to paint directly on the model. Unlike the 2D painting, which is based on 2 dimensions, the 3D painting detects the 3 dimensions of the model and paint on the model surface and fades out based on the nearest faces to the camera view.

While the 3D painting gives the impression that it uses only the painting tools such as the Brush tool, the 3D painting in Photoshop involves using other drawing tools in the Tools panel such as the Brush tool, Pencil, Clone Stamp, Gradient, History Brush, Eraser, Blur tool, Dodge tool, Mixer Brush (new in CS5), and the rest of the tools in the second section in the Tools panel which are related to drawing and painting.

Since the drawing and painting tools are based on the same concept over the 3D objects, we will cover the 3D painting using the Brush tool and see the different options and commands related to the 3D painting based on this tool, and you can apply the same options and commands to any of the paintings and drawing tools in Photoshop.

The idea behind 3D painting is that when you paint over the 3D object, you actually paint over the materials applied to this mesh, which is by default the diffuse texture. You can apply your painting over other textures such as the bump texture, glossiness, and shines, etc.

For example, when you paint using the bump texture, Photoshop translates the brush color and size to a grayscale depth effect inside the 3D object mesh without affecting the mesh itself. However, it looks like you are pushing on the mesh of the object to create up and down areas in the surface of the mesh similar to sculpturing on the model surface. This painting is affected by the brush size, because the bigger the brush is, the bigger bumping effect you get. Also, the darker color brushes create more depth while the light color brushes create less bumping effect.

3D Painting Modes

As mentioned, you can choose to apply the 3D painting on any of the texture materials on the object. If the object does not have materials applied to it. A new material is created to apply the paint effect on it.

The painting effect results depend on the painting mode, and you can choose the 3D Paint Mode from the 3D menu. The available painting modes are:

- Diffuse
- Bump
- Glossiness
- Opacity
- Shininess
- Self-Illumination
- Reflectivity

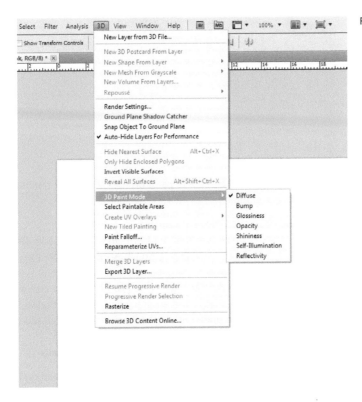

Figure 8.11 The 3D painting modes.

While the diffuse mode paints on the 3D object using the paint colors, the other modes use the grayscale of the color to create texture effects such as the bumping effect we mentioned above. On the other hand, when you choose the opacity mode, you can use the painting brush to create transparency areas on the 3D model.

Since practice is our best method for understanding the feature, the following example shows how to use the painting feature to paint over a 3D hand statue to give it more color details. The 3D painting gives you more

Figure 8.12 The 3D model for the hand statue.

artistic feel and you will be able to paint on the model with different colors and from different angles.

1. Open the Photoshop file 3Dstatue.psd.
2. In the 3D panel, make sure that the Paint On option is set to Diffuse and the Quality to Interactive (Painting) to allow painting over the model.
3. Choose the Brush tool and select dark brown.
4. Start by painting on the hand statue base and 3D rotate around the object to reveal other sides and accuracy paint on the model.
5. Change the brush to golden yellow and paint the hand. Make sure to 3D rotate around the object to paint the whole surface.
6. Change the color to lighter yellow and paint over the nails.

This is a simple example of what you can do with the 3D painting feature, and you can add more details to the model such as giving the hand more colors or using custom brushes or the shapes to create a tattoo on the hand as below:

1. Select the Shape tool from the Tools panel and choose Custom Shapes icon.
2. Open the Shapes drop-down and choose the Yin Yang shape or any of the listed custom shapes.
3. Draw a shape on the hand with the color you choose. Notice that the shape is drawn on the hand texture.
4. 3D rotate the model to see what it looks like.

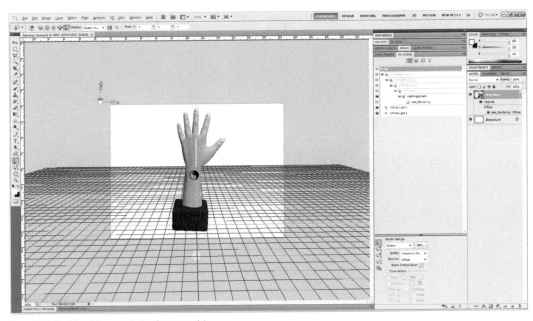

Figure 8.13 The 3D painting over the hand statue model.

The 3D painting is much harder than working with materials and textures. However, it gives you a greater ability to create customized materials and effects over the 3D models, which are similar to digital painting and artistic painting, than can be done using 3D applications

Paint Falloff

When you paint on the 3D model, you can set the paint falloff to the angle of the painting area. This area starts with the model's part that faces the eye and ends with the last area of the model the eye can reach around the object. You can reach the Paint Falloff dialog box from the 3D top menu, and divide the painting area into two sections:

- The Paint Falloff minimum angle: When you start painting over the object, the painting area starts with the point that faces the camera or the viewer. This is the painting area where you can paint on the model before the painting area starts to fade out. The minimum angle ranges between 0 and 55 degrees.
- The Paint Falloff maximum angle: The maximum area is total paint falloff area, and it extends over the minimum area by adding the fadeout on the edges of the painting area. The maximum angle ranges between 55 and 90.

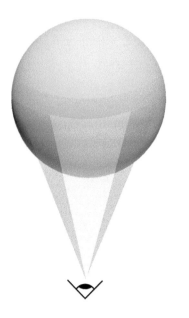

Figure 8.14 3D Paint Falloff angels. The paint falloff minimum angle is presented with the green color, while the maximum angle is presented with the total green and red colors.

Identifying the Paintable Areas

Due to the nature of the painting over the 3D model when using a projection-based painting model, there are areas that cannot be reached by the painting or drawing tool, and the human eye can be tricked in the third dimension. However, you may need to identify the paintable areas in the model. The paintable areas range between areas that got the optimal painting chance and areas are reachable and unreachable areas. However, there are two methods of viewing the paintable areas in the model:

The first method is from the 3D menu through the Select Paintable Area command. When you select this method, a selection appears around the optimal areas for painting.

The second method is through displaying the paintable areas through the Paint mask render setting presets. When you select the Paint Mask from the Render Setting in the 3D panel, the 3D model appears in three colors. White represents good paintable areas. Blue shows areas that are positioned or scaled less than ideal for project-based painting. Red defines areas that are not positioned optimally.

Control the Display of the Paintable Areas

When you paint on a 3D model, you may like to hide parts of the model and reveal other parts to be able to have more control over your painting areas and reach than a hidden part in the mode. Thus, Photoshop

provides 3D menu commands that give you more control in painting on the model.

When you select the specific part of the model using any of the selection tools, you find the following options to control the display of the model polygon:

- Hide Nearest Surface: This option hides the selected parts of the model that are in front of the camera.
- Only Hide Enclosed Surface: This option only hides the triangles within the mesh of the model that are fully inside the selection.
- Invert Visible Surface: When you hide part of the model surface, you can use this command to invert your selection.
- Reveal All Surfaces: This option displays any hidden surfaces.

Summary

The process of texturing and painting over the 3D models is one of the most important steps in the modeling and 3D animation. This step is responsible for dressing the model up with realistic materials that can either mimic real-life materials or create different styles of materials that give the model its look and feel.

Working with Light

Light is the main language between the human eye and the objects around it. When light falls on an object and reflects to the human eye, how it reflects is based on many factors, such as the object's volume, surface texture, materials, and colors. Light is the main tool of the eye in determining the object's volume.

When light falls on 3D objects, it reflects based on the 3D object's shape, which creates light areas and shadowed areas. The differences between light and shadow create the object's or the scene's depth. Light is thus one of the major factors to consider when building 3D objects and scenes.

Light is an important function not only in displaying the object, but also in rendering the object. The render process calculates the light in 3D scenes based on its type and quality. Rendering light is one of the most resource-intensive processes, especially when you employ high-quality rendering techniques such as ray-trace rendering.

Light sources affect 3D objects and scenes differently based on the type and properties of the light, such as intensity and color. Photoshop includes three main types of lights that affect 3D objects. When you apply a light, it affects

Photoshop 3D for Animators. DOI: 10.1016/B978-0-240-81349-3.00009-6

the selected 3D layer only. The following light types are included: Infinite, Spot, and Point (see Figure 9.1), plus Image-based lights.

The Infinite light is a surrounding light that gives a global light effect to the object, such as sunlight or a landscape light. This type of light gives a light effect all over the 3D model as if it were in an outdoor scene. The infinite light is important because you can use it to lighten all the object's parts with a global light that does not focus sharply on a certain area of the object. It gives an impression of a global light that is directed to the object from a specific side.

When you create a 3D object in Photoshop based on a 2D layer, Photoshop by default adds three sources of infinite light to allow you to not only see the model, but also to notice the 3D model depth in the 3D space through the light and shadow applied to it.

The Spot light is a direction light that points to and lights a specific area of the model. The light is a cone shape that is narrow and intensifies near the light source and spreads wider and wider by the end of the cone.

The Spot light affects the 3D surface in a circular area that gets an intensive light in the center of the area and fades out from there. The Spot light can be used to direct light to a certain area on the object but can still give illumination to nearby areas, just as a car's headlights illuminate the road in front of it.

Note: When the 3D model has no light source applied to it, it looks black, with no internal details or textures appearing.

The Point light provides another type of wide light that is still focused and looks more like a light source such as a lightbulb. This light affects a wider area of the object than the Spot light does, and is less intense than the Spot light. The Point light is an intermediate level between the Infinite light and the Spot light. As the name of the light implies, it is a point of light that you can easily move and edit using the 3D light control tools.

Although each of the light types has its own effect on an object, using more than one type of light is common. Also, you can use different light sources to unify the 3D object with the scene around it or other objects. For example, you can use the Point light to create a light source from a candle, for example, that lights an opened book and use also an Infinite light to add a global light for the candle and the opened book.

Each type of light has properties that control its effect on the object, and you can create, edit, change, or delete these light types in the 3D panel.

This chapter starts with a discussion of each light type's properties and the options associated with it. As we go through each type, we will build the light for a scene of an old book by candlelight, using a different type of light to ensure your understanding of the light type options and how to work with them together.

When you click the Filter by Light icon in the 3D panel (Figure 9.2), it selects the light applied to the object based on its type (which can be only one of

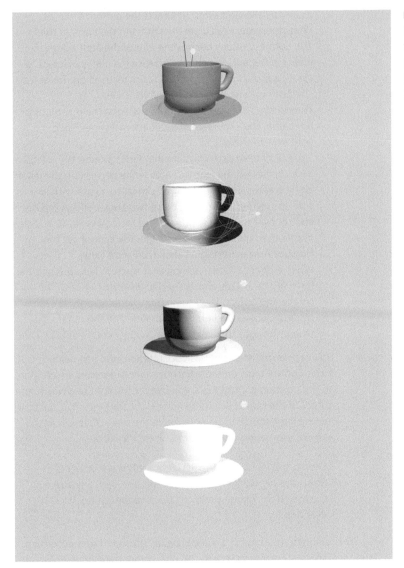

Figure 9.1 The different light types in Photoshop. The top example shows the Infinite light, the middle example is the Spot light, the third one is the Point light, and the last is the Image-based light.

Infinite, Spot, Point, or Image-based light). The second half of the 3D panel allows you to specify the light options based on the type of light:

- The drop-down list lets you choose the type of light.
- Use the Intensity values to control the density of the light, ranging from 0 to 10.
- The Color value lets you change the color of the light via the Color Picker.
- The Create Shadow option lets you activate shadows from one mesh to another beyond it or the ground plane. Though this option creates a

Figure 9.2 The 3D Light options.

more realistic light effect, it affects the performance, as Photoshop must calculate the light and the applied shadows.

- The Softness value changes the blur of the light edges to give it softer edges; you can increase the light's softness to create a more natural light that is not focused on the object. The Softness values range from 0 to 100%.
- The Hotspot Area is the center of the light, the most intensive light area, and is presented as an internal cone inside the light flow to the object.
- The Falloff is an external cone that fades around the intensive area. Increasing the Hotspot Area while decreasing the falloff angle creates sharp light edges, similar to a light with low softness values; controlling these two angles allows greater control over the light's softness and focus. This value is always higher than the Hotspot Area value. You cannot set the Hotspot Area value higher than the Falloff value.
- When a light falls over an object, it starts to fade out and the intensity decreases after a specific distance between the light source and object. The Attenuation values specify the inner distance where the light starts to fade and the outer value where the light totally fades out.

You can control the light position, rotation, and pan using the 3D Light Control tools on the left of the light properties. In addition to the position control tools, you can set the light to point to the center of the object using the Point Light to Origin. You can also set the light source to be pointing in the same direction as the camera view using the Move to Current View icon.

Shortcut: While any of the 3D Light tools is selected, hold down the Alt key (Option on the Mac) and click anywhere on the model to change the focus point of the light or its direction.

These 3D positioning tools are not available in all the light types according to how they operate. For example, you can only rotate the Infinite light, not move or pan it, because it is a global light.

The 3D light position tools are helpful to direct the light to specific areas in the model or change the current light position.

Note: The Toggle Misc 3D Extras icon in the bottom of the 3D panel lets you activate the 3D Light guides, or visual indicators, for the light source; these guides change based on the type of light and help position the light and control it. It gives a fast guide to the light applied to the object.

In the bottom of the 3D panel, you can create a new light source or delete a current light source using the Delete icon.

Infinite Light

The Infinite light is the light most suitable to mimicking natural environment light. We will create a light in this exercise that helps you understand the usage of the Infinite light's best practices, using a pyramid and editing the global light in the scene using the Infinite light. Follow these steps:

1. Open the file Pyramids_light.psd.
2. Create a New layer.
3. Choose 3D > New Shape from Layer > Pyramid.
4. In the 3D panel, choose the Materials section.
5. Select the first pyramid side.
6. From the Material Picker, choose Stone Granite 2 to create a granite effect. If the material does not exist, add it by clicking the Material Dropper context menu and choosing Metal. But first, make sure that you already have installed the extra materials that were discussed in Chapter 8.

Note: You can download the extra materials via 3D > Browse 3D Content Online. These materials are downloaded in .ZXP format and can be installed with the Adobe Extension Manager.

Figure 9.3 The 3D pyramid's 3D layer.

A new 3D pyramid shape is created in the new layer. Next, we will create two other smaller pyramids to complete the scene:

1. Select the 3D Camera control tool, and change the view of the pyramid to top from the Property toolbar.
2. Show the plane guide by clicking the Toggle 3D Misc Extras icon in the bottom of the 3D panel.
3. Duplicate the 3D pyramid layer and move the new layer to the top right of the current one using the navigation arrows.
4. Resize the new pyramid to be smaller than the first pyramid.
5. Duplicate the new layer to create the third pyramid.
6. Move it to the top right of the second pyramid.
7. Resize it using the 3D Resize tool to be smaller than the second one.
8. Select the top two 3D layers and merge them by choosing 3D > Merge 3D Layers. This action ensures that changing the view for the layers or position will not affect the arrangement of the pyramids.
9. Select the newly created 3D layer and the other 3D pyramids layer and merge them together.
10. Use the 3D Rotation tool to place the 3D pyramid model on the desert group. You can use the Ground Plane to place the 3D model properly.

Note: When you control the Infinite light, you will notice that not all of the options are activated, based on its effect: you cannot drag, slide, or point the light's focus to the center of the object, because it is a global light that thus affects all of the object's parts.

By default, Photoshop creates Infinite lights to be able to view the model properly. The three light sources create a global environment. However, we will create a "night mode" light that matches the desert scene in the background:

1. In the 3D panel, click Filter by Light to show only the light resources on the model.
2. You will notice the default three light sources under the Infinite Light category. Select Infinite Light 1 and set its Intensity to 0.2.
3. Repeat the previous step with Infinite Light 3 with the same Intensity value.
4. Select Infinite Light 2.
5. Set the Intensity value to 0.5 to reduce the light's strength.
6. We will rotate the light source to appear as if it is coming from the back of the pyramids. Hold the Alt key (Option on the Mac) and click where you would like direct the light on the model.
7. Select the Rotate the Light icon to the left of the Light icon.
8. Drag the mouse on the stage to rotate the light or use the 3D-Axis widget when the 3D Light tool is selected. Make the light come from the back side of the pyramids as if it were coming from the sun on the horizon.
9. Set the render quality to Ray Traced Draft or Final from the Scene section in the 3D panel to be able to see the final light and shadows applied to the object.

Applying the Infinite light can be done in several ways, such as the main light source in the previous exercise, or by adding it as a global light for the scene before adding more directed light.

Figure 9.4 The 3D pyramids: final light results.

Spot Light

The Spot light provides direct light to the 3D model and more of a focus on specific areas in the model, as mentioned earlier. However, you will see in the following exercise the impact of the Spot light cone on the 3D model. In the exercise, we will use the Spot light to light a street wall with different-colored Spot lights.

1. Open the file 3dstreet.psd. This file includes two 3D postcard layers that represent the street at the ground and the street wall. The ground has the Stone Granite material applied to it from the Material drop-down list. The wall has the Stone Brick materials applied to it.
2. Open the 3D panel and go to Filter by Light.
3. Create a new Spot light source by clicking the icon on the bottom of the 3D panel.
4. Click the 3D Light guide in the Toggle Misc 3D Extras in the bottom of the 3D panel.
5. Drag the light cone so that the light falls on the street wall.
6. Use the Rotate Light tool or the 3D-Axis tool while the 3D Light tool is selected to rotate the light source, as in Figure 9.5.
7. Click the Spot light in the 3D panel to display its properties.
8. Click the Color Picker and specify a red color for the light.
9. Create a new Spot light source and apply the previous steps to it, but change its falling angle as in Figure 9.5.
10. Change the light color to blue.

11. Repeat the previous steps to create a third light source and make it green.
12. While the ground layer is selected, repeat the steps to add three Spot lights that complete the light spot on the ground.
13. Set the render quality to Ray Traced Draft or Final from the scene section in the 3D panel to be able to see the final light.

Note: When you change the Spot light color, the cone outlines change to the new color and indicate the relation between each cone and the light that falls from it.

Figure 9.5 The 3D street wall with multiple light spots.

This exercise shows that you can change the light's properties to create different effects and apply the light in different ways to create a multiple-color theater light.

Image-Based Light

The new Image-based light in Photoshop CS5 shines on the object based on an image source. When you apply this type of light, you can load a source image and the object will shine based on the light and dark areas in the image.

When an object is placed inside a room or in an environment, the global colors affect the object and let it shine based on bright areas around it. You

can use this type of light to make the object fit naturally into its environment.

In the following exercise, we will apply the image-based light to a sphere and make it shine using the environment light around it:

1. Open the file 3Dsphere.psd from the chapter's files on the DVD. This file includes an image of a 3D sphere on a new layer.
2. Select the sphere layer, and in the 3D panel, from the New icon at the bottom of the panel, choose Image-Based Light.
3. In the image source, load the image see_background.jpg.

Figure 9.6 The image-based light.

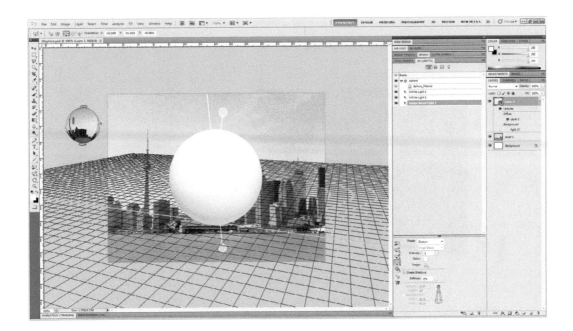

Point Light

The Point light is another directed light source that can be used to direct light to more specific areas of the model, such as in the following exercise. This exercise demonstrates one of the uses of the Point light—a lightbulb on an opened book:

1. Open the file 3Dbulb.psd. This file includes a scene with the basic Infinite light applied to the models.
2. Select the 3D table model layer in the Layers panel.
3. In the Filter by Light section in the 3D panel, click the New Light icon and choose Point Light.
4. Use the Drag the Light icon to the left of the light options to move the Point light to the bulb, so that it appears as if the light is coming from

the lightbulb. Hold the Alt key (Option on the Mac) and click where you would like direct the light on the model.

5. Delete the two Infinite lights applied to the table to see the effect of the Point light.
6. Go to the Filter by Mesh section and choose the Select Bulb mesh.
7. In the material settings in the 3D panel, edit the opacity of the model to give it a transparency similar to that the lightbulb's glass. Set the opacity to 50.
8. Set the Self-Illumination to a light gray light, to give an impression that the light is coming from inside the 3D bulb.

Figure 9.7 The 3D lightbulb scene.

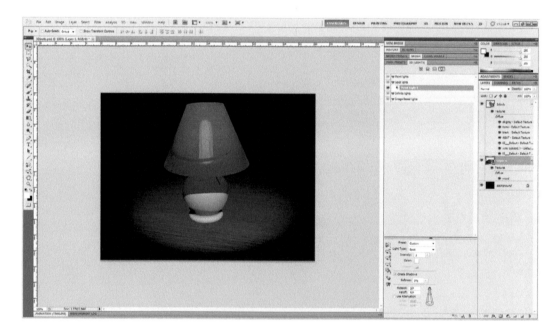

These steps create the light's effect on the 3D lightbulb. The next steps create a light falling from the lightbulb onto the table. We will use the Spot light to create the light cone from the light source to the table:

1. Select the 3D Table layer.
2. In the Mesh section of the 3D panel, choose the Table mesh.
3. Go to the Light section, and from the New icon on the bottom, choose New Spot Light.
4. Activate the 3D light guides from the Toggle Misc 3D Extras icon at the bottom of the 3D panel. To activate this icon, select the 3D Light Rotate tool.
5. Use the Drag Light tool to move the light source to the 3D bulb, which makes the light appear as if it were coming from the lightbulb.
6. Rotate the light cone to fall directly over the table using the Rotate Light tool.

Because we need the Spot light to provide the effect of light from a lightbulb that is falling over the table, we will set to be brighter and more focused on the table:

Figure 9.8 The final light effect for the 3D lightbulb scene.

1. Select the 3D table layer.
2. Select the Spot light from the 3D panel.
3. Change the Intensity value to 3 to make the falling light bright and appear as if it is coming from a nearby source.
4. Set the Hotspot to 25 degrees; this value reduces the gradually fading areas on the Spot light circles over the table.
5. Set the Falloff value to 50 degrees to light a wider area of the table.
6. Set the render quality to Ray Traced Draft or Final from the Scene section in the 3D panel to be able to see the final light and shadows applied to the object.

Though following these steps will provide you with a good understanding of how to use lights to create different effects, lighting is actually an experimental process. You should try different options and combinations of options to see the final result and different effects that you can create with light.

Light options can totally change the quality and the look of your scene. For example, you can use light to create a realistic effect by applying the real-life light effects, or to apply dramatic effects and unusual light to give your 3D scene or object a special effect.

The previous three examples demonstrated each type of light separately. This is not the usual way to use light, as light in the real world comes from different sources at the same time and affects the object differently. The following example merges the three types of lights in Photoshop to create a complete light effect on the 3D objects in the scene.

Here's an exercise in how to use the three types of light to apply dramatic light effects on a scene, which here includes an old candle that lights an old book on a table with a dark background. First we will create the 3D scene that we will apply the light effect to:

1. Create a New Photoshop file with a black background.
2. Create a new layer and add the Cube Warp model via 3D > New Shape From Layer.
3. In the 3D panel, choose the Material section.
4. Click the icon next to the Diffuse value. Choose Load Texture and load wood.jpg.
5. Use the 3D Rotate tool to rotate the cube as in Figure 9.9 to act as the tabletop.
6. Choose New Layer from 3D File and navigate to the chapter's files on the DVD; select Book.obj.
7. Place the book model on the table.
8. Choose New Layer from 3D File and navigate to the chapter's files on the DVD; select Candle.obj.
9. Place the 3D candle model on the table as in Figure 9.9.

Figure 9.9 The 3D candle scene.

Note: When exporting an .OBJ model that includes applied textures or materials, the 3D application exports an .MTL file that includes the material information. In order to import the .OBJ files into Photoshop while retaining its materials, make sure the MTL file is saved with the .OBJ file.

Now that we've built the 3D scene, let's add and edit light options to create the desired light effect. Start by editing the candlelight:

1. Select the 3D candle layer.
2. Open the 3D panel and go to the model meshes. Select the candle_light mesh.
3. Set the Opacity of the light to 75.
4. Set the Self-Illumination to orange.
5. Select the Candle Holder polygon.
6. Click the Material drop-down list and choose the Metal Copper materials. If it is not already listed, you can choose Metal from the context menu and append it to the current materials. These extra materials are installed in Photoshop as mentioned in Chapter 8.
7. Go to the Light section to set up the candlelight.
8. From the New Light icon at the bottom of the panel, choose Point Light.
9. Move the Point light to the center of the flame's tip.
10. Change the light's Intensity to 2% to increase the light at the center source of the light's tip.

Figure 9.10 The 3D candlelight effect using the Point light.

Apply the light to the old book on the table:

1. Select the old book model's 3D layer.
2. In the 3D panel, go to the Light section.
3. Keep the default Infinite light to give a global light to the book; this light is supposed to come from the candlelight.

Next, we will create a Spot light that fall from the candlelight to the area around it on the table, which will cover parts of the book:

1. Create a new Spot light from the New Light icon.
2. Move the light to give the effect of the candlelight falling on the book, as in Figure 9.11.
3. Set the Hotspot Angle to 35 degrees to give more of a focus on the area just under the candlelight.
4. Set the Falloff Angle to 50 degrees to make a wide circle of light fade out away from the candlelight.

Repeat the Spot light steps with the wood table to complete the effect of a spot of light applied to the paper:

1. Select the 3D wood table layer.
2. In the Light section, choose a new Spot light from the New Light icon.
3. Use the 3D Rotate and Move tools to place the Spot light in the same place as the Spot light applied to the book model to complete the candlelight effect on the book and the table.

Figure 9.11 The 3D candlelight: final results.

4. Set the Opacity and the Color values of the new Spot light to complete the light on the old book.

5. Set the Hotspot and Falloff Angles to make the new Spot light complete the one on the old book with the same values.
6. Preview the final scene rendered to see the final results.

You can change the light values and options to create different light atmospheres and effects.

Summary

Through the chapter's examples and options, you have learned the different light types in Photoshop and how to use each type of light to create specific light results for the 3D models and scenes. Also, you know about the importance of light and light sources in the 3D scene and how they can change the scene's final rendered results.

Mastering the light options comes through experimenting with the different light options and combinations of different light sources, as most 3D projects use multiple light sources.

Working with light is one of the major factors that affects the final render process, not only for the final result but also for the hardware processing issue, as it takes a lot of memory and graphics resources to allow the computer to render the light properly, especially when you render the 3D object using the Ray Traced option, which creates object details mainly based on the light and shadows in the scene.

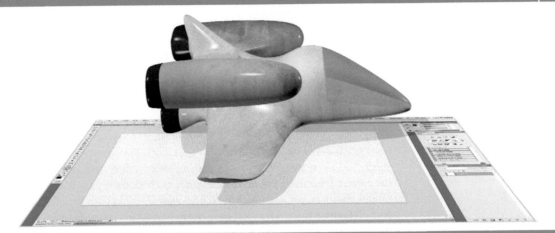

3D Camera

I previously introduced the concept of the camera in 3D graphics, as well as the 3D camera tools in Photoshop and how Photoshop provides 3D tools that allow you to control and edit your 3D content in Photoshop and the camera that is used to view to this content. Actually, the camera is an important part of any 3D scene, even if you do not assign a camera to view the 3D model or 3D scene.

When you create a scene in Photoshop or any 3D application, the application literally assigns a default camera that lets you view the scene or the model through it. You can then assign more cameras and save them as a preset to view the object from different views and angles. This capability helps you view the object from different angles and switch between them without affecting the object position. It can also help you create 3D animation using cameras.

The way the 3D Camera tools look is deceiving, as you may think at first that they work similar to the 3D control tools, though they do not. You control the 3D object with the 3D Control tools, which change the object's properties such as position and rotation; the 3D Camera tools change the viewer's position toward the object, as I discuss later in this chapter.

In this chapter, you'll learn more about the Camera tools, which include the 3D Rotate, 3D Roll, 3D Walk, 3D Pan and 3D Zoom tools. (Figure 10.1) and you'll see how they can affect your view of the object.

3D Camera Rotate Tool

The 3D Camera Rotate tool rotates the camera around the object in any of the three dimensions; the rotation of the camera can be changed by

Photoshop 3D for Animators. DOI: 10.1016/B978-0-240-81349-3.00010-2

Figure 10.1 The 3D Camera tools in the toolbar.

dragging over the object or through the Orientation values in the Properties toolbar.

Comparing the position of both the 3D object and the camera in the 3D space, you will notice differences in both locations' values. You can change the camera view using the numerical values to change the view of the model. However, you can reach the model view by using both the 3D Object and 3D Camera tools, which will have different position values for each of them to reach same model view.

Note: While any of the 3D Camera tools in the toolbar is selected, you can use the 3D-Axis tool to control the camera. I covered how to use the 3D-Axis tool in detail in Chapter 5.

Changing the camera orbit by dragging over the object is slightly different from the 3D rotation for the object:

1. Select the object and choose the 3D Camera Rotate tool.
2. Click and drag the mouse around the object.
3. When you drag over the object to the right, the camera moves to the right.
4. When you drag over the object to the left, the camera moves to the left, and a twisted-to-left arrow appears.
5. When you move the mouse up or down, the mouse shape changes to the up and down arrow to show you that the camera will rotate around the object vertically.

You can use the 3D Orbit tool to animate the camera around the object without affecting the object position itself. For instance, you might want to create an animation that navigates around the object to reveal its hidden sides.

When you use the 3D Rotate tool and the 3D Camera Rotate tool, notice the difference between the two tools:

- The 3D Rotate tool rotates the object itself. However, when you drag the object, it moves in the same direction of the mouse.
- The 3D Camera Rotate tool rotates the camera that views the object. So, dragging with the mouse over the object, notice that the object is moving in the opposite direction of the mouse (Figure 10.2).

3D Roll View

Shortcut: Press N on the keyboard to activate the 3D Camera tool.

The 3D Roll View tool rotates the camera in the Z direction only. However, when you roll the camera, you do not affect the object at all: only the camera is rolled in the opposite direction of the mouse:

1. Open a new Photoshop document.
2. Choose 3D > New Layer from 3D File.

(a)

(b)

Figure 10.2 The 3D Rotate tool and the 3D Camera rotate tool. In part (a), the 3D object moves in the opposite direction of the 3D camera moves. In part (b), the 3D object moves in the same direction the 3D Rotate tool moves.

3. Navigate to the file named 3Dspace_ship and click OK to add it to a new 3D layer.
4. Open the 3D panel; click on the first icon from the left on the bottom and choose 3D Ground Plane. This option will display the 3D plane under the object.
5. Click and hold on the 3D Camera tool in the Tools bar; choose the 3D Camera Roll tool.
6. Drag over the 3D model to the right and the left.
7. When you drag the mouse to the right, the model rolls to the left and vice versa. This means that the model is not moving: the camera is rolling to the left and right. Also, notice that both the 3D object and the 3D plane are rolling (Figure 10.3).

Figure 10.3 The 3D Camera Roll View tool with the Ground Plane.

The same concept applies to all the 3D camera control tools.

3D Pan View Tool

Note: When you pan the camera to the right, the object moves to the left, and vice versa.

Use this tool to pan over the object with the camera in any of the three dimensions. The 3D Pan View tools work similar to the 3D Pan tool, except that they move the camera itself, not the object.

Using the 3D Pan View tool is similar to the 3D Pan tool; you use the numerical values and drag over the object. When dragging over the object using the 3D Pan View, the mouse arrow changes to show the direction for the camera pan.

The 3D Pan tool is useful in 3D animation, especially when you are viewing a large 3D object and would like to pan over it to reveal its details to the viewer. Also, it can pan over 3D scene backgrounds so that the characters can move over it.

3D Walk View Tool

In animation storyboarding, you might need to walk through a 3D scene or object with the camera to give the viewer the impression that he or she is moving inside the 3D scene. The 3D Walk View tool lets you simulate this effect by walking around the object or inside the 3D scene.

When using the 3D Walk View tool, you can drag over the object in the workspace or use the numerical values in the Properties toolbar. Drag over the object horizontally to walk around the object or through the scene in horizontal directions. When you drag over the object vertically, the camera moves away or closer to the object.

3D Zoom Tool

The 3D Zoom tool lets you zoom in or out from the 3D object or through the 3D scene. When selecting the 3D Zoom tool, the mouse's shape changes to indicate that you can slide vertically over the object. You can zoom the camera in and out from the object.

You can also zoom over the object using the Properties toolbar values. The 3D Zoom tool properties are different than other tools' properties, as it works as the camera lens's zooming features.

There are two methods for using the zoom lenses. The first one is the Perspective camera view and the second is the Orthographic camera view. You can switch between both view from the Properties toolbar when you choose the 3D Camera Zoom tool. Let's see the difference between both camera views in a little more detail.

Perspective Camera View

The Perspective camera view simulates real perspective of the 3D objects view, as 3D content that is far from the camera is smaller than the 3D content that is near the camera. This depends on the camera lens. This method uses parallel lines to calculate the vanishing point of the object. However, this method is dependent on the 3D object's vanishing point.

The Standard Field of View value sets the camera lens view, which reflects the zooming of the camera. A smaller lens value makes the object view smaller and the higher lens value makes the object larger.

Figure 10.4 The Perspective camera view options.

In the Perspective camera view, the Standard Field of View has three different measurement degrees, based on the vertical degrees, horizontal degrees, and the size of the lens in millimeters.

You can also set a blur at a specific distance using the DOF (Depth of Field) value. This value creates a blur on the object that appears when the object reaches a specific distance in front of the camera.

In the following exercise, you will see how DOF affects the 3D model at a specific distance from the camera:

1. Open a new Photoshop file.
2. Create a new layer.
3. Choose 3D > New Shape from Layer.
4. Choose the Hat model.
5. Click the 3D Camera tool or press the N key shortcut to activate it.
6. Choose the 3D Camera Zoom tool from the Properties toolbar.
7. Make sure that the Perspective view is selected.
8. Set the DOF Blur value to 2 and Distance to 0.25.
9. Drag over the 3D model to see how the blur appears when the camera becomes a specific distance from the object (Figure 10.5).

Orthographic Scale Zoom

The Perspective view mimics a real-life view by creating an illusion of a vanishing point. So objects in front of the camera look bigger than the objects far from the camera when they are the same size.

Figure 10.5 The DOF Blur effect in the 3D model.

The Orthographic Scale zoom discards the vanishing point concept. When you zoom in and out with the camera, only the object scale appears to be changing with the camera view.

When you drag with the 3D Camera Zoom tool over the object with the Orthographic Scale mode, you change the scale of the object, which is calculated based in part on the object size. For example, the view of the object can be 1/10 of the object size, which is larger than 1/50 of the object size. So an object with the value 1/50 looks farther away than the same object with a scale of 1/10.

When the Orthographic Scale value is 1/1, the camera is in the middle of the object, so the object does not appear on the screen.

In the following exercise, you will see the difference between the Perspective camera view and the Orthographic Scale zoom:

1. Open the file 3Dspace_ship.psd, which includes a 3D spaceship model.
2. Click the 3D Camera tool or press the N shortcut to activate it.
3. Choose the 3D Camera Zoom tool from the Properties toolbar.
4. Make sure that the Perspective view is selected.
5. Choose the 3D Object Rotate tool or press the K key as a shortcut.
6. Start dragging the object to rotate it and see how the object's sides maintain the vanishing point based on the distance of the camera.
7. Click the Orthographic Scale Zoom icon.
8. Click the 3D Object Rotate tool.
9. Click and drag over the object and notice that the object is not affected by the vanishing point (Figure 10.6).

Figure 10.6 The spaceship on the right is using the Orthographic Scale Zoom. Notice that it doesn't look quite right, as it does not consider the perspective of the object. The spaceship on the left is using the Perspective camera view. However, it appears correct considering the perspective of the object.

Note: You can access the 3D Camera control tools from the 3D panel through the icons on the left under the 3D scene layer structure.

Although the orthographic view does not look natural because it neglects one of the important concepts in the view, the concept of perspective, it is useful when trying to identify the object's dimensions and scale without being deceived by perspective.

Camera Views

Working with a 3D graphic can be deceiving, because the human eye sees two dimensions better than the third dimension, mainly because of the perspective factor. If your eye is not trained well, you cannot depend on it completely to sense the depth or the third dimension of the model. However, most 3D applications provide multiple views in the workspace to allow the user to view the object from different positions, which provides more control and makes it easier to work with the 3D content, because it allows you to see the model from different views and edit the model based on the best view of the part that you would like to modify.

Although Photoshop does not provide this multiple-view workspace like other 3D applications, it provides you with the Views drop-down list that you can use to switch between existing views or to create your own custom views.

The 3D Views drop-down list appears on the Properties toolbar when you click the 3D Camera tool in the Tools toolbar. However, you can choose any of the available views that let you view the object in 3D, such as the Front, Back, Right, Left, Top, and Bottom.

In this exercise, we open the 3Dspace_ship file and change its view:

1. Open the file 3Dspace_ship.psd.
2. Click the 3D Camera tool or press the N key shortcut.
3. In the Properties toolbar, click the View drop-down menu and choose from the different 3D object views.

Custom Views

When you change the position of the 3D object, the current view changes to create a new Custom View; this view can be a special view for the 3D model or scene that is not listed in the Views drop-down list. Although you can create as many custom views as you like, you can save these custom views for further reference:

1. Open the file 3Dspace_ship.psd.
2. Click on the 3D Camera tool. Notice that the view is set to Default.
3. Click the 3D Camera Rotate tool.
4. Drag over the spaceship to change the camera rotation. Notice that the view is changed to Custom View 1.
5. Click the Save the current view icon next to the View list.

Figure 10.7 The 3D camera view.

6. In the New 3D View dialog box, name this view "Space view 1" and click OK (Figure 10.8).
7. Click the 3D Camera Rotate tool and change the rotation of the camera view again.
8. Click the Save View icon and name the new view "Space view 2."

At this stage, we have saved two views for the spaceship. Let's recall these saved views after changing the camera position:

1. Use the 3D Camera Rotate tool to change the view of the camera field.
2. From the View drop-down list, choose "Space view 1." The object reverts to the saved view.

You can also delete custom views by clicking on the Delete View icon next to the Save View icon.

It is very common to change the 3D camera properties, especially when you would like to change the view of the 3D model instead of changing the scene itself. After these changes, you can always revert to the default camera position by clicking the Home icon at the top of the Properties toolbar or choosing Default from the View list.

Note: You cannot delete the built-in views in the View list, such as Front, Back, and Left view.

Working with the Ground Plane

The Ground Plane is a grid plane to guide you around the position of the 3D model based on the whole scene. When you import or create a 3D object in

Figure 10.8 Saving a new 3D Camera custom view.

Photoshop, it includes a Ground Plane associated with each model. This Ground Plane is not visible by default. You can view the Ground Plane from the 3D panel by following these steps:

1. Select the model 3D layer.
2. Open the 3D panel. If it does not appear in the Photoshop workspace, choose Windows > 3D.
3. At the bottom of the 3D panel, click and hold on the icon on the far left.
4. A list of the available guides appears; check the 3D Ground Plane to activate it.

While the Ground Plane is activated, there are two main differences when working with the 3D Object tools and the 3D Camera tools. The first set of tools affects the object properties and position itself. The Ground Plane is not affected. But changing the 3D Camera properties and position affects the Ground Plane because you move the camera itself.

You can edit the Ground Plane properties from the 3D section of the Preferences dialog box. You can choose the plane size from the drop-down list: small, medium, large, extra-large, and huge. You can also set the grid spacing to be small, medium, or large. You can change the color of the Ground Plane as well by choosing the color from the Color Picker.

Working with Multiple Cameras

As mentioned earlier, the 3D camera is one of the most important resources in the 3D scene, as it not only provides views for the object, but also helps

Figure 10.9 Multiple cameras imported into the 3D scene panel.

in 3D animation. Though Photoshop does not support the creation of additional cameras for the 3D object or the scene, you can still import a 3D object with multiple cameras applied to it; Photoshop then identifies the new cameras and imports them into the 3D scene.

You can view the imported cameras in the scene in the 3D panel scene structure (see Figure 10.9).

Note: For an unknown reason, some 3D imported files end up with different views than the original source. Check the views of the imported 3D models to make sure they are the same as in the source 3D file.

While the extra imported cameras appear in the 3D panel structure, you cannot edit it. The extra camera adds new views to the Views list. So when you click the 3D Camera tool and open the drop-down list, you will find the extra camera listed as one of the listed views. When you edit these views, it creates custom views that can be saved, as mentioned previously.

Summary

Understanding cameras in the 3D scene and how they work is very important when working with the 3D scene resources and objects and creating 3D animation, as many of the 3D animation techniques require that you understand how the cameras work and how to animate them.

Although the camera concept in Photoshop is similar to that of most 3D applications, using the cameras is different because of the nature of the Photoshop workspace and structure. But practicing with the cameras can help you better understand how they work and the best camera methods.

Understanding Animation in Photoshop and 3D Animation

Through its history, Photoshop has gained many minor enhancements and features, in addition to major features that take the product to a new level. The 3D and animation features that are covered in this book bring new opportunities for Photoshop users.

Before the animation feature came to Photoshop, users relied on a dead application that was bundled with Photoshop called ImageReady. For many years, Photoshop users used ImageReady to create animations based on Photoshop PSD files. ImageReady did not follow the same timeline that was used in other video and animation products; its animation employed a frame-based animation concept in which animation is based on a sequence of slides that change over time. It was just another version of Photoshop that supports animation. Merging both tools was an excellent idea for better workflow and easier-to-create animation directly in Photoshop.

Furthermore, the timeline in Photoshop inherits not only the ImageReady Frame animation concept, but also the Timeline animation concept of Adobe's professional animation and video tools, such as After Effects and Premier. This unification enhances the workflow between different products and makes it easy for video experts to be familiar right away with the Photoshop timeline concept.

Photoshop 3D for Animators. DOI: 10.1016/B978-0-240-81349-3.00011-4

Note: Although the animation in Photoshop is either Frame animation or Timeline animation, you can easily convert your Timeline animation to a Frame animation. This conversion is one-way: you can not convert a Frame-based animation back to a Timeline animation.

Note: Although the Timeline animation supports 3D properties in animation, such as changing the camera position and 3D rotation, the Frame animation does not support animation of the 3D properties.

The Animation panel in Photoshop includes two main types of animation: the Frame animation, in which animation is based on slides or frames, and the Timeline animation, in which animation is based on keyframes and layers that include the changes in the object's properties and in-between frames that show the gradual transformation between two keyframes. The Timeline technique is the one already familiar to some from other Adobe products such as After Effects and Premier.

The Timeline animation is the most common in the animation world; it is the standard type of animation in many existing animation products. This type of animation comes with extended capabilities and the ability to apply 3D-based animation. In this chapter, we will start with the Timeline animation and see how to use it in both 2D and 3D animations, and after the Timeline animation, we will discuss the Frame animation.

Photoshop Timeline

Frankly, it was a crazy idea to have a timeline in Photoshop. But no one can deny that it gives Photoshop another powerful feature that allows Photoshop users to produce video and animation content without the need to rely on video animation products tools such as After Effects. Although the animation in Photoshop is basic when compared with professional video tools, it is useful for creation of video and animation content based on Photoshop layers without the need to learn other complex video tools.

The concept behind the Animation panel (Figure 11.1) is that each layer in the Photoshop document is represented with a layer in the Animation panel, and each layer includes sublayers in which you can edit the object properties over the timeline.

A basic animation consists of two keyframes in the same layer; when the Current Time Indicator (which shows the current active frame and indicate the animation frame progress) moves over the timeline, the object moves based on the frames per second (fps) rate. The fps rate refers to how many frames of the animation are played in one second. A higher fps rate creates faster, smoother animation and larger files; a low fps rate creates slower, choppier animation and smaller files.

Keyframes can be created manually or automatically when you move or change the object's properties on a specific frame.

Timecode or Frame Number

The Timecode area displays the current time (in hours, minutes, seconds, and milliseconds) and fps of the animation. The fps value is set by the document setting and output type. For example, if the animation output will be for the

Timecode / frames per second Timeline

Start working area bracket

Layer name

Time-Vary Stopwatch

Layer properties

Keyframe navigation arrows

Animation layer

Layer start point

Unselected keyframe

Selected keyframe

Delete keyframe icon

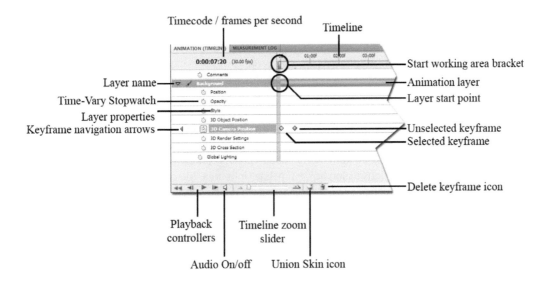

Playback controllers

Timeline zoom slider

Audio On/off Union Skin icon

Context menu

Current Time Indicator

End work area brackets

Layer end point

Convert to frame animation / Convert to timeline animation

Figure 11.1 The Animation panel.

NTSC broadcasting standard, the animation speed is 29.97 fps; if the output is for the PAL broadcasting standard, the animation speed is 25 fps. You can also set a custom fps rate according to your output needs, such as for the web, mobile devices, and so on.

The document duration and fps settings can be set in the Document Settings dialog box, which is accessible via the Animation panel context menu.

You can also change this value to display the frame number instead of the timecode from the Animation panel's context menu > Animation Panel Options dialog box > Timeline Units area. The correct choice of units depends on your project and what indicator you would like to see while working through animation. For example, when working with video production, you may want to see the timecode instead of the frame number, as your project may depend on the time of the animation. On the other hand, when you create an animation for the web, you may work based on a frame number limit, because the total number of frames affect the final size of the animation.

Layers

Layers are the most important area of the Animation panel, as it is where we create and work with the animation. The layers include the objects in the Photoshop layers as well as the animation for each object. The main layer area in the timeline represents the duration of the object's visibility on the stage. You can set this duration by dragging the start or the end of the layer.

Each layer includes property sublayers that include the properties of the object and can be animated through the timeline. The properties of sublayers include the following:

- The Position is where you can change the X and Y position of the object on the stage. You can use it to move the object around the screen.
- The Opacity allows you to change the opacity of the object and control its transparency value. You can change the value of the layer opacity from the Opacity slider in the Layer panel.
- The Style lets you change the setting of the styles and effects applied to the object through the Layer Style dialog box.

You can follow the same animation concept to create animation for 3D object properties that appear in the Animation panel, such as:

- 3D Object Position: Animates the object in the 3D space, including rotation, slide, pan, roll, and zoom.
- 3D Camera Position: Animates the camera that views the object, including roll, walk, pan, and zoom.

- 3D Cross Section: Available in the 3D panel, and covered in detail in Chapter 12. Lets you cut the 3D polygon into two sections and hide one of them, then animate the surface that cut the 3D polygon to change the visible part.

The properties mentioned above are used to create the animation by assigning keyframes to the property to animate it. Next to each of the property layers is the Time-Vary Stopwatch icon, which activates the keyframe animation. When you activate this icon, it places a keyframe where the Current Time Indicator is located. So if you change the place of the Current Time Indicator and any of the object properties such as the position, a keyframe is added automatically and the animation is generated between the two keyframes. In the exercises in this chapter, you will learn how to create animation using the Animation panel in Photoshop.

In addition to automatically adding keyframes, you can add keyframes manually by pressing the "Add or remove keyframes" icon on the left of the Time-Vary Stopwatch. When you activate it, it turns yellow to indicate that there is a keyframe in the current frame. You can also delete the keyframe by deactivating the "Add or remove keyframe" icon. One reason why you might use the manual keyframe placement is to create a keyframe without changing any of the object properties. For example, you might want the object to pause and not be animate for a period of time.

Next to the "Add or remove keyframes" icon are the keyframe navigation arrows, which you can use to navigate through keyframes. When using the keyframe navigation arrows, it is important to place the Current Time Indicator exactly over the keyframe. For example, if you would like to change the properties of an existing frame, you can use the keyframe navigator to place the Current Time indicator over the keyframe and then change it. Placing the Time Indicator manually over the keyframe might result in inaccurate placement—you might place the indicator on a frame nearby to desired keyframe—which will cause any changes to create a new keyframe instead of editing the current one.

There is an audio component as well, if you import a video file with audio. You can toggle audio tracks on/off with an icon next to the video layer.

There are two other properties layers that influence the whole layer:

- The Comments layer, where you can add comments or notes over each part of your animation on the timeline.
- The Global Lighting, where you can edit the style and light angle that is applied to the whole object in the document, including styles that are applied to an object, such as the drop shadow, inner shadow, and outer shadow.

The global angle of the light is a value in the Styles dialog box and can be changed in the animation by creating keyframes with the Global Lighting

Warning: If you have a keyframe on a specific property in the current layer and uncheck the Time-Vary Stopwatch next to this property, you will delete all the keyframes assigned to it.

property, then changing the Global Angle value in the Style dialog box by clicking the Add New Layer Style icon in the Layers panel.

Working Area Brackets

The Working Area Brackets let you set the working area that will be rendered. You can set the start and end point by dragging the start bracket and the end bracket to the frames where the rendering should start and end.

At the bottom of the Animation panel, there are additional function icons that are arranged from left to right as follows:

- The Navigation Arrows: Allow you to play the animation or step through the frames. You can also use keyboard shortcuts (similar to that of After Effects) by activating the shortcuts from the flyout menu.
- The Enable Audio Playback: Allows you to enable playing audio in the video content while playing back the animation on the timeline.
- The Zoom Slider: A very useful option; allows you to zoom the timeline in and out. It is helpful if you are working with a particularly long animation with a lot of frames and you want to navigate through these frames more quickly.
- The Onion Skin icon: Lets you activate the Onion Skin modes. The timeline indicator displays only the current frame; the Onion Skin modes display the frames before and after the selected frame. These frames display fade and less opacity. You can set the Onion Skin settings from the context menu. In this dialog box, you can set the number of the frame you would like to see before and after the current frame and how these frames will be displayed; for example, you can set the number of frames you would like to show before and after the selected frames. Also, you can set the space between the Onion Skin frames and the maximum and minimum opacity for these frames. In the Onion Skin Options dialog box, you can also set how these onion frames will intersect with each other using the Blend Mode drop-down list. The Onion Skin mode works as a guide for animators to see how the animation flows after and behind the current active frame to make sure that the animation flows well and the movement works properly.
- The Delete Keyframe icon lets you delete specific keyframes.

The Animation panel's context menu includes important commands that can extend your animation capabilities and give you more control over your animation; in the following exercise, we will use some of these commands to see how they can be used in a project. But first, let's go over some of the important functions in this menu.

Keyframes Interpolation

When you create an animation in Photoshop, you create two keyframes that include in-between frames that display the gradual change of the object

from the first keyframe to the last one. This is what is known as a *linear keyframe*: the keyframe that affects the previous and following frames.

There is another type of keyframe: the Hold keyframes. This type of keyframe does not affect the frame around it; that is, things happen suddenly. You can change the keyframe status from Linear to Hold or vice versa through the Keyframes Interpolation command or by simply right-clicking the keyframe and changing its type.

Set Start and End of Work Area

These two commands work similar to the Work Area bracket and allow you to change the start and end of the work area that will be rendered. To set the start point of the active working area in the animation move the Current Time Indicator to this point in the timeline and choose Set Start of Work Area; do the same thing for the end of the working area. Set these two points to tell Photoshop the area that should be rendered in the animation.

Figure 11.2 Set Start and End of Work Area. Notice how the work area is cropped.

Move Layer In and End Point to Current Frame

These two commands affect the start and the end point for each layer and its properties keyframes as well. When you choose Move Layer In to Current Frame, the layer start point moves to the frame where the Current Time Indicator is. However, to set the start or the end of the layer to specific frame, move the Current Time Indicator to this frame and select move Layer In Point to Current frame to set the layer's start point and Move Layer End Point to Current Frame to set the layer's end point. You can use this command when you need the layer to appear after a specific period of time or disappear after a certain time.

Figure 11.3 Move Layer In and End Point to Current Frame. Notice how the layer is cropped.

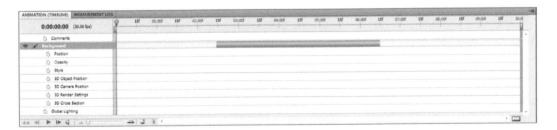

Trim Layer Start and End to Current Frame

Figure 11.4 Trim layer Start to
Current Frame. Notice how the layer
area before the cut has been removed
completely.

These commands completely cut out parts of the animation beyond the start and end points of the Current Time Indicator. Thus, these commands differ than the previous ones, in that they remove the layer content completely before and/or after the current frame. Use this command to cut specific frames from the layer and remove any keyframes applied to these frames as well.

Trim Document Duration to Work Area

This command completely removes the areas outside the Work Area brackets, including any keyframes. In some cases, you can find a lot of unused space in the timeline that takes up space and might cause confusion, So you might want to remove the unused space in the animation work area.

Split Layer

This command splits the layer in the currently selected frame to two duplicate layers, with each layer displaying part of the split layer. You can use this command when the layer animation moves over other layers and then turns to move behind them during the animation, similar to how the moon spins around the earth: the moon moves over the earth and then turns to move behind it. In this case, you can create an animation for the moon in a layer over the earth object and then split the layer at the point where the moon spins behind the earth.

Figure 11.5 Split Layer. Notice
that the layer is split and each part
is placed in a new layer.

Lift Work Area

This command is used to hide part of the animation in a specific layer. It is used by setting up the current work area to include the part you want to hide and choosing the Lift Work Area command. The hidden area is left empty and the next part of the layer is separated and moved to a new layer. You can use this command to exclude part of the animation on a specific layer.

Figure 11.6 Lift Work Area. Notice that the lifted area has been removed from the timeline and the rest of the layer is still in position.

Extract Work Area

The Extract Work Area command works the same as the previous command, but the part following the removed frames moves to fill the empty area of the deleted frames.

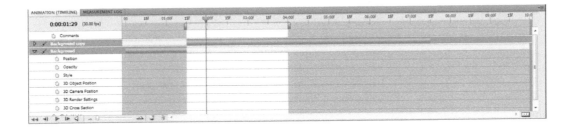

Make Frames from Layers

This option converts the layer to a single frame at the exact location of the Current Time Indicator. You can use this command to turn the layer into one frame that displays suddenly in the animation, such as with the flicker effect.

Figure 11.7 Extract Work Area. Notice the different between the Extract Work Area and Lift Work Area commands. Here, the layer has been shifted in place of the deleted part.

Flatten Frame into Layers

This command converts each single frame in the layer in the Animation panel to a separate layer. You can use this command to turn the layer animation in the Animation panel to separate layers that appear in the Layer panel.

You can also set favorite layers through the Show command, then choose to display only those layers. This option is useful for large projects in which you need to work in certain layers without getting distracted by other layers.

Creating a 3D Timeline Animation

Let's see how to use the Timeline animation features to create an animation of a 3D model. In the following exercise, we will create an animation of a spaceship that surfs around a planet orbit completely in Photoshop. I will be using a 3D model that I created in 3D Studio Max and exported as a 3DS file. The background of the animation is a video footage of the earth rotating slowly.

Let's start by creating a new video document and creating the scene background by adding the video layer to the file:

1. Create a new Photoshop document, and choose Presets > Film and Video > NTSC preset.
2. An alert message will appear to tell you that Photoshop will use the Pixel Aspect Ratio Correction to view your video content with the specified aspect ration in the document preset. You can disable this by deselecting the Pixel Aspect Ration Correction command in the View menu. The purpose of this correction is to provide a preview of how the video will look like with respect to the final screen output (and standards). For a more accurate preview, you can use the Video Preview option from the File > Export menu, but this works only when an output device is attached to your computer.
3. Choose Layer > Video layers > New Video Layer from. Locate the Earth_ footage.mov video footage in this chapter's folder on the DVD; the video footage will be placed in a new video layer.
4. To insert the 3D model, choose 3D > New layer from 3D File (or use the Scene Panel). Navigate to the Space_ship.3ds file and select it.

Figure 11.8 The New Video Document presets.

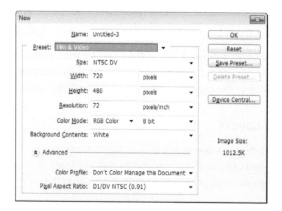

5. Use the 3D Pan tool from the Tools panel to place the model at the bottom left of the screen; this will be the first frame in the animation (Figure 11.9). You can also set the position of the first frame from the top properties bar to be X = 10.6, Y = 21.1, Z = −72. The exact position of the spaceship depends on your view and how you would like it to animate around the earth.

Figure 11.9 The spaceship scene.

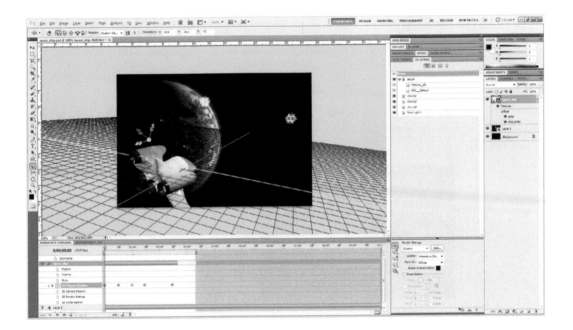

At this stage, we have the starting point of the animation; in the following steps, we will create keyframes that guide the spaceship to its orbit around Earth and make it vanish into the distance (the Z dimension):

1. Open the Animation panel, select the spaceship layer and expand it.
2. Activate the Time-Vary Stopwatch icon next to the 3D Position property layer by clicking on it; this will create the first keyframe in the animation.
3. Move the Timeline Head to the frame number 15, create a new keyframe manually by clicking the Add or Remove Keyframe icon or move the spaceship as seen in Figure 11.10. You can also edit its position to X = 13.2, Y = −41.2, and Z = −77.
4. Move the Timeline Current Time Indicator to frame 30 in the timeline and move the spaceship to position X = 0, Y = −56.6, and Z = −84.1.
5. In frame 45, move the spaceship to the position X = −4.9, Y = −59.2, and Z = −105.
6. In frame 75, move the spaceship behind the earth to vanish away in the distance by adding the values X = −12, Y = −53.1, and Z = −115.8.

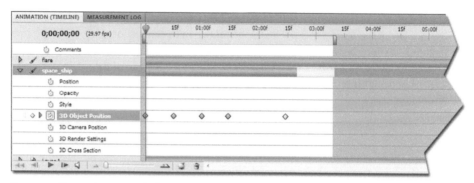

Figure 11.10 The spaceship animation keyframes.

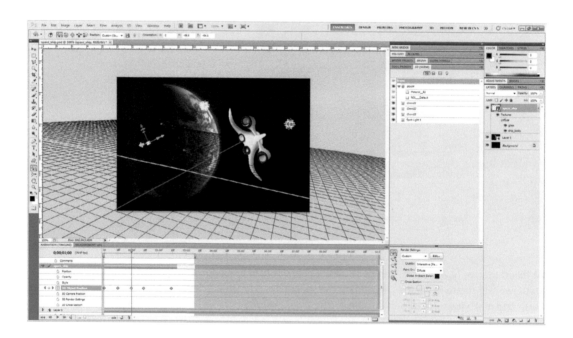

Figure 11.11 The spaceship animation progress.

Now the animation of the spaceship should look similar to the one shown in Space_ship.psd. However, to make the spaceship merge more with the global space environment, we will create a lens flare effect over the whole scene:

1. Create a new layer over the spaceship and video layers.
2. Fill it with black by setting the foreground color to black and choosing Edit > Fill from the top menu and set the fill color to the foreground from the Fill dialog box.
3. Choose Filter > Render > Lens Flare.
4. In the Lens Flare dialog box, use you mouse cursor to move the lens focus point to the right and set its value to 110%. Also, set the style of the lens flare to 50–300 mm Zoom.

5. In the Layer panel, select the Lens Flare layer. From the Layer Blending Option drop-down list, choose Screen as the blending mode for the layer; this mode makes the Lens Flare transparent and displays the scene under it.

Shortcut: You can fill the layer of the foreground color by pressing Alt + Delete (Opt + Shift + Delete on the Mac).

After finalizing the animation in Photoshop, it is important to set the working area to your animation period; otherwise, the rendering process or export of your animation will include the unwanted parts of the timeline. To set the working area and crop the unwanted space in the timeline, drag the Work Area end bracket to the left to the end of your animation. For example, in the previous animation, drag the bracket to the left to frame number 75.

You can review the final output of the animation by viewing the Space_ship.psd example attached to this book.

Frame Animation

The second method to create animation in Photoshop is the Frame animation. This is the method that was inherited from ImageReady. Although this method does not include as many capabilities as the Timeline animation does, it is helpful in creating simple web animation such as animated GIFs with low resolution. With this method of animation, you have more control over the number of frames in the final movie, as you create only the slides that include the animation and set the in-between frames later based on your desired number of transitions in each animation.

Note: The Frame animation method does not support animation of 3D properties (i.e., camera positions, 3D rotations).

You can activate the Frame animation or toggle between both Frame and Timeline animations through the Convert to Frame Animation/Convert to Timeline Animation button on the bottom right of the Animation panel.

Before we get into an exercise to learn how the Frame animation method works, let's briefly review some of the important functions and features that are available when you activate a Frame animation in the Animation panel.

Note: The Frame animation does not support layers, as does the Timeline animation, so the animation represented in each frame is actually the sum of the animation you created in all the Photoshop layers. However, it depends on the layers in the Layers panel to create the animation.

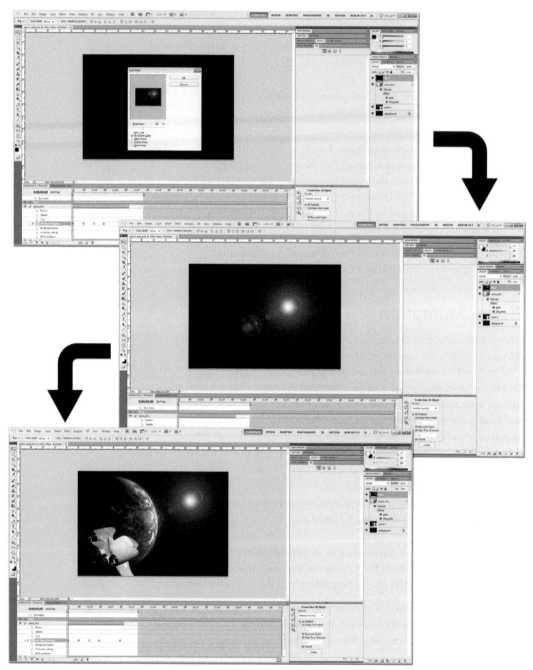

Figure 11.12 Add the Lens Flare effect over the whole animation.

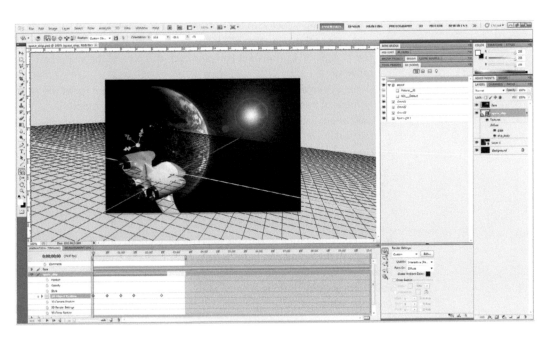

Frames

The frames are displayed as slides that show an animated object; each slide shows the change in the status of the object. Animating these slides by showing them one after another creates the animation (Figure 11.14).

On the bottom right of the frame thumbnail, you will find a small arrow that reveals different options for how long this frame should appear before the transition to the next one, or the delay of each frame. You can edit each frame individually or by selecting multiple frames and click any of the frame's arrows to set delay times for all the frames.

Figure 11.13 The final look for the 3D spaceship animation.

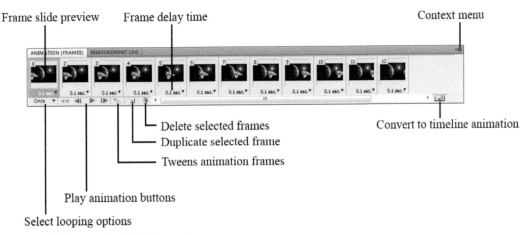

Frame slide preview Frame delay time Context menu

Delete selected frames
Duplicate selected frame
Tweens animation frames
Convert to timeline animation
Play animation buttons
Select looping options

Figure 11.14 The Frames view in the Animation panel.

- The Play Loop selector: In the bottom right of panel, you can specify how many times the animation will loop.
- The navigation buttons: Let you play back and control the animation preview.
- Tweens Animation Frames: This icon gives you the option to set the number of frames between any two frames to create a smooth animation. The more in-between frames there are, the smoother the animation will be.
- Duplicate Selected Frames: When you select a frame or group of frames using either CTRL (CMD on the Mac) or Shift, click this button to duplicate the selected frames.
- Delete: With this icon, you can remove one or more frames from the animation sequence.

In addition to the functions in the main panel, you can click the icon at the top right in the Animation panel header to display the context menu associated with the frame animation; this menu includes extra commands. Following are descriptions of some of the important commands in this context menu.

Reverse Frames

This command reverses the animation by reversing the animation sequence. This command is useful when you would like to flip the animation sequence without having to recreate it again.

Optimize Animation

The optimization process for animation is very important, especially when you would like to play your animation on the web or mobile devices. It is a best practice to optimize the animation to the lowest size possible to make sure that the animation will work properly over low bandwidth. There are many methods to optimize the animation in Photoshop; the Optimize Animation command lets you reduce the size of the output animation through two methods, which are already selected when you click the Optimize Animation command to display the Optimize Animation dialog box:

- Bounding Box: Crops the unchanged areas in the animated frames.
- Redundant Pixel Removal: Converts the unchanged pixels to transparent.

Generally, the optimization process comes at the end of the project when you finish the animation and the project is ready to export to the web or mobile devices. In some cases, the optimization process is not required, such as when you're creating high-quality video content or the most important factor is the quality of the content, not the size.

Creating a Frame Animation

After reviewing the main functions in the Frame animation, in the following example, you'll see how to use Frame animation when animating 3D models in two dimensions. Actually, the Frame panel does not support 3D animation in the 3D space. However, we will animate the spaceship in the following example in only two dimensions by moving it from the left side of the screen to the right side:

1. Create a new file similar to the previous example and insert the video layer as the animation background and the 3DS file of the spaceship model.
2. Place the spaceship on the left side of the screen.
3. Make sure that the Animation panel is set to the Frame Animation mode by clicking the Convert to Frame Animation icon on the bottom right of the Animation panel.
4. Select the first animation frame and click the Duplicate Selected Frames icon.
5. In the second frame move the spaceship to the right side of the screen.
6. Select the first frame of the animation, and click the Tween icon to create in-between frames that display the animation of the spaceship from the left to the right.
7. In the Tween dialog box, add 11 in the Frames to Add field.

Figure 11.15 Creating an animation based on the frames view in the Animation panel.

Figure 11.16 Settings in the Tween dialog box.

Figure 11.17 The spaceship Frame animation in the Animation panel.

The default time delay between each frame is 5 seconds; this default delay is too long to see a smooth transition between frames, so reduce the time delay between frames as follows:

1. Select all frames and click the Time Delay arrow at the bottom of any of the frames.
2. Select 0.1 seconds as the time delay between frames. You can select any of the listed delay times or a custom delay time.

The previous exercises can be considered as a starting point for creating animation and 3D animation in Photoshop. The 3D animation tool in Photoshop is pretty simple—it gives you extended capabilities along with traditional core functions in Photoshop, making it easy to create professional-looking animations.

Summary

Although this book covers the 3D process in Photoshop elsewhere, this chapter is the most important chapter, because it covers how to use the information in this book to create 3D animation in Photoshop. Now that you understand the animation concepts, you can use the information from the other chapters to import 3D objects and apply textures, light, and camera views to build your animation scene using the concepts in this chapter. You will learn how to render and export the animation in the rest of the book; I cover the rendering and exporting features in chapter 13.

You can also integrate the animation created in this chapter with other applications, such as Adobe Flash and After Effects. I consider this chapter to be the real center point for the book, as the rest of the chapters are actually about extending the 3D animation process in Photoshop.

Render Preparations

Now that you've gotten to this chapter, you've gone through the process of creating and animating 3D content in Photoshop. You've also seen how to add textures and light and how to set the camera view for the 3D objects. This chapter takes you through the next step: preparing the 3D object or 3D animation for final export or render process. The render process is where we create images and video animation files in commonly used formats out of the 3D scene source.

The render process converts the 3D scenes to images and video animation based on the render settings. The process has a wide range of options that determine the final result. Before we jump to the render process (and the export process, in the next chapter), we will cover here the different render settings and how to prepare your 3D content for final rendering into any of the commonly used 3D formats or exporting to video animation or image sequences.

Note: The render options are related to the selected 3D layer. You can set different render options for each layer separately.

The wide range of final 3D rendering results depend on the 3D render options, which specify how the 3D content details such as faces, meshes, vertices, and texture maps will be rendered. Furthermore, the render process is affected by the light and camera view of the object.

Photoshop 3D for Animators. DOI: 10.1016/B978-0-240-81349-3.00012-6

Photoshop provides a variety of render options presets that you can reach from the 3D panel or the Render Settings dialog. The render presets include a variety of predefined render settings. The default render setting is Default; you can choose to display the edges or the vertices of the polygon by choosing the Wireframe or Vertices render options. There are other render options, such as the Depth Map, Ray Traced, and Paint Mask. You can also change the parameters of these presets and create and save your own custom render settings.

In this chapter, we cover the render settings in the 3D panel, as well as other related options, such as the antialiasing and cross-section options.

3D Render Settings

When you select a 3D layer and open the 3D panel, the panel displays properties associated with that layer (Figure 12.1). The Scene tab includes information about the whole scene, including the layer render settings.

The first render setting option is the Presets drop-down list. This menu includes different predefined settings that you can apply to the 3D object without any other settings or modifications. The render presets include the following presets, which are illustrated in Figure 12.2:

Figure 12.1 3D Scene in the 3D panel

- Bounding Box: Converts the model to a cube that represents the outer boundaries of the object.
- Default: Default render setting; uses the solid style (as explained later in this chapter).
- Depth Map: Shows the model as grayscale, with shades that vary based on depth and distance from the viewing camera.
- Hidden Wireframe: Shows the wireframe that constructs the option.
- Line Illustration: Shows the object as white outlines; the filled-in space in the object is black.
- Normals: Displays the object based on its faces' direction or normal direction (I explain more about normals later).
- Paint Mask: Shows the paintable areas in the model and the areas that will not be affected with the painting tools.
- Shaded Illustration: Displays the model along with the black wireframe that represents the object polygon faces.
- Shaded Vertices: Displays only the vertices or the points that construct the object.
- Shaded Wireframe: Displays the object's wireframe shaded with the same texture applied to the object.
- Transparent Bounding Box Outline: Similar to the bouncing box, but shows the faces of the outline cube with shaded colors.
- Transparent Bounding Box: Similar to the previous preset, but hides the outline and displays only the faces as transparent.

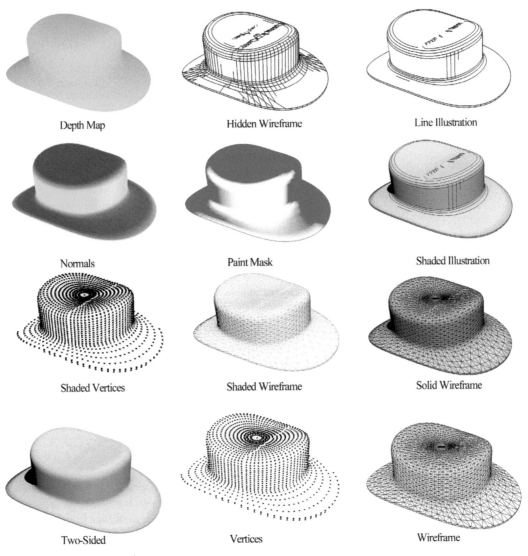

Depth Map	Hidden Wireframe	Line Illustration
Normals	Paint Mask	Shaded Illustration
Shaded Vertices	Shaded Wireframe	Solid Wireframe
Two-Sided	Vertices	Wireframe

Figure 12.2 3D render presets examples.

- Two-Sided: Prepares the object for the cross-section feature (discussed later in more detail).
- Vertices: Shows the vertices of the model without shades and with more transparency.
- Wireframe: Similar to the Shaded Wireframe, but shows the lines that construct the model in black.

These presets are actually based on different render settings combinations, as you will see later in the section on the Render Option dialog box, which

can be accessed through the Render Option button in the 3D panel or from the Render Option dialog box in the 3D menu.

Quality

The Quality options set the display quality of the 3D object. You have to set the quality level in order to maintain both display quality and optimal display resources performance. The Quality options are interactive: these include Ray Traced Draft and Ray Traced Final. The Ray Traced options provide better quality, and some effects are supported only in the Ray Traced options, such as shadows and lights. The Ray Traced option is considered the most important and the most commonly used render quality method that provides high-quality rendered output. This rendering quality setting is recommended for a high-quality model look.

You can always choose Ray Trace Draft or Final to see how the model will look like after exporting or final render. However, choosing these options will render the model using the Ray Trace method, which takes time to load and calculate the shadows and light. If necessary, you can stop the render process by clicking the on the stage.

Because the Ray Trace is considered one of the most important rendering methods in Photoshop, there is a section in the 3D tab in the References dialog box that contains options for the Ray Tracer threshold. This section provides a High Quality Threshold slider that lets you set the highest quality that the Ray Trace render can reach before it stops the rendering process. Using a lower threshold value will let the render stop while rendering information in the model such as shadows and light.

Paint On

As discussed with painting and texturing in Chapter 8, the Paint On options set the texture map that you will directly paint on the model. For instance, you can set the Paint On option to Diffuse if you would like to paint on the model and change its colors using any painting tool. Or you can set the Paint On option to Bump to change the polygon surface depth.

Global Ambient

The Global Ambient color represents the global color that reflects on the 3D model and its applied texture. However, changing the ambient color affects the environmental color applied to the model. To change the ambient color, click the color sample and change the color.

Cross-Section

The cross-section slices the 3D object using a plane into two sections on the X, Y, or Z plane, according to the plane's position. The result is part of the

model that shows inside the edges of the content. However, the cross-section can be implemented to display the interior part of the model; for instance, you can use it to create a section in a car model to view the inside parts. You can also use it to create an animation effect that cuts the 3D model or displays the 3D model gradually, as shown later in this chapter.

The Cross Section tool includes different settings that let you customize how the planes cut or intersect the 3D object. Before showing an example of how the cross section works, here are the different options available under the Cross Section tool (Figure 12.3):

- The Planar checkbox shows or hides the plane that slices the 3D object. Also, you can set its color and opacity from the Opacity slider.
- The Intersection checkbox adds a highlight to the part that intersects with the plane; you can change the highlight color by clicking the color box next to the checkbox.
- The Flip Cross Section option, located next to the Intersection color selector, lets you invert the hidden part of the model.
- The X, Y, and Z axes specify the axes of the plane that will rotate and move around it.
- The Offset value lets you move the plane; the direction of the plane movement is based on the axis of the plane.
- Tilt A and Tilt B rotate the plane around its axis; this affects the slicing direction of the 3D object.

Figure 12.3 3D model with the Cross Section option enabled.

The Cross Section is used to display part of the output render, but as our main concern here is 3D animation, I thought it would be a good idea for you to see an example of how to use the cross section features to create animation, such as displaying 3D text gradually by animating the cross-section plane over the 3D text and setting it to be rendered or exported as 3D animation. You will see how to use the Cross Section and render options to create an animation effect over 3D text by converting it from a wireframe to solid-color text. In addition to the using the cross-section, we will use the two-side render preset to display the wireframe of the object:

1. Open the file 3Dtext.psd, which includes 3D text with a solid polygon mesh.
2. Open the 3D panel, and from the Presets drop-down list, choose a two-side render option to enable the display of the wireframe.
3. In the Cross Section section, check the box next to Cross Section to activate the cross section plane. The Cross Section plane appears to cut the 3D text: half of the 3D text disappears.
4. Set the planner axis to Z.
5. Use the Offset value to move the plane to the top of the text.
6. Click Flip Cross Section to show the whole text as wireframe.
7. Uncheck the Plane box to hide the plane from the animation render.
8. Open the Animation panel and extend the 3D layer properties to the Cross Section properties layer.
9. Click the Animation Stop Watch to activate the animation.
10. Move the Current Time indicator to frame 30.
11. In the Cross Section Offset, set the value to 100. This will move the plane to the right to reveal the 3D text.
12. For better rendering quality, set quality to Ray Traced Draft or Final from the Quality drop-down list in the 3D panel. This option provides smoother edges, but will make the animation display the shadows, slowing down the render process.

Render Options

When you click the Edit button in the 3D Scene panel under the Render Settings, the Render Options dialog box displays to set the render settings for the 3D layer (Figure 12.5).

At the top of the dialog box, the Presets drop-down list shows the predefined render options that you can apply directly to the model. These presets are similar to presets in the drop-down list in the 3D scene panel. However, the drop-down list in the 3D panel provides faster access to the render presets.

Next to the Presets list, the Delete and Save icons allow you to delete or save your custom render options. The render options are saved in P3R format.

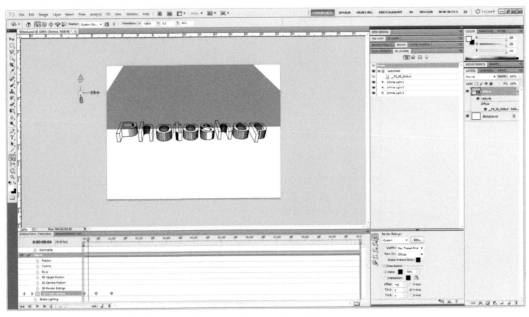

Figure 12.4 Set the planner axes to Z and move it to the top of the object using the Offset value.

Figure 12.5 Text animation using the Cross Section option.

Figure 12.6 The Render Options
dialog box.

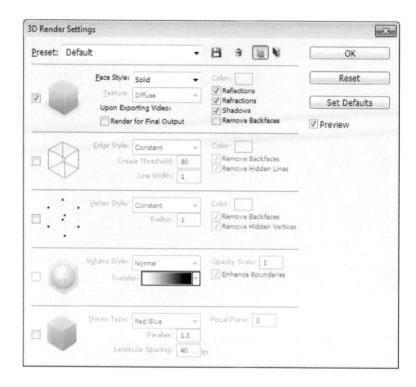

Figure 12.6 The Render Options
dialog box.

Note: Make sure to
activate the live preview
by checking the Preview
checkbox.

When you activate the Cross Section option, you have two sections in the
model; each of the section can have its own render setting. The two icons
next to the Delete preset icon lets you switch between the two sections.
However, the render settings are defined to each of the sides separately.

The render settings include five sections; each of the sections sets the render
options for part of the 3D model polygon mesh, as described in the
following sections.

Face Style

The first part in the Render Settings dialog box is the Face settings. This
section includes information about how to render the output of the
polygon faces. This gives the 3D shape its final results. The face rendering
includes different styles. **Solid** renders the model without any rendering
for the shadows, reflections, or refraction. This option removes any of these
effects applied to the object during work in Photoshop. This type is called
the Default render option in the Presets drop-down list. The Solid face
uses GL by default (interactive mode render quality option) and does
not render effects like shadows, but you can make this type use the Ray
Traced quality by choosing any of the Ray Traced options in the Quality
drop-down list.

When you choose this option, the reflection, refraction, and shadows display options are deactivated. In addition to these options, there are two options that are commonly shared with all the face rendering methods:

- The Render for Final Output option provides better rendering and smooth edges when exporting the 3D content for video animation. When you choose this option before exporting the 3D animation, it forces Photoshop to render the animation or the 3D model using the Ray Trace method regardless of the option you choose in the Quality menu. However, this option is important to make sure that the render output will be high-quality.
- The Remove Backfaces option removes the back faces of the 3D objects, such as the Two-Sided rendering option, which hides the back sides of the model.

Unlit Texture discards the light and renders the 3D object without the light. When you select this method, you will have the option to display one of the applied texture methods from the Texture drop-down list. By default, the Diffusion texture is selected. However you can change the rendered texture to any of the listed texture options.

Flat creates a flat look for 3D content, as it applies the same setting for all the object's normals. The normals (explained later in this list) are responsible for the surface effects, such as bumping effects.

Constant covers the model with a color that you can specify from the Color selection next to the Texture list.

Bounding Box displays the 3D object as a box around the object dimensions. It shows the total volume of the object. The bounding box displays as a transparent box; you can change its color from the Color Picker.

Normals are virtual vector perpendicular lines over the faces. The normals change in direction when the polygon or the face changes in direction, as illustrated in Figure 12.7. You can think of the normals as virtual lines that fall vertically over the object. However, this vertical direction gives these lines different falling angles, based on how the face is curved to form the polygon. This means that the normals can either fall vertically from the X, Y, or Z axes or the angles between them. Photoshop identifies the main falling angles for the normals with three colors; each color represents one of the axes.

Note: When you select the normal as a render option for a flat surface, it does not display any of the normal colors.

Depth Map displays the 3D object with a grayscale map depth. The 3D object converts to a grayscale surface with bright and dark areas based on the position of the 3D models to the default camera view.

Paint Mask displays the paintable map of the object's face based on the three colors white, blue, and red. White indicates the paintable areas. The oversampled areas display in red and undersampled areas display in blue. This option is very important when using the painting and drawing tools to paint over the object, because it is a guide to prepare the model for better

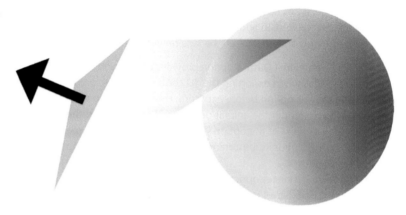

Figure 12.7 Understanding normals.

painting results. Furthermore, it indicates the areas of the model that will be paintable and how they will be affected with the painting tool.

The Face style renders the object as a 3D filled model. However, you can use this style along with its various options to output the 3D filled model for your project. For example, you can use the Unlit option to display only the texture applied to the model and discard the model polygon; this can help you view where the texture is warped or applied to the object. Also, you can use the Constant option to create a solid-color area that represents the model, which can be used to create a masked area based on the model shape.

Edges Style

The Edges style controls the render options for the edges and wireframe of the 3D object polygon. Along with the settings (explained shortly), there are four options that are common to all the rendering options:

- The Remove Backfaces hides the back face edges in two-sided 3D content.
- Remove Hidden Lines removes the lines that overlap with the foreground lines.
- Crease Threshold identifies the complexity of the wireframe structure. Its value varies from 0 to 180. If the polygon edges are under the threshold value, the edges are removed. Thus, the larger the Crease Threshold value is, the less complexity the model has (see Figure 12.9).
- Line Width sets the thickness of the edge lines.

The Edge style drop-down list includes four options that work similar to the options for the Face styles. However, these options are applied to model edges only. These options include:

- Constant
- Flat

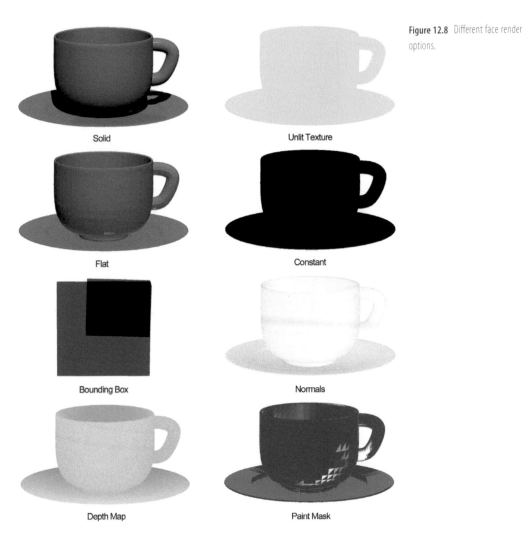

Solid

Unlit Texture

Flat

Constant

Bounding Box

Normals

Depth Map

Paint Mask

Figure 12.8 Different face render options.

- Solid
- Bounding Box

This style can be used to display only the wireframe for the object. However, you can use it in design as a wireframe version of the model, or you can use it as a guide for the model outlines and shape, such as some design ideas that require merging between the 3D filled model and the wireframe version to display how the model polygon is constructed.

Vertex Styles
These options affect the 3D object's vertex. The vertex is the smallest part of the model; it is a point in the 3D space that joins two lines or two edges. It

High Threshold Low Threshold

Figure 12.9 The Crease Threshold effect on a polygon mesh render.

Line width is 1 px Line width is 2 px

Figure 12.10 Changing the line width in rendering object with Edge style.

includes options similar to the Edge settings; when you change these settings, only the 3D model vertex changes. The only difference is an extra option that let you specify the radius of each vertex through the Radius value.

Using the Vertex style displays the vertex that is used to form the model, and how it is arranged. You can use this method to identify how the vertex is constructed and whether there is an error in the vertices that can affect the model, such as overlapped vertices, wrong vertex placement, and so on.

Volume Styles
As mentioned in Chapter 6, you can create a volume model out of 2D layers such as text layers and DICOM medical images (see also Chapter 4).

The **Volume** options set the options for the 3D volume content created based on DICOM files, which are medical images that can be imported into

Photoshop as a sequence of images. Photoshop can convert these sequenced images to a 3D object. (DICOM files are covered in Chapter 4.) The volume rendering includes four main rendering options, which are Normal, Maximize Intensity Projection, Alpha Blended, and Transfer Function.

The **Transfer Function** adds a gradient overlay the 3D volume object through the gradient slider.

The **Opacity Scale** sets the transparency of the rendered model, with a range from 0 to 10.This render style becomes active by default when working with the DICOM 3D volume objects. However, you can use it to render and export these types of 3D volume objects and apply the render options to it.

Stereo Styles

The stereo options prepare the 3D model for two of the technologies that use illusion to provide more depth to the media or image field.

The first technology is the Red/Blue image display. This technology provides two fields for each image view; one of the fields is red monochrome and the other is blue or cyan monochrome. Each of the fields offsets the main object position. Meanwhile, when you view the object through stereo glasses or red/blue glasses, you can see the image or video with a 3D depth of field.

Figure 12.11 The Red/Blue and Lenticular stereo styles for rendering.

Red/Blue Stereo rendering

Lenticular rendering

The second method is the Lenticular method, which divides the image vertically, so it gives more depth to the view. This method is used mainly in advertising, so that the image can change from one image to another image, or part of the image can change depending on the position of the viewer.

199

Note: You can choose one or more rendering options at the same time to merge the rendering options. For example, when you select both Face and Edges rendering options, the rendered object will display both the faces and the edges of the object in the render results.

After setting the render options, you can preview the results through the 3D menu by choosing Render for Final Output.

Rendering Examples

Now, let's merge this knowledge by using the render option, along with some tips and tricks in Photoshop.

The first exercise is to create a 3D model for the pyramids in Egypt that explores what's inside the pyramid by using the cross-section. We will also use both the Face and Edge render options to create the effect of wireframes in the pyramid structure.

In this example, I have used a DAE model for the pyramid, as the model should include a lot of edges and segments to show the structure:

1. Open the file 3d_pyramids.psd in this chapter's folder on the DVD. This Photoshop file includes a 3D pyramid model that has a texture applied to it (Figure 12.12).
2. While the pyramid layer is selected, choose 3D Scene from the 3D panel.
3. Set the render preset to Two-Side.
4. Set the quality to Ray Trace Draft or Final for more smooth edges.
5. Select Cross Section to slice the 3D model.
6. Uncheck the Plane to hide the plane.
7. Set the plane axis to Y.
8. For the Offset value, choose +5.
9. Set the Tilt A value to –155.
10. Set the Tilt B value to –5.

In the following steps, we will duplicate the model. The new model will have only the Edges render option:

1. Duplicate the pyramid layer and remove the Cross Section.
2. Open the Render Option dialog box.
3. Uncheck the Face options and activate the Edges option.
4. Set the Edges option to Constant.
5. Change the color of the edges to dark brown.
6. Set the Crease Threshold and the Line Width to 1.

Next, we will fade the Edges structure to give the appearance as if were an extension of the main building:

Figure 12.12 The 3D pyramid.

Figure 12.13 The 3D pyramid with the slice plane.

7. Select the 3D edges layer.

8. Choose the Polygon Lasso tool, select the Pyramid edges, and discard the edges that appear over the lower pyramid sides that face the camera.

9. In the Layers panel, choose the Mask tool to select the pyramid edges. The final look should be as if the pyramid edges completed the main pyramid structure.

10. Select the Mask thumbnail on the Edges pyramid layer.

11. Choose the Gradient tool and set the gradient to go from black to white.

12. Use the gradient layer to fade the edges from the side of the main pyramids by adding the gradient mask to the mask thumbnail.

The final result should look like Figure 12.14.

Figure 12.14 The final result of the pyramid with the Edges structure effect.

Summary

Preparing the model for final render and setting the render options for the model is penultimate step before export the 3D model or the 3D project in Photoshop. Understanding the render process helps you export a good-quality model with your chosen the render method. By understanding each render method, you can customize the render options to provide different effects and different styles for the 3D output.

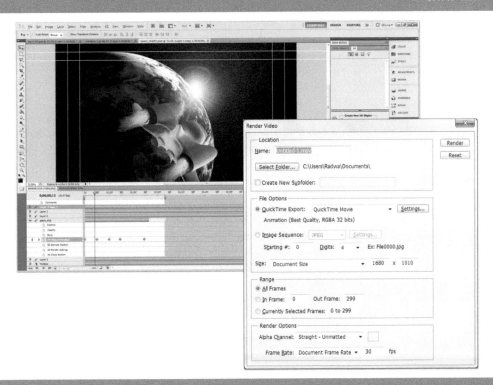

Rendering Animation for Video and Image Sequences

Usually, the end user does not view the source Photoshop PSD files. The source files include the work resources for the project workspace such as layers, effects, and editable text. Rendering is the process of creating image or video output from the source 3D model or animation. When you deliver the project to your client, you provide it in a final video format such as MOV, AVI, or FLV. The render process converts your working files from source file format to formats that can be used by the end user on the web, the desktop, DVDs, and other forms of video animation. For example, you can render the project to FLV and MOV files to use for the web and export the video project to AVI format for use on the desktop or DVD.

The final delivery formats do not allow users to see your source file structure, layers, or working sequence. Thus it secures the integrity of your project. As the end user will not have the project source file at hand and will not be able to edit it, your project source file and resources remain unavailable—and safe. Consequently, the final process after creating 3D animation in

Photoshop 3D for Animators. DOI: 10.1016/B978-0-240-81349-3.00013-8

Photoshop is to render it as a final product through the Export dialog box and its options.

Note: Although the render process gives you more options to save or export your 3D animation content, the Save As command provides another method for saving specific frames as image formats such as JPG, PNG, TIFF, and BMP. You can save a specific frame in the animation by placing the Current Time Indicator on this frame and choosing File > Save As.

You can export your 3D object directly from Photoshop using the Export 3D Layer command from the 3D menu; this option gives you the ability to export 3D content to common 3D formats such as Collada DAE, U3D, OBJ, and Google Earth KMZ, and to programs such as 3D Studio Max, Maya, and others. You can take the models you create in Photoshop to other 3D applications like these for additional modeling capabilities or for follow-up projects.

The render process gives you other options as well: you can export the 3D animation to other video formats such as 3G, FLV, FLC, AVI, QuickTime, MPEG-4, and DV streaming. You can also export the 3D animation frames in the Animation panel as sequenced images in different formats such as JPG, PNG, PSD, PICT, or TIFF.

Note: Rendering as video exports to video formats such as MOV, AVI, 3G, and FLV. Rendering as a sequence of images creates sequenced images; the animation frames are saved as different image formats such as JPG, BMP, TIFF, and PNG.

The benefit of understanding each render format is the ability to create suitable rendered output that works properly with your delivery media. For example, when you create video for the web, it should be small and of high quality at the same time. Understanding the FLV video options will help you export the video content for progressive or streaming Flash technologies to deliver the video. Web video animation is concerned with file size; producing video animation for video or TV broadcasting requires an understanding of video specifications required to create high-quality content.

After setting up the render settings for the 3D animation, the time comes to export it as a video file or image sequence. To do so, choose File > Export > Render Video. The Render Video dialog box appears to let you choose the output format; there is a wide variety of options associated with each format. In this chapter, I discuss the Render Video dialog box options and try to shed light on the most commonly used video formats and their options, as well as the different image formats that are used to export animation as an image sequence.

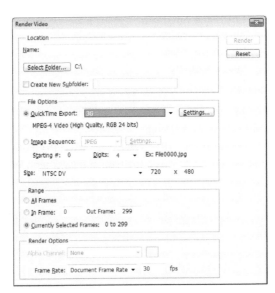

Figure 13.1 The Video Render dialog box.

After you finish your 3D animation project and set its render options, you are now ready to render your project by selecting the File > Export > Render Video. The Render Video dialog box includes four main section: Location, File Options, Range, and Render Options.

Location

The Location section is where you set the name of the video and the save location. You can also create a new subfolder in which to save the files by checking the Create Subfolder checkbox and adding the name of the new folder.

File Options

When you export your 3D animation to video or sequence images, you have a wide range of formats to choose from. The File Options section includes a variety of formats for either video or sequence images.

Video Export

Let's start by discovering the video formats in the QuickTime Export drop-down list and the setting available for each format. The video export supports the following formats:

- 3G mobile video
- FLC, video animation
- FLV, Flash video

Note: You must have the FLV QuickTime encoder installed to be able to export video as FLV video.

- QuickTime video
- AVI Windows video
- DV Stream video
- Image Sequence
- MPEG-4

3G Mobile Video

This format exports your 3D animation to third-generation mobile phones, including several settings that depend on the mobile network that will publish the content and the type of the content. See Figure 13.2.

Figure 13.2 3G export options.

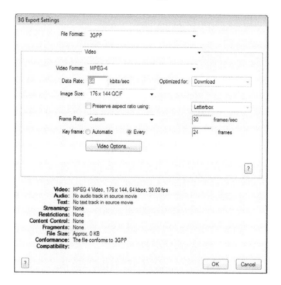

The file format drop-down list includes a number of formats that allow you to export the 3D animation based on different mobile network standards. For example, 3GPP is the standard for the GSM networks, and 3GPP2 is the standard for CDMA 2000.

The following exercise shows how to create 3G video content for mobile phones based on the 3D animation of the spaceship:

1. Open the file Spaceship.psd.
2. Select File > Export > Render Video.
3. From the QuickTime Export setting drop-down list, choose Flash Video, and open the 3G Export dialog box.
4. Select 3GPP from the file format drop-down list.
5. Select Video from the content type drop-down list.
6. Set the Video codec from the Video format list. You can choose MPEG-4, H263, H264, or Pass through if you do not want to compress your video.
7. In the Data rate, set the kilobits to be transferred when play back the video content. The highest data rate produces high-quality content, but the video data rate does not exceed the network's available data rate.

8. Choose the video size from the Image Size list based on the specifications of the mobile phone that will be used to play the content.
9. In the Frame Rate, choose Current to use the original frame rate for your 3D video animation.
10. The Keyframe setting specifies the number of frames between every two keyframes. Set this to Current to inherit the keyframe of the 3D animation in Photoshop.

The Streaming video option lets you prepare your video content to stream from a server. When you select Enable Streaming, you can maximum the streaming packets and file size. Also, when you choose Optimize for Server, the server can process your files faster.

FLV Flash Video

The FLV format is a Flash video encoding format that uses different video compression technologies to provide a low file size with high-quality video content. The format is mainly to produce content that is compatible with other Adobe technologies and tools such as After Effects, Flash, Flex, and AIR. However, it is also used to deliver video over the web using different Flash methods such as streaming and progressive video.

The streaming format delivers video as packets that allow many users to receive similar content simultaneously, as in online e-learning courses. This method does not save the video to the local drive, which is more secure for video delivery. Video footage that you do not want to be available on the user's machine can be secured this way, such as streaming tutorial sessions that you want the user to see on a website without giving him or her the ability to download it.

The progressive download format delivers video in batches, while you play the video. This method is less secure, as it saves the video to the local machine.

The FLV Export dialog box (Figure 13.3) is easy to use to set a wide range of options for exported FLV content:

1. Select File > Export > Render Video.
2. From the QuickTime Export setting drop-down list choose 3G and click the Setting to open the FLV Export dialog box.
3. The FLV dialog box appears with main four tabs to set the video options: Encoding Profiles, Video, Audio, and Crop and Resize.
4. In the Encoding Profiles tab, you can choose from the presets encode profiles based on the data rate of the playback video content. You also open external XML encoding profiles data files by clicking the Open icon and save your custom profile through the Save button as well.
5. The Video tab allows you to set the encoding options of the video. To enable the video encoding, make sure that the Encode checkbox is selected. The video encoding options are as following:

Note: I cover the usage of FLV content into Flash in Chapter 14, where we'll dig deeper into both progressive and streaming video for a better understanding of how to implement Photoshop animation in Flash using FLV video.

Figure 13.3 The FLV Flash video export options.

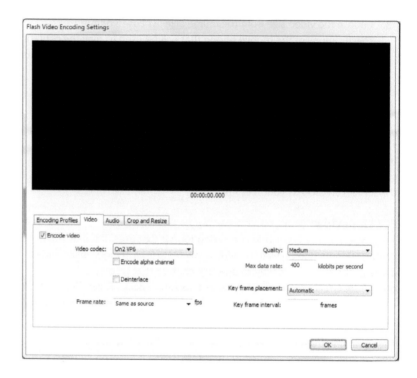

- The Video Codec, Flash option includes two main video codecs: Sorenson Spark and On2VP6. On2VP6 is much better, as it supports alpha channels (which create transparent videos). On2VP6 produces higher-quality content with a smaller video size.
- The Deinterlaced option lets you convert analog video content to digital video content.
- The Frame rate sets the speed of your video content; I recommend keeping this the same as the source video speed.
- The Quality sets the data rate of the video. You can choose the quality from the drop-down list or by entering the data rate value.
- The Keyframe placement option lets you either use the current value by setting it to Automatic or to specify the number of interval frames between each two keyframes.

6. In the Audio tab, you can specify whether to encode the audio with the Encode checkbox. The encoder that is used to encode the video is MPEG Layer III (MP3). You can also set the data rate for the audio by selecting the best data rate for your bandwidth from the drop-down list. Stereo and higher data rates increase the quality of the sound and the file size. It is a good practice to set this carefully, so as to balance the best quality possible with a small file size.

7. The Crop and Resize tab includes three parts to edit the video dimensions, crop the video edges, and edit the start and end points.

Currently, you can edit the video by resizing it. To resize the video, check the Resize checkbox and set the width and the height of video output.

FLC Video Animation
Also known as the FLI video format, FLC is developed by Autodesk. It is mainly used to create computer-generated animation for workstations and Windows and Apple computers.

QuickTime Video

QuickTime is a widely used video format that is compatible with both Windows and Apple systems. The advantage of this format is that it is widely used by many users and video tools. When you click the Settings button, the QuickTime Settings dialog box appears for you to set the QuickTime video output. The QuickTime dialog box has three sections: Video, Audio, and Internet Streaming. Although you can't currently edit the audio setting, I will cover both the Video and Internet Streaming sections.

Video Settings
The Video section allows you to edit the video settings and size of the video output. When you click the Settings button, the Video setting dialog box

Figure 13.4 The QuickTime export options.

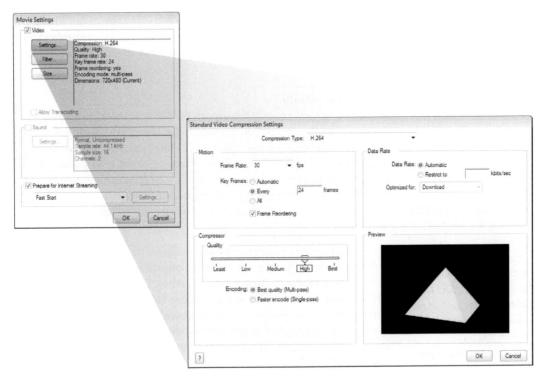

appears to let you set the QuickTime settings. The Video settings consist of five main parts:

- Compression type, this section lets you choose the compression type for the output video from the drop-down list. Choosing the suitable compression type affects the output video size and quality and depends on the display media. However, it is always a good practice to type which compression is the best for your animation. The Video or the animation compression types always maintain both quality and low size for the animation output.
- The Motion section includes fields for the frame rate and keyframes for the animation, or you can leave it at Default to use the original animation frame rate and keyframes.
- The Data Rate section sets the data rate of the video. When you select the Restrict to option, you can specify the output media for your animation.
- The Compress section includes a slider to set the quality of the output video animation; to set the quality of the output video, drag the slider to the right to increase the quality or to the left to decrease the quality. The relation between quality and size is covariant: the higher quality the video is, the larger it becomes, and vice versa.
- The Preview section provides a preview for the output video.

Filters

One of the most useful options when exporting video files as QuickTime is the filter features, which let you add filters over the whole video animation while rendering it. The filters include lens flare, blur effect, color adjustment, film noise, and color tint.

Export Size Setting

This dialog box lets you edit the exported video size. There are a lot of standard sizes that depend on the output device or media, such as TV, video, and web, and Photoshop provides a list of preset sizes in the Dimensions drop-down list. You can also set this to Compressor Native in the drop-down list to keep the output video file the same as the original animation in Photoshop. This option is helpful when you would like to avoid any compression and have the output video remain as the same size as the original.

Note: Keep in mind that resizing the video or changing its aspect ratio to something other than that of the original may affect the video quality and cause distortion, especially when you try to increase the video size.

The Custom option lets you specify a new size for the output video, with or without preserving the aspect ratio of the original video. To save the aspect ratio, check the Preserve Aspect Ratio checkbox. The is one of the common options when you would like to export video files with a different size than the source; this way you can create the source file with one size and export the file to different sizes. For example, you can export the video at a size for mobile devices, and also at a size that is compatible with video on the web, such as YouTube.

Prepare for Internet Streaming

Internet video streaming allows you to receive video over the Internet as packages of data from a video streaming server, such as in a streaming online session that is broadcast to many users at the same time, and ensures that everyone is viewing the same content as other users, and allows you to broadcast the content to many users compared to the other technologies. It is useful for online training sessions and also video delivery sites such as YouTube.

The streaming video is not stored on the local machine, as it is sent as packages upon the user's request, which is sent when the video player starts to play and call the video packages from the server. One of the advantages of using this method is that the user does not have to wait for the video to load to see a specific part of the video.

This section lets you set the streaming options for the QuickTime file. Basically, you can choose from three main options:

- Fast Start: Sets the video to play from the web before the video completes downloading to the local machine.
- Fast Start—Compressed Header: Similar to the previous option, but compresses the header of the video.
- Hinted Streaming: Sets the video to be streamed from a QuickTime streaming server.

AVI Windows Video

AVI is the most popular video extension for Windows users, and supports a wide range of video codecs and compression values. When you choose AVI as your rendered video file format, open the AVI settings dialog box, which is similar to the Quick Time dialog box and includes similar options. The only difference is that it includes different video compression codecs. The video codecs are methods to compress the video, as the original videos are always large and hard to handle, especially for playing on web and mobile devices. Thus it is a good idea to consider compressing the video using the video codecs. Try the commonly used codecs to get the best quality and smallest size for the video.

The AVI options settings dialog box includes options to specify your output video and audio. The video options include the following:

- The Compression Type includes different compression codecs that you can use to compress the exported AVI video. You can try different compression methods with your video to see the best result regarding the quality and total video size.
- The motion lets you set the animation speed in terms of frames per second. Also, you can set a custom keyframe placement; for example, you can set a keyframe every 24 frames by adding the number of frames

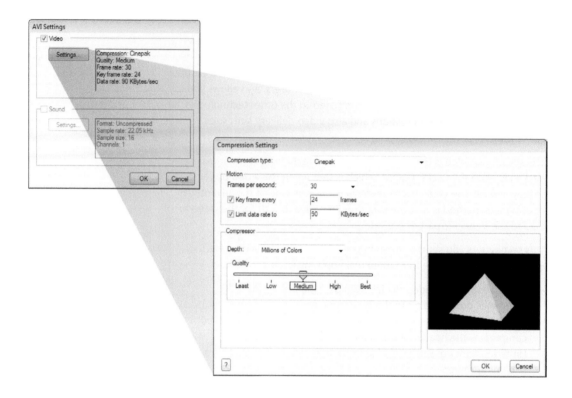

Figure 13.5 The AVI Windows Video export options.

between each two keyframes. Furthermore, you can set the data rate of the animated video.

- The Compressor section lets you set the depth of the output video, which indicates the number of colors in the video. Also, you can set the quality of the exported video.
- The Preview area lets you preview the video animation output.

DV Stream Video

This video format is used to transfer video content to nonlinear video systems such as cassette tapes and videotapes. The DV settings include the following features:

- In the DV format option, you can choose either DV or DVCPro. DVCPro reduces errors that can occur when recording the video to tape.
- The broadcasting standard format that will be used to display the video content over TV (either PAL or NTSC).
- The Scan mode determines whether the video will include interlaced fields. The interlaced method is a technique that breaks the video frames that will be displayed on old CRT screens into lines to reduce bandwidth consumption. You can disable the interlaced method by choosing Progressive from the drop-down list.

- The Aspect Ratio, which you can set to 4:3 or 16:9.
- The Preserve Aspect Ratio option resizes the video output while preserving it aspect ratio. There are two main options for displaying the resized video with preserved aspect ratio. The first one is letterbox, which adds a black frame around the resized video. The other is to crop the resized video.

Images Sequence

The QuickTime Export option allows the exporting of content not only as video, but also as sequenced images. To export animation as sequenced images, choose Image Sequence from the drop-down list. The Image Sequence option allows you to export content as BMP, JP2, JPEG, MacPoint, Photoshop, PICT, PNG, QuickTime Image, SGI, TGA, or TIFF.

Each format has its own options that affect the sequence's quality and number of colors. In the following exercise, you will see how to use this method to export video animation as sequenced images in the PNG format with a transparent background:

1. Open the file Chessboard.psd.
2. Select File > Export > Export Video.
3. In the Quick Time Export drop-down list, choose Image Sequence.
4. In the Image Sequence, choose the PNG format.
5. Click the Option dialog box.
6. From the Color list, choose Millions of Colors+ to enable the transparent background.

MPEG-4

The MPEG-4 format supports video delivery to a range of bandwidths and is used to deliver video over large bandwidth, such as streaming video over the web, video on CDs, and TV broadcasting.

MP4 is one of the MPEG-4 export formats and it is a widely used format for many new mobile phones. Therefore, in the following example, we'll convert the video animation to the MP4 format:

1. Open the file Spaceship.psd.
2. Select File > Export > Export Video.
3. In the Quick Time Export drop-down list, choose MPEG-4 and click the Setting button to open the MP4 Export Settings dialog box.
4. You have two options: MP4 and MP4-ISMA. The ISMA (Internet Streaming Media Alliance) is a group of companies including Apple, IBM, Sun, Cisco, Philips, and Kasenna that has put forth standards for streaming technology to increase the compatibility of the streaming video with any player. Choosing this option is useful when creating

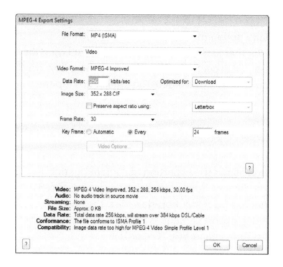

Figure 13.6 The MPEG-4 video export options.

content that is compatible with these standards. Generally, the commonly used format is MP4; and MP4-ISMA usage is limited.

5. Under the file format list, you can choose the setting type: video settings, audio settings, or streaming settings. Choose the video option.

6. The Video Format lets you set the compression for the animation. You have three main options: H.264, MPEG-4 Basic, and MPEG-4 Improved. The best choice is H.264, which produces lower size and higher quality. The other MPEG-4 options work on devices that support MPEG-4 files, such as mobile devices. You can also choose to not compress the video at all, but this will produce a very large file.

7. In the Data Rate field, set the data rate transfer for the video, such as 64 Kbps.

8. In the Image Size field, you can choose from the listed size presets or add a custom size. You can also set it to Current to keep the original size.

9. In the Frame Rate area, set the frame rate of the animation or set it to Current to keep the original frame rate.

10. The Video Options button opens the settings associated with each video format. In the dialog box you can set the encoding mode to either best quality or fast encoding.

Export Image Sequence

The Image Sequence option is an important feature that allows you to export video frames to sequenced images. The QuickTime Export option uses QuickTime to export animation as an image sequence, the Image Sequence Export option supports exporting video to an image sequence with other formats. The Image Sequence Export feature allows you to export images to different formats, such as BMP, Cineon, DICOM, JPG, OpenEXR, Photoshop, PNG, Targa, and TIFF.

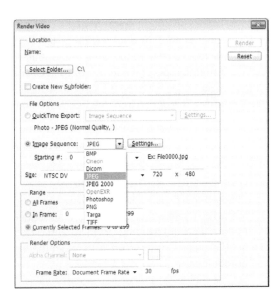

Figure 13.7 Exporting animation as sequenced images.

The settings button next the Image Format drop-down list lets you configure the settings associated with each type of formats.

When you export video as an image sequence, you can specify the name of the sequenced frames by using the Naming option under the Image Sequence Export option, and you can set a starting number for the image sequence by adding it to the Start # field. In the Digits field, you can set the number of digits that is used to name the exported frames; the digits are limited to five digits. You can use this option to name the exported frames sequence, as the exported files are often numerous, and you might like to keep the frame names in sequence for easy use. For example, when you import the sequenced files to Flash, Flash can understand the naming sequence. You can specify only the first frame, and Flash will import the rest of the sequence.

It is not necessary that the output dimensions be the same as the source animation content in Photoshop. You can specify the size of the output video or image sequence content through the Size Presets list. The Size Presets list is important because it includes a wide range of size standards in the video production based on many factors such as the TV broadcasting system (either PAL or NTSC). The Presets list also depends on the output aspect ratio and the type of the output video. For example, the PAL system is one of the standards supported in many countries in Africa and Middle East. This standard's dimension is 720px × 576px with a frame rate of 25 fps. NTSC is another TV broadcasting standard and is commonly used in North America and Japan. However, this format's standard is 720px × 486px with a frame rate of 29.97 fps.

215

You can choose an output preset from the presets list, or you can set a custom dimension for the output content. It is important to keep the aspect ratio of the resized content the same as the source animation file so as to avoid a distorted aspect ratio for the output. Or you can set the size of the output image sequence to be the same as the document size by choosing the Document Size option from the Size Presets drop-down list.

In the following exercise, you will see how to export Photoshop video animation as a JPG image sequence, optimize the JPG files' quality, and prepare the naming of the exported frames:

1. Open the Space_ship.psd file in Chapter 11 on the DVD.
2. Choose File > Export > Render Video.
3. In the File Options section, select Image Sequence.
4. Choose JPG from the drop-down list and click the Settings button.
5. Set the Image Quality value to 13 to get the highest quality for the output frames.
6. Set the sequence number. In the Start # value, type 0 to start the count from zero. In the Digits value, select 2 to have the frames numbered with two digits.

Figure 13.8 Exporting an animation as a JPG image sequence.

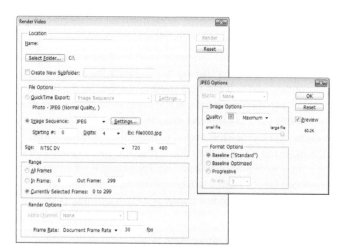

When you render the video animation as a sequence of images, make sure to prepare a folder for saving the exported frames, as the huge number of images that result must be organized. It is also important to have all the frames in the same naming sequence. This sequence lets other applications such as Flash, After Effects, and even Photoshop identify that the images are in sequence. Choosing the best format depends on your usage for the sequence. For example, if you will use this sequence for web or Flash animation, JPG would be the best choice, as it provides low file size and good quality. On the other hand, if you would like the image sequence to support transparency, then PNG is the best solution, because it results in

high-quality transparency compared with other formats that support transparency, such as GIF.

Range

When you export your 3D animation as a video or image sequence, you can choose to export only part of the animation by setting its range. For example, you can export one or two seconds of the animation for a preview, or you can have an animation that is divided into parts or scenes, so that you can export part or scene of the animation individually.

As we mentioned earlier, the Work Area bar in the Animation panel sets the animation frames that will be rendered from the animation. You can use the Work Area bar to set the start and the end of the animation work area.

Figure 13.9 Video and image sequence export range.

The Range part gives you another method to change the rendered area of the animation through the Export dialog box. It specifies the number of the animation frames that will be rendered in the output. The output range includes three options (Figure 13.9):

- All Frames: Renders the entire timeline regardless of the work area you set previously in the Animation panel. Make sure that your animation uses the whole timeline time, or you will get undesired repeated frames in the either the rendered video or the exported image sequence.
- In Frame and Out Frame: Sets a specific range of frames to be rendered in the output; you can specify the frame number where the animation render starts and the frame number of the last frame in the animation.
- Currently Selected Frames: Renders only the frames that are selected in the timeline work area. This method keeps the same work setting that you specified previously in the Animation panel.

Render Options

The Render options include other settings, such as alpha channels and the frame rate of the exported video animation.

Alpha Channel

The Alpha Channel setting determines the video or image sequence transparency options. Generally, when you create transparent content in Photoshop, such as PNG images, the object's outline may include pixels with

transparency. Some of these pixels get colors from the background layers or may not appear fully transparent. These pixels need to be fixed using the matting technique.

Note: When you export the 3D animation to a format that does not support the alpha channel, the Alpha Channel option is disabled.

The matting technique guides Photoshop to correct these edges or pixels and let them match the background of the video or the image. For example, if the image sequence or video file will be displayed over a red background, then it is a best practice to set the matting for the exported sequence of images or the video file to be red, which means that Photoshop can translate the transparent edges better.

Figure 13.10 Alpha Channel options.

The Alpha Channel settings include the following matting options, which will help you understand how Photoshop reacts with the transparency of the exported content:

- None: Avoids the alpha channel and the background of the exported video, or images become as the same as the document background color.
- Straight–Unmatted: Exports the alpha channel with its default without any matting color.
- Premultiplied with Black: Mattes the alpha channel with black.
- Premultiplied with White: Mattes the alpha channel with white.
- Premultiplied with Color: Allows you to choose the matting color for the alpha channel using the Color Picker.

As you can see in the following images, the matting affect appears with antialiased pixels in the image edges. The following two figures show the difference between an unmatted image's edges and an image matted with red edges.

Frame Rate

Similar to the dimension presets, there are default video frame rates that are associated with each standard. For example, the video output for the PAL standard requires the video output frame rate to be 25 fps, and the NTSC video standard requires the animation to be 29.97 fps.

In the Frame Rate section, you can choose the frame rate preset that suits your output standard from the drop-down list, or you can add your custom frame rate to the provided frame rate presets.

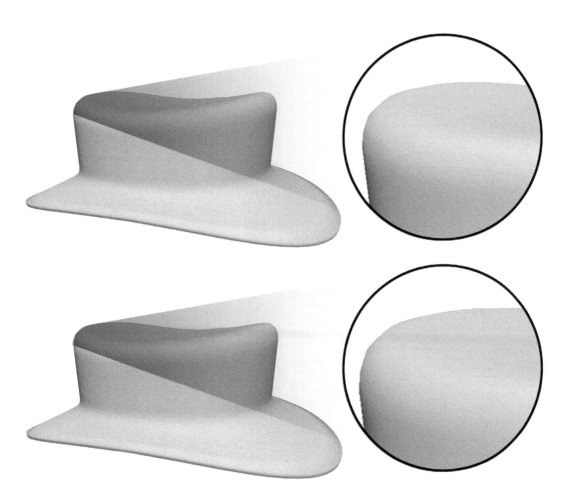

Changing the frame rate in the export process affects the video animation speed. Subsequently, the final output can be either faster or slower than the original video. A high frame rate produces a higher number of frames per second, which consequently increases the size of the rendered video or sequence images and the animation speed as well. A low frame rate produces fewer frames per second, which exports smaller videos of lower quality. The lower fps animation exports fewer sequence frames for the total animation.

Figure 13.11 The top image shows an unmatted image edge; notice the transparent pixels and how its opacity fades to white. The bottom image shows a red-matted image edge; notice the transparent pixels and how they are covered with red.

Summary

The video render process converts your Photoshop animation into video or image sequence content that you can implement in your project or deliver to the client as a final product. Understanding the video export settings and options can help you produce content that meets your needs or client requirements.

Integration Between Photoshop and Flash

Apart from the features in all Adobe products, there is another advantage to using Adobe products: the integration between products. This integration improves the workflow between products, as it provides easy methods for moving between products easily, without extra steps such as converting your project.

In addition to integration through the easy transfer of formats between products, Adobe Bridge provides an intermediate tool that allows you to navigate resources and open them in their native program, as we discussed earlier in this book. Furthermore, Adobe implements metadata information technology through the XMP format, which allows you to attach information to files, XML-based information that can be read by different Adobe products. Therefore, Adobe products are able to read the files' information such as the author, date, and camera data.

Photoshop 3D for Animators. DOI: 10.1016/B978-0-240-81349-3.00014-X
© 2011 Taylor & Francis. All rights reserved.

Along with integration, there is another feature: user interface unification. When Adobe acquired Macromedia, it worked to create a unified user interface across all the products. All Adobe products share the same workspace look and feel, including the docking palettes, menu structure, and product interface. This is actually quite helpful, as once a new learner gets familiar enough with the Adobe products, he or she will be familiar with other Adobe products. For example, the Timeline in both Photoshop and After Effects is similar: once you learn how to create an animation in Photoshop, you will be able to create an animation in After Effects without the need to learn anything else about the After Effects Timeline.

Some products are commonly used together. For example, if you are working with Adobe products to produce video content for TV and broadcasting, you need Photoshop, After Effects, and Premier. When you work in web design and developing, you need Photoshop, Flash, and Dreamweaver. Adobe produces different Creative Suite bundles that match such needs, including the Web Premium, Print, and Video Premium, as well as the Master Collection, which includes all the products.

One of the products that is commonly used with Photoshop in web, desktop, and animation projects is Adobe Flash Professional. Adobe Flash is a mainly vector-based application that is not used to create bitmap content. Adobe Flash users are generally dependent on Photoshop to create bitmap resources and edit images for their Flash projects. And Photoshop users depend on Flash to create web animations. One common repeated task in the design and animation process is to move files between Photoshop and Flash.

Therefore, we begin our discussion on integration by covering the workflow between Photoshop and Flash, with particular attention to 3D content and 3D animation. Although this chapter requires a basic knowledge of Flash, it will take users with no Flash experience to the next step for extending their design abilities by using some easy Flash features to bring their Photoshop animation to the web.

As mentioned, Flash does not provide the best method for bitmap and image editing. For example, resizing bitmaps in Flash can cause distortion to the bitmap quality. So the best method is to prepare the bitmap files in Photoshop prior to taking them into Flash. The first step is to prepare the resources in Photoshop.

Prepare Files in Photoshop

Most of the projects that use bitmap in Flash are concerned with the size of bitmap images, especially when working with web animation or if the Flash animation includes a large number of sequence images. Flash files that include large number of sequence images can be large and slow over the web. On the other hand, Flash animation that uses image sequences

consumes a lot of processing resources. Preparing Photoshop 3D animation for Flash involves exported files sizes, dimensions, and the number of the exported sequence images.

File Size

When exporting 3D animation from Photoshop as video or sequenced images, the animation includes a large number of bitmap sequences that can dramatically affect the total file size. Size optimization is one of the important tasks when exporting content. For example, if you have a 3D animation that includes 120 frames of image sequence and each frame is 10 Kbs, the sum of the animation will be 1.2 MB. This can be large—if you are creating a web banner animation, for example. If you can halve the image sizes by optimizing them, the total animation size will be 600 k, which is better!

In the following example, you will learn how to optimize sequenced images for animation before exporting them to Flash:

1. Open the Photoshop animation document PsdFlash.psd. This file includes 3D animation for a Photoshop logo that we will take to Flash to create a Flash banner.
2. To maintain the transparency of the animation we must export the animation as either GIF or PNG format. I do not recommend GIF, as it reduces the colors in a way that creates lower-quality images, and if you increase the quality of the exported image, it will result in larger files. I recommend PNG. Although there are other formats that support transparency, these two are the best for the web and are commonly used over the Internet. Choose File > Export>Render Video.
3. In the Render Video dialog box (Figure 14.1), select the QuickTime Export checkbox, and click the Setting button to open the Image Sequence dialog box.
4. In Format drop-down list, choose PNG.
5. Click the Options button, and set the color option to Millions of Colors+. This option maintains transparency (Figure 14.2).

This setting exports the animation in a transparent PNG image sequence. If your animation does not support transparency, then JPEG is a better choice for the exported content, as it results in smaller files and the ability to control the images quality:

1. Follow the previous steps, but choose JPEG as the export format for the animation.
2. Click the Options button to open the JPEG dialog box.
3. Set the quality of the exported images through the Quality slider. The Least quality produces a low size and low quality. The Best value produces the highest quality possible and the highest size.

Figure 14.1 The Render Options dialog box.

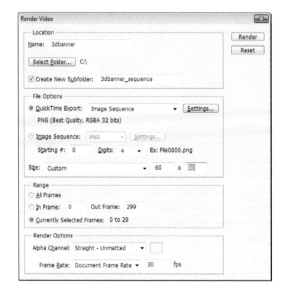

Figure 14.2 Exporting animation as a sequence of PNG images.

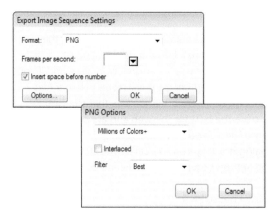

Figure 14.3 The JPEG Export Options dialog box.

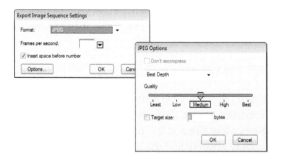

File Dimensions

As mentioned, Flash is mainly a vector-image application. Resizing images in Flash can cause distortion or quality reduction, so the best method for resizing bitmaps for Flash is actually to resize it in Photoshop before importing it into Flash. This is the second step you have to take before exporting Photoshop 3D animation as a video or image sequence to Flash. You must also resize the Photoshop content with the same aspect ratio; otherwise, there will be distortion or stretching in the content.

I discussed earlier how to change the file dimensions from the Video Render dialog box. You can also change the size of the Photoshop file via the Image Size dialog box in the Image menu. Both methods provide resizing with the same aspect ratio. Some animation sizes need to be changed to fit a specific banner size, which might be different than the original Photoshop animation file. You can change the dimension of the file with different aspect ratios through the Image > Canvas Size dialog box. This example shows how to change the Photoshop animation file to fit a banner size of 468px × 60px.

1. Open the Photoshop animation file 3dbanner_bakcground.jpg.
2. Make sure that the animated 3D object is at the left center of the screen. Also make sure that the 3D object height does not exceed the banner height, which is 60px, or the object will be cropped.
3. Open the Canvas Size dialog box (Figure 14.4).
4. In the New Size area, set the width of the object to 468px and the height to 60px.
5. In the Anchor area, click on the left center block to align and crop the file along this area, and press OK.

Figure 14.4 The Canvas Size dialog box.

Note: The Canvas Size option can crop or extend your file size without stretching its content, but note that when the file is cropped, you might find that some of your graphic element such as the background gets cut as well. However, you have to consider this while doing the cropping. For example, the cropped version can contain only the important elements in your design or you can fix the background to look similar to your design before cropping.

Number of Frames

When you export a Photoshop animation as an image sequence, the exported frame may be too large and affect the total size of the animation and the processing for this amount of sequence, especially when you are working in web animation. The best method to optimize the exported frame sequence to Flash is to manage the number of exported frames in Photoshop. This method helps to maintain the number of exported frames and gives you more control over the animation. For example, you can drop specific frames in the animation to help reduce size and increase performance.

Optimizing the number of frames depends on reducing the fps rate, which subsequently affects the speed of the animation. However, you have to be careful when reducing the fps rate of the animation so as to not affect the output animation flow.

In Photoshop, you can reduce the fps rate through the Timeline panel or the Video Render dialog box. To change the fps rate through the Timeline:

1. Open the Timeline panel context menu.
2. Choose Document Settings to open the Document Timeline Settings (Figure 14.5).
3. You can select a frame rate from the drop-down menu to set the fps to any of the standards rates or you can add a custom fps rate in the fps field.

Note: When you render your Photoshop animation, make sure the work area does not have repeated frames at the end of the animation or empty frames unless they are needed. Such frames will increase the file size unnecessarily.

Figure 14.5 The Document Timeline Settings dialog box.

The other method to change the fps rate of the animation is through the Render Option in the Render Video dialog box.

Importing File to Flash as Sequence Images

As mentioned earlier, there are two methods to import Photoshop animation in Flash: you can import it either as a sequence of images or as video

content. Importing animation as an image sequence can provide more control over the animation, especially when you work with animated banners, for which it is often necessary to drop some frames, edit frames, and so on.

Let's jump from Photoshop to Flash and see how to use the sequenced image files that we exported previously from Photoshop. Flash supports a wide range of imported formats, such as JPG, JPEG, GIF, and PNG; the most commonly used formats for the web are JPG or JPEG (for better file compression) and PNG (for transparency).

Flash provides two ways to import images. The first method is to import the sequence images to the stage directly as sequenced frames and the other is to import the images to the library, from where you can either drag it to the stage or display it through ActionScript coding.

We'll use the first method for the following exercise and import the images directly to the stage:

1. Open Flash and create a new document, either an ActionScript 2– or an ActionScript 3–compatible document.
2. In the Properties panel, navigate to the Properties section and set the document fps rate to 30 fps, then set the dimensions to 468 × 60 pixels and the background color to black.
3. Create a new movie clip 468 × 60 pixels to import the image sequence. Choose Insert > New Symbol or press CTRL + F8 (CMD + F8 on the Mac).
4. In the New Symbol dialog box, name the new symbol Bitmap_ animation and set the type to Movie Clip. This will allow the symbol to

Note: You can directly import the image to the stage; in our example, I added the image sequence inside a movie clip section to apply the reflection effect that you will see in the following steps.

Figure 14.6 Flash document settings.

play the animation inside it when it is exported. Click OK to create the symbol. The new symbol is created and Flash will open the new symbol to allow you to import an image.

5. Choose File > Import > Import to Stage.

6. Navigate to the image sequence and choose the first image of the sequence, then press OK.

Note: Make sure that the naming sequence is correct so that it imports correctly.

7. An alert message appears to let you choose to import either only this image or the whole sequence of images. Opt to import the whole sequence.

8. The image sequence is arranged in the timeline as frames. You can now preview your animation by pressing the Enter key to see the animation on the timeline.

9. Exit the symbol editing mode by clicking the Scene 1 on the top left of the documents.

10. You will notice that the stage is empty and does not show the symbol on it. Now, open the Library panel by choosing Window > Library or pressing CTRL + L (CMD + L on the Mac).

11. Drag the symbol Bitmap_animation to the stage.

12. Test the movie by choosing Control > Test Movie > In Flash Professional. You can preview your animation by pressing CTRL + Enter (CMD + Enter on the Mac).

Figure 14.7 The sequence of images animation in the Flash timeline.

In the previous steps, you saw how to import a Photoshop animation to the Flash timeline. In the following steps, we will go little further, by creating a simple reflection of the 3D animation in the stage:

1. Select the movie clip symbol and copy it.
2. Create a new layer by pressing the New Layer icon at the bottom left of the Timeline layer.
3. Paste the symbol in the same place as the original one by choosing Edit > Paste in Place.
4. Shortcut: To paste object in place, press CTRL + Shift + V (CMD + Option + V on the Mac).
5. Select the original symbol and flip it via Modify > Transform > Flip Vertically.
6. Move the flipped symbol to below the top symbol to act like the reflection effect.
7. Select the flipped symbol.
8. In the Properties panel, go to Color Effects and choose Alpha from the Style drop-down menu.
9. Set the Alpha value to 35.
10. Preview the animation by clicking CTRL + Enter (CMD + Enter on the Mac).

Figure 14.8 The Flash animation with reflection.

The question is why we didn't just create the reflection in Photoshop before exporting it to Flash. The extra content in the image sequence will increase the size of the files. On the other hand, when we use the same symbol in Flash as a reflection, it still uses one symbol. Repeating the symbols on the stage does not affect the size of the animation, as they are multiple instances of one symbol.

229

PSD Importer

Importing images to Flash as a sequence of images is the traditional method. But this approach does not support files that include multiple layers. Instead, it imports files with layers as a single-layer image. To import files with multiple layers and preserve these layers in Flash, we had to save each layer as a separate file and then import all the files to Flash as sequenced images.

The PSD Importer is a brand-new feature recently added to Flash (after CS3) that allows Flash to import PSD files while preserving the Photoshop layers and to convert them to Flash layers or frames. Although the PSD import feature does not support importing Photoshop animations, it can help you import 3D content to Flash as bitmap layers.

Note: Flash has a similar Import dialog box where you can import Adobe Illustrator files.

So let's dig deeper into the PSD Import dialog box in Flash through the following exercise, which will give you a better idea of how to easily import Photoshop files to Flash.

Figure 14.9 The PSD Import dialog box.

1. Open a new Flash document.
2. From the Properties panel, set the FPS rate to 30 and the dimensions to 400px × 400px.
3. Choose File > Import > Import to Stage.
4. Navigate to PsdFlash.psd (on the website at http://www.photoshop3d. net/downloads/); double-click.
5. The PSD import dialog box appears. The left section of the dialog box includes the imported PSD layers and folder. Next to each layer, a box lets you choose the imported layers. To the right of each layer is an icon that identifies the type of the layer as bitmap, text, and so on.
6. Under the Layers list, the Merge Layers button allows you to merge two or more layers. To merge any number of layers, use the Shift key to select the layers, and click the Merge Layer button. When you select any layer, the layer options appear at the right side of the dialog box, and the first option is to select how the layer will be imported. These options depend on the type of the original layer:
 - Bitmap image with editable layer styles is for bitmaps. If the layer has a style applied to it, it will be separated in another layer.
 - Flattened bitmap image is for bitmaps as well, and flattens the layer with the style applied to it or converts the text and vector layers to bitmap images.
 - Editable text applies to text and allows to import the text as editable text in Flash.
 - Vector outline imports the text as vector lines.
 - Editable paths and layer styles imports the vector layers as editable paths.
7. The Create Movie Clip for Layer checkbox lets you convert the layer to a movie clip and give it an instance name for ActionScript programming. The registration point area sets the center point of the movie clip.
8. The Publish settings set the compression and the quality of published the images as following:
 - The compression option can be either Lossy or Lossless. The Lossy option is used in images, and the Lossless option is used for text layers.
 - The Quality options let you choose to use the publishing settings that you can find when you publish the Flash movie or set a custom Quality value for each layer.
 - The Calculate Bitmap Size option provides an estimate of the size of the layer after compression.
9. The Convert Layers to drop-down list lets you choose to either convert the imported layer to frames or to layers.
10. Place Layers at Original Position imports the layers to the same position as in the original Photoshop document.
11. You can also change the current stage to have the same dimensions of the imported Photoshop file by choosing Set Stage Size as Photoshop Canvas.

Shortcut: Import video to the Flash stage by pressing CTRL + R (CMD + R on the Mac).

Importing a File to Flash as Video

The other method to import 3D Photoshop animation is by exporting it as a video animation from Photoshop. The image sequence is more suitable for banner animation and animation resources that include a low number of animated frames; the video animation is more suitable for large animations.

The default video format for Flash is FLV; files in this format can be imported from Photoshop through the Render Video dialog box. Flash supports a wide range of video formats, but FLV is commonly used because it displays video at a low size and high quality. It is one of the best formats to use for web video.

There are three main methods for working with video in Flash: embedded, progressive, and streaming.

Embedded Video

The embedded video is the oldest method for importing video inside Flash—and the least efficient method. The only advantage of this method is that it includes the video in the Library and Timeline. However, you can work with the video as any symbol in the Library, such as applying effects, adding masks, and convert to 3D.

Although the embedded method adds the video to Flash like any other imported content, it has some disadvantages that limit its use. The disadvantages of using the embedded method are:

- If the imported video is larger than 120 seconds, you may face some trouble, especially in sound synchronization.
- The video is limited to 16000 frames, which is the maximum length of the Flash timeline. Adding Flash content of more than 16000 frames may not work properly.
- When playing the video on the web, the browser needs to download the whole video first before it can start to play it back.
- Adding video to the Flash file increases its size dramatically.
- It is not easy to edit or update the video, as you need to open Flash to edit the video or import it again.
- This method is not secured, as the video source must be downloaded to the local machine before playback can start.

There is another method to import an FLV file into Flash: with the embedded method directly to the Library panel. This option works only with FLV video; it imports the video directly to the library, from where you can drag it to the stage. You can import files to the library through the following steps:

1. Open a new document in Flash.
2. Open the Library panel from the Window menu or press CTRL + L (CMD + L on the Mac).

3. In the Library panel, open the context menu and choose New Video.
4. The Video Properties dialog box appears. Add the name of the new video.
5. In the Type section, choose Embedded to add the video to the timeline.
6. Click the Import button and navigate to the FLV video.

Progressive Video

Both the progressive and streaming methods were added to Flash after the Embedding method as ways to avoid a lot of its disadvantages and to provide extended capabilities for working with video content in Flash.

Figure 14.10 Importing video to the Flash Library panel.

Progressive video supports playing video externally, for which the Flash SWF calls the FLV or MPEG-4 video and control files from an external path. However, this method provides an easy solution to update video files by simply replacing it with the current one without the need to open Flash and import the video again.

Flash also provides the ability to control the video player through the FLVPlayback component. This component provides a wide variety of player skins that can be easily used with out any programming skills through the Video Import dialog box, as you will see shortly. The FLVPlayback component generates a SWF file for the video player and saves it in an external path. So it is important to have the main SWF file, the player controllers' SWF file, and the video FLV saved in one location to ensure that the video content will play properly.

As mentioned earlier, progressive video has advantages over the embedded video method, some of which are:

- The progressive method keeps the video file saved externally. So it is easy to update by just replacing the external file without needing to open Flash.
- To preview content with the progressive method, you do not need to publish the whole video, which can take a long time. You need to publish only the SWF file that will call the video content.
- This method sends the video content as parts. However, it does not require the whole video to be downloaded to be able to play it. Once the

first part is downloaded, the video starts to play and the next part is downloaded in the background.
- The progressive method does not have a limitation on the video length or number of frames, as the embed method does.
- You can use a different frame rate than that of the original Flash file.

The disadvantage of using this method is that the progressive video is downloaded to the local machine. Thus, it is less secure than the streaming methods.

Streaming Video

This method provides a more reliable connection between the local machine and the server to deliver the video to the user. However, streaming video requires the server to have Flash Media server running on it.

The greatest benefit of using this method is that it allows many users to connect to the server to watch a live session, by sending all users the same video stream in the same time.

Streaming video shares with progressive video some common concepts such as that the FLV or MPEG-4 video is played externally and sent from the server in small packets, but there are some differences. Following are the advantages and characteristics of streaming video:

- The streaming video allows many users to see the video at the same time and the server can send the same packets of information to all the users at the same time, so it is more usable in video conference and online sessions.
- The streaming video starts once the video's first small segment is delivered and the rest of the video is delivered to the users in small segments. Once the controller play head reaches a specific part of the video, the server sends this part's segment to the user.
- This method is more secure, as the streaming media is not downloaded to the local machine.
- This method allows more information to be retrieved about the user, such as the bandwidth capacity of the user's network.

Understanding the different video delivery methods in Flash is important so that you can make the right choice. Following is an example of how to import video content in Flash using the Import Video dialog box.

Flash allows you to import many different formats and convert them to FLV or F4V formats, which are saved next to the SWF file that calls it when the user plays the video. In the following exercise, you will see how to import a video in QuickTime and how the Video Import wizard converts the video to FLV.

1. Open a new Flash Document.
2. From the Properties panel, set the file dimensions to 800px × 600px.
3. Choose File > Import > Import Video.

Figure 14.11 The Import Video to Flash Wizard.

4. The Video Import dialog box appears; select the Load External Video with Playback Component option.

5. Navigate to the Flashvideo.mov file and press OK.

6. An alert message appears to show that the format is not supported in Flash Player and the file should be converted to FLV or F4v.

7. Click the Adobe Media Encoder to open the Media Encoder tool, which allows you to set the options for the exported FLV or F4V format.

8. In the Media Encoder, set the format of the exported video to either FLV/F4V or H.264 for HD video.

9. In the Preset section, you can choose from the available presets or Edit Export Settings to set your custom setting.

10. The Export Setting dialog box includes two sections: the left part lets you preview the video output and crop the video using the Crop Output icon at the top left. You can also crop the timeline of the video by using the work area in the slider under the video.

11. The right section includes the video formats and presets available. Also, it gives the option to export video and audio.

12. Under the video summary, there are five tabs that let you edit the setting of the video. The Filters tab lets you add filter effects, such as Gaussian Blur. The Format tab lets you set the exported video to be either FLV or F4V. The Video and Audio tabs let you set the setting and compression for the video and audio; these options are similar to the FLV Export option in Photoshop. The FTP tab lets you set an FTP account to directly upload video content to the server.

13. Click Start Queue to begin converting the video to FLV.

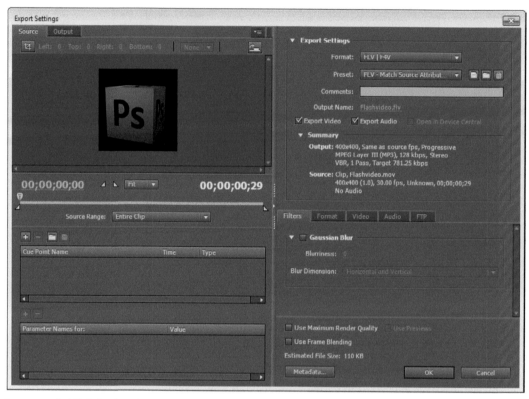

Figure 14.12 Flash Media Encoder settings.

Figure 14.13 The video player Skins options.

14. Go back to the Import Video dialog box in Flash and click "Browse" to navigate to the FLV video file.
15. Click Next to go to the Skins section; in this section, you can select the player skin you would like to use with the video from the Skins drop-down list.
16. Click OK to return to the Flash stage and Flash will add the FLVPlayback component to the stage.
17. Test the video to see the video output and the player skin.

Summary

In this chapter, we covered the basics that allow you to use Photoshop animations and 3D content in Flash to extend both your Photoshop and Flash capabilities and to take your Photoshop animations and 3D content to the web through Flash.

Working with both Flash and Photoshop is one example of the integration between Flash and Adobe products; in the next chapter, we will cover different type of integration. However, practicing different types of integration can help enhance the project workflow and capabilities.

Integration Between Photoshop and After Effects

Adobe After Effects is the part of the Adobe Creative Suite that enables you to create video production and animation, especially for TV broadcasting, video animation, cinematography, DVD production, and other uses. The ability to integrate your 3D Photoshop project and Adobe After Effects can extend your ability to create animation effects and apply a wide range of the video styles and effects.

In this chapter, you will see how to integrate Photoshop with Adobe After Effects by taking the PSD files directly into Adobe After Effects while preserving Photoshop layers and objects such as 3D objects, video layers, text layers, masks, styles, and so on. We will start by discussing the resources that you can import from Photoshop to After Effects and focus on 3D and video animation, including its structure in the After Effects composition. You will also learn easy methods to enhance your animation through applying

Photoshop 3D for Animators. DOI: 10.1016/B978-0-240-81349-3.00015-1

animation presets and video effects from After Effects presets. After Effects presets include video- and animation-ready effects that you can easily apply to your animation with a click of your mouse.

The Integrated Photoshop Resources

Note: Although you can export a Photoshop animation as video and import it into After Effects, importing a PSD layer gives you more ability to apply effects on each object separately.

One of the most important integration features between Photoshop and After Effects is the support for importing Photoshop layers into After Effects. Although this integration is shared between other tools as well, such as the ability to import Photoshop layers into Flash and Illustrator, importing Photoshop layers to After Effects preserves a lot of the Photoshop work by reading Photoshop layer styles, effects, adjustments, and so on.

The way Adobe After Effects reads the imported Photoshop layers depends on the import settings. However, in general, After Effects supports different types of PSD layers as follows:

- Video layers: After Effects supports importing video layers from Photoshop and preserves the styles applied to the layers, such as the drop shadow, outer glow, bevel, emboss, and so on.
- 3D layers: When you import the 3D layer into After Effects, it imports the 3D object with the full ability to control the object through navigation controls similar to the navigation arrows in Photoshop. The 3D layer properties are imported as sublayers for the 3D layer in After Effects. In addition to the main 3D layer, After Effects imports the Photoshop default camera as a separate layer so that you can edit the camera properties.
- Effects and Styles: When you import a layer with styles, After Effects reads the style applied to the layer and adds it as a property layer in the Timeline panel layers.
- Mask layers: The imported layers with masks are merged with the applied mask. So you cannot edit a Photoshop mask once it is imported to After Effects.
- Adjustment layers: The adjustment layers—such as brightness and contrast, hue and saturation, and levels—can be imported to After Effects as a separate control layer with the adjustment value applied to it. This layer affects the layers below it, similar to Photoshop.
- Layers folders: Although After Effects does not support layer folders to group layers, it converts the grouped layers to a separate composition. When you import a PSD file that includes grouped layers, After Effects adds the grouped layers in a separate composition that is placed inside the composition of the PSD imported layer.

Beside the previously mentioned layer types, the rest of Photoshop layers are imported as normal shapes that you cannot edit directly in After Effects.

Note: When you have animation applied to the layers in Photoshop, it is discarded when you import the Photoshop layer in After Effects. It is preferable to create the animation in After Effects if you plan to enhance your Photoshop animation with After Effects animation effects.

Import Photoshop Files to After Effects

After Effects supports different options when importing Photoshop layers; these options are related to how After Effects will handle the imported Photoshop layers. As you will see in the following exercise, you can either import the Photoshop file as footage with flattened layers or as a composition with the Photoshop layers preserved.

Note: Although you do not have to have experience with After Effects to complete this chapter, we will go step by step to import Photoshop content to After Effects and enhance it with animation and video effects and render the files as a final video production.

Let's start with the following exercise so that you can learn how to import Photoshop files into After Effects:

1. Open Adobe After Effects.
2. Locate the Project panel on the left side of the application. If it is not there, open it via Window > Project. The Project panel is considered the library of resources that you will use in your After Effects animation.
3. Choose File > Import > File or press CTRL + I (CMD + I on the Mac).
4. Navigate to the Photoshop file video_animation.psd in the for this chapter on the DVD.

Shortcut: Import files to an After Effects project by pressing CTRL + I (CMD + I on the Mac).

When you choose the Photoshop file to import, the Import dialog box appears to let you choose the import method. There are two main methods for importing the Photoshop layers, discussed in the following subsections.

Footage

This option imports either one layer of the Photoshop file or a group of Photoshop layers and imports the PSD file as one image. When you choose the Footage option from the Import dialog box, the following options appear:

- Merged layers: Merges the PSD file layers to one layer and imports the layer as After Effects image footage in the Projects panel.
- Choose Layer: Specifies which layer to import; when you select this option, the Layers drop-down menu appears to let you choose the layer you would like to import. You can also choose to merge the styles applied to the layer in the footage or ignore the style in the imported layer.

Figure 15.1 Import Footages command in After Effects.

Figure 15.2 The Import dialog box in After Effects.

When you choose to import a specific layer, you can specify the footage dimension to be either the document size or the imported layer size. When you choose the Layer Size option, the footage dimension becomes the same as the edges of the Photoshop layer. However, the created footage can be smaller than the Photoshop document.

Composition

This option imports the Photoshop layers into an After Effects composition; the composition is the working area, which includes the After Effects

animation. Each composition can include many layers and act as a separate video document. The After Effects project can contain more than one composition, and each composition acts as a scene, so you can render it separately from other compositions in the After Effects project.

When you import the Photoshop files as a composition, the PSD layers are preserved as layers inside the created composition. However, when you choose the Composition option from the Photoshop File > Import dialog box, you get the following options:

- Editable Layer Styles: Converts the Photoshop styles to After Effects editable styles attached to the imported layer properties.
- Merge Layer Styles into Footages: Merges the layer styles with the imported layer footage. However, the styles become uneditable.
- Live Photoshop 3D: Imports the 3D layers while preserving its 3D properties and gives you the ability to control the 3D object in After Effects through the 3D controls. In addition to the ability to control the 3D objects in Photoshop, checking this option imports the Photoshop default camera as a separate layer that can be edited in After Effects.

Note: When you import the PSD files as a composition, a new folder appears in the Projects panel that includes the imported layers as resource footages.

The After Effects project is the file that saves your After Effects work. It contains the footages, which are the resources for your project, and the composition acts as the separate scenes in your video animation. Each composition is considered a separate file that is exported and rendered separately. The After Effects project is saved in the AEP format and can contain multiple After Effects compositions. However, the AEP file includes the source files for the composition and the resource footages, such as the Photoshop layer and video files.

Understanding the After Effects Timeline

Although our concern is the integration between Photoshop and After Effects, to enhance the 3D animation using After Effect effects presets, we need to dig a little deeper in the After Effects basic concepts for a better understanding of how the effects are applied to layers. We will not get very far into the timeline features and options. On the other hand, you will find the After Effect timeline pretty easy, especially because it shares the same concepts as the Photoshop timeline.

The Photoshop timeline discussed earlier in Chapter 11 actually follows the same idea as the After Effects timeline, except for few issues, such as how the After Effects timeline includes all the properties of the footage, including the styles, effects, and masks associated with it. This is because After Effects does not have a layer panel like that of Photoshop.

Note: You cannot directly edit the 3D object layer's transform properties such as scale, rotation, and position. Rather than making a direct change in the Properties, you can change the 3D object properties through the 3D Controller layer.

3D Objects in After Effects

When you import a Photoshop 3D object into After Effects, it preserves all of the information required to handle the 3D object in After Effects. It not only

Figure 15.3 The video layer imported to Photoshop.

Figure 15.4 The animation timeline in Adobe After Effects.

imports the 3D model, but also the default Photoshop camera used to view the 3D object, and applies a controller layer that is used to control the 3D object.

Before jumping into an exercise that shows you how to work with the 3D layer in After Effects, let's get an overview of the associated control layer and camera layers that appear when after importing the Photoshop file.

When you import a Photoshop 3D layer and have checked the Live Photoshop 3D option in the Import dialog box, three layers appears on the timeline:

- The 3D Object layer: This is the main layer, which includes the 3D object. Although you cannot edit all of the 3D object properties directly from the 3D object layer, such as scale, transform, and rotate, you can edit these properties from the 3D control layer.

- 3D Controller layer: This layer contains the controllers for the 3D object, such as the transform properties including rotate, scale, and position, and material options, such as shadows, diffusion, light, shines, metal effects, and so on.
- 3D Camera layer: When you import a 3D Photoshop layer into After Effects, the Photoshop default camera is imported as a separate layer in the composition. You can change the camera transform properties such as position, rotate, and point of interest. The 3D camera layer also includes camera properties such as zoom, depth of field, focus, aperture, and blur level.

In the following exercise, you will see how to use the 3D controllers to rotate the 3D object in the 3D space:

1. Open Adobe After Effects.
2. Choose File > Import > File or press CTRL + I (CMD + I on the Mac).
3. Navigate to the file 3dcar_aftereffects.psd, which includes a 3D layer in Photoshop.
4. In the Import dialog box, choose Composition as the Import Type and make sure that the Live Photoshop 3D Layer is selected.
5. Open the Timeline panel and expand the 3D object layer.
6. In the Live Photoshop 3D section, set the camera option to Use Composition Camera, which activates the Controller layer to modify the object.

Figure 15.5 The imported 3D layer in After Effects and its properties.

Figure 15.6 The Effects and Presets panel.

Applying After Effects Presets

Now that you've seen how to import Photoshop 3D files to After Effects and the timeline in After Effect, we will move on to see how to use After Effects to apply effects to the imported objects and the presets in After Effects.

After Effects includes a large number of effects and presets. Though you can add the effects manually from the Effects menu and set each effect's values from the Effect panel, After Effects makes it much easier by presenting a number of comprehensive collections of video effects as presets that allow you to apply the effects with just a double-click on the preset. I will talk only about presets and how to use them to easily apply effects in After Effects—working with effects is outside our focus, which is on the integration between the two applications.

Presets are arranged in the Effects and Presets panel, which you can display from the Windows menu. Each collection of presets is arranged based on its usage and type. In the following example, we will apply an animation preset to the 3D car model that we opened earlier:

1. Select the 3D model layer from the timeline.
2. Make sure that the Current Time Indicator is on the first frame.
3. Go to the Effects and Presets menu on the right side. If it is not open, you can open it from the Windows menu.
4. In the Effects and Presets panel, navigate to the folder Transitions–Movement and select Card Wipe–3D pixelstorm. The preset will be applied directly to the 3D model.
5. Preview the animation by pressing the spacebar or use the play controllers in the Preview menu. You can open the Preview panel from the Windows menu.
6. In the Effects Controls panel next to the Project panel, increase the number of rows and columns of the model fragment to 40 instead of the default, which is 20. This creates more of a fragment effect on the layer.
7. You can also set the number of the defragment animation frames by dragging the keyframes of the animation closer to or away from each other.

As the Effects and Presets panel includes a wide range of effects, the best way to learn about each effect is to apply it to the model and see its properties and how to change it to get the effect you want.

So far, you've seen how to import a Photoshop 3D file to After Effects and apply the animation presets to the 3D model. In the next step, you will learn how to render the 3D files to a video animation, an image sequence, or as Flash SWF content.

Figure 15.7 The applied preset properties.

Export 3D Animation in After Effects

Although the Export feature allows you to export an After Effects animation using the QuickTime component, it is not the best method to output an After Effects animation, because it does not give you the same capabilities that you can get with the Render command.

The Export Video command in the File menu is the easiest method for creating video from the After Effect animation. The Export feature supports different types of formats, such as Flash SWF, FLC, 3G, Adobe Premier Project, AIFF, MOV, AVI, AU, DV Stream, FLV, Image Sequence, MPEG-4, and WAV.

Note: When you choose to export video using the Export command, After Effects displays a warning message that reminds you that the Render command will give you additional capabilities.

Figure 15.8 The 3D animation with the presets applied to it.

One of the features that is notable about the Export feature in After Effects is that you can export the 3D animation as a Flash SWF file or Flash FLV video directly without the need to open Flash. The SWF Export feature can export the content as vector-editable content or bitmaps. When you export the content as an SWF file, the SWF dialog box (Figure 15.9) includes the following features:

- Images: Includes information about the quality of the exported bitmaps and how the unsupported effect will be exported. After Effects can either ignore the unsupported features or convert it to bitmaps.
- Audio: Concerns the exported audio quality, such as sample rates, channels, and bit rate.
- Options: Includes different sections such as the looping options, prevents the import of the SWF content, adds the object names and web links markers, and settings for whether Illustrator artwork will be flattened.

Let's see how to export the animation we have as SWF content that you can play on the web, desktop, or mobile devices:

1. While the 3Dcar_aftereffects.aep is still open, choose File > Export > Adobe Flash Player (SWF).
2. The Save dialog box appears to save your file as 3Dcar_aftereffects.swf.
3. The SWF Settings dialog box appears. Set the quality of the JPEG based on the destination of your file. For example, if you will publish the SWF file to the web, it is better to keep the JPEG quality low enough to

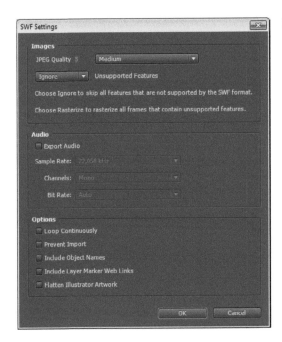

Figure 15.9 The SWF Export options.

generate a smaller file. But note that low quality will affect the quality of the frames as well. So you must choose the quality level that ensures both a fairly low size and good output as well.

4. Choose Rasterize from the Unsupported drop-down menu to let After Effects rasterize the effects or the features that SWF cannot read. Otherwise, After Effects will ignore it and it will not show up in the final SWF.

5. Click OK to start rendering the animation as SWF.

When you choose other formats, you will notice similar options and dialog boxes as the Render option in Photoshop.

Render 3D Animation in After Effects

The standard method to export After Effect projects is through the Render option. The Render option allows you to output content in different formats with different options. Adobe After Effects allows rendering of multiple files through the Render Queue panel. Let's render the previous exercise's file:

1. While the 3Dcar_aftereffects.aep is still open, choose Composition > Add to Render Queue. The animation is added to the Render Queue panel (Figure 15.11), which lets you choose the Render options.

2. The Queue panel appears and includes the 3D car composition in it.

Figure 15.10 The Render Queue panel.

Figure 15.11 The Render Settings dialog box.

The Render options are categorized into three dialog boxes as follows:

- Render Settings: When you click Best Settings, this dialog box appears to let you set the quality of the rendered content, resolution, and how the render process will act with the effect, color depth, guide layers, and so on. The dialog box also includes information about time sampling and frame rate.
- Output Module: This dialog box allows you to specify the output formats and color management options. The formats available in the Format drop-down list are much more than the Export options, such as

Figure 15.12 The Output Module dialog box.

high-definition formats and sequence images. The dialog box includes video output color formats and stretching and cropping options, as well as audio settings.

- Output: This dialog box lets you save the output in the desired path.

Based on this information, let's set the render options and render the composition animation:

1. In the Queue panel, choose the Render Settings dialog box. Set the Quality to Best and the Resolution to Full and click OK.
2. Open the Output Module dialog box. From the Format drop-down list, choose the video format in which you would like to export the video.
3. On the right of the Video Output section, click Format Option to set the quality and compression options for the selected video formats. These options are different based on the chosen video format.
4. Use the Stretch and Crop values to change the dimensions of the output video. Click OK to apply these settings.

5. In the Output To selection, choose the name and the path to save your output video.
6. Click the Render button to start the render process.

Summary

After reviewing the final step in the video production by rendering the video to final output, you have now seen the integration between Photoshop and After Effects. Furthermore, we discussed how you can extend your animation capabilities by applying After Effects' animation presets and effects.

You also saw how you can integrate Photoshop and other Adobe applications such as Flash to extend your ability to output the 3D animation project for the web, desktop, and mobile devices. And you've seen how easy it is to move between applications with the deep integration between Adobe Creative Suite products. I also covered the deep support for 3D layers in applications such as After Effects, which can help in preserving a lot of the 3D properties in the imported files.

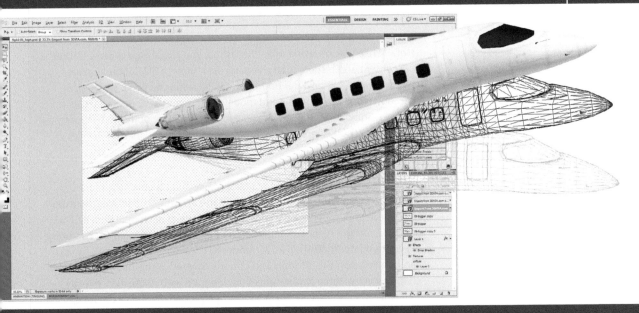

Working with Third-Party Tools

Content in 3D has been an important resource in 2D and 3D designs—designers always need 3D content, either creating it from scratch or importing it from other 3D applications into Photoshop. Before Adobe announced the 3D feature in Photoshop CS3 a few years ago, there were many third-party applications and plug-ins that tried to bridge the gap between Photoshop and 3D content. These third-party applications were based on the ability to communicate with Photoshop directly or through plug-ins.

After the release of the 3D feature in Photoshop, designers relied more on Photoshop to create 3D content and work with 3D resources in Photoshop. This wasn't the death of third-party applications that brought 3D content in Photoshop, because some of these applications still provide advantages for the 3D process workflow and more capabilities for designers who work in 3D content in Photoshop.

Let's jump a little bit away from the 3D feature in Photoshop and discover the advantages that we can gain from these third-party additions to the 3D workflow process. This final chapter gives you an overview of some of the most useful third-party applications that allow you to extend what you can do with 3D content in Photoshop.

Photoshop 3D for Animators. DOI: 10.1016/B978-0-240-81349-3.00016-3

Note: While you are working in Photoshop, you can always browse through 3D content and resources by choosing 3D > Browse 3D Content Online, which opens your browser to the Adobe 3D resources page, where you can download 3D materials and models from famous 3D publishers such as TurboSquid, DAZ 3D, 3DVIA, and Archive 3D. Some of these third-party 3D resource publishers provide tools and plug-ins to work with 3D files in Photoshop.

3D-native applications such as 3ds Max, Maya, and Cinema 4D allow interaction with Photoshop only through the 3D formats that you can export from these applications and import into Photoshop, such as 3DS, U3D, OBJ, and KMZ. On the other hand, third-party applications and plug-ins can bring 3D content into Photoshop as 2D rendered content or 3D models that you can handle using the 3D tools and options covered in this book. In this chapter, I cover three applications that integrate with Photoshop directly to create 3D content: DAZ 3D Studio Bridge plug-in, Strata 3D CX Suite, and 3DVIA.

You do not need prior experience with these applications to continue with this chapter, as we will overview the features in these applications to discover how to use third-party tools to enhance your work in Photoshop. Then you can choose the product that is more suitable to your needs and your Photoshop workflow.

DAZ Studio 3D

DAZ Studio 3D allows you to create 3D models and animations based on a library of characters and resources associated with each character (Figure 16.1). You can use DAZ 3D library base models as a starting point for your modeling by modifying the base content. This content can be human figures, animals, elements of nature, and other objects.

Note: You can download and install the version of DAZ Studio 3D and the DAZ 3D Photoshop plug-in from the DAZ site, http://www.daz3d .com. There are also other DAZ models and resources at this site.

DAZ 3D modeling starts with a base model, and you can download these models from the DAZ 3D site (http://www.daz3d.com). Once you install the initial model, you can add extra content such as clothes and accessories to the initial model and edit its mesh and pose. Also, you can animate the model based on the DAZ 3D timeline.

Similar to other 3D applications such as Poser, DAZ Studio 3D provides a library of models that you can start with it your own 3D model. Although you cannot create a model from scratch in DAZ 3D, you can use it to create 3D characters based on the DAZ 3D library of objects and edit these objects, then import your work into Photoshop as a 3D layer.

DAZ 3D provides a plug-in to Photoshop that synchronizes content between the DAZ Studio 3D workspace and Photoshop. It creates a new Photoshop document that includes the same content as the DAZ Studio 3D file. When

Figure 16.1 The DAZ Studio 3D interface.

you change the 3D model properties in DAZ 3D, the plug-in updates the Photoshop file. The DAZ 3D Photoshop plug-in exports the 3D content as 2D layers in Photoshop, but has an option to export the content as 3D binary formats, such as U3D and DAE files.

Figure 16.1 The DAZ Studio 3D interface.

In the following exercise, you will see how to import a DAZ 3D model to Photoshop using the DAZ Studio 3D plug-in and how this content in DAZ 3D Studio can be updated automatically in Photoshop. We'll start by initializing the DAZ 3D scene. In this exercise, we will use one of the default DAZ 3D examples that already exist when you first install DAZ Studio 3D. This will illustrate the flow of the integration process between both applications:

1. Open DAZ Studio 3D. At the top left side, you will find the Content tab, which allows you to navigate the available DAZ 3D resources.
2. Select Studio3 > QuickStart > QuickStart.
3. From the preview area under the Content path, double-click the QuickStart Scene to load it. The scene will start to load on the workspace (Figure 16.2).

Now we need to activate the communication between DAZ Studio and the plug-in installed in Photoshop; this takes a couple of steps in both DAZ Studio and Photoshop:

1. After loading the scene to DAZ Studio 3D, click Edit > 3D Bridge.
2. Open Photoshop.

Figure 16.2 The 3D scene in DAZ Studio.

3. Choose File > Automate > DAZ Studio 3D Bridge.
4. In DAZ Studio 3D, choose Edit > 3D Bridge.

The DAZ Studio 3D plug-in provides full control over the integration of Photoshop and DAZ Studio to allow you to import DAZ Studio content into Photoshop. Furthermore, you can change the 3D model properties in DAZ Studio and update it in Photoshop. When you open the DAZ Studio 3D plug-in, the plug-in panel appears (Figure 16.3), which includes the following buttons:

* Close DAZ Studio: You can use this button to close DAZ Studio 3D.
* Preview Image: This button creates a new document in Photoshop and imports to it a locked 2D layer for the rendered 3D model in DAZ Studio. In the previous exercise, you can generate a preview for the 3D scene in Photoshop by clicking this button. Photoshop creates a new file with the same dimensions as the DAZ 3D scene, and imports the 3D scene preview to it as a locked layer.
* Update Image: When you change the original 3D scene or model, you can click this button to update the preview layer in Photoshop.
* Enable Auto Update: If you are frequently changing the model or the 3D scene, you can click this button to activate the automatic updates once you change the original scene. This option is helpful when you are changing the 3D scene or model properties such as the position or human pose, and you would like to have these changes updated automatically in Photoshop.

DAZ Studio 3D Bridge

3D Bridge Running...

Close DAZ Studio

Preview Image...

Update Image

Enable Auto Update

Render to New Layer

Export Scene as U3D...

Export Scene as DAE...

Import Image Maps...

Export Image Maps...

Close

Figure 16.3 The DAZ Studio Bridge in Photoshop.

Render to New Layer

This option renders the 3D scene and adds the final result to a new 2D layer in Photoshop. This new layer is not editable. The main difference between the preview image and updated image is:

- The preview image is a locked layer that allows you to preview the 3D scene in Photoshop. When you change the original model in DAZ Studio, you can click this button to update the preview layer.
- The rendered image is the final render result from DAZ Studio. However, it is not editable and cannot be updated, even if you update the original 3D scene.

Although the preview image is not the final rendered image and is used as your preview of the scene changes, the rendered image shows the final render results, including the final materials and light resources.

The following steps show the difference between the preview image and the rendered image of the 3D scene:

1. Open Photoshop and choose File > Automate > DAZ Studio 3D Bridge.
2. In DAZ Studio, make sure that the 3D Bridge option is activated from the Edit menu.
3. Click the Preview Image button to generate a new preview layer for the 3D scene.
4. Click the Render to New Layer option to generate the final image for the rendered scene. DAZ Studio renders the scene and the result is placed on a new Photoshop layer (Figure 16.4).

Export Scene as U3D

The Export Scene as U3D lets DAZ Studio export the 3D scene in the U3D format and import it into a new Photoshop document with 3D layer that includes the 3D scene. The advantage of using this method is that it imports the 3D scene to Photoshop as an editable 3D layer with a simple click. The imported 3D layer is fully editable with the Photoshop 3D tools and 3D panel.

Figure 16.4 The rendered 3D scene in Photoshop.

In the following steps, we will continue the previous exercise and see how to import the DAZ 3D scene into Photoshop as a 3D editable layer using the DAZ Studio 3D plug-in:

1. In Photoshop, click the Export Scene as U3D.
2. In DAZ Studio, a dialog box appears that let you set the U3D properties. Click OK to start rendering and importing the content in a new Photoshop document.

Export Scene as DAE

As mentioned earlier, DAE Collada file and U3D are commonly used formats for transferring 3D files from different applications. This option lets you export the DAZ 3D scene in the DAE format and import it into Photoshop as a new Photoshop document. The scene is imported as a 3D layer, so you can easily edit it using the Photoshop 3D tools.

You can create the 3D layer in Photoshop based on the DAE format by following the same steps as creating the U3D file and clicking the Export Scene as DAE button. The only change is that exporting content as a DAE file does not require editing or accepting any options in DAZ Studio.

The difference between importing a 3D scene from DAZ Studio as U3D and DAE is that the U3D format ignores the DAZ Studio cameras applied to the object. However, the imported scene as U3D format appears in the 3D layer as a whole scene without focusing a camera on any specific area.

On the other hand, importing the 3D scene as DAE preserves the original scene cameras that are applied to it in DAZ Studio. When you use the Export Scene as DAE button, the imported 3D layer inherits the same camera focus and positions the original scene. However, using DAE is recommended to preserve the original scene's look in Photoshop.

Note: When importing the 3D scene as a 3D layer, the 3D properties are not imported properly. You must review the 3D properties for the 3D scene objects after importing it into Photoshop.

Import Image Maps

The DAZ Studio plug-in provides you with the ability to open DAZ Studio 3D scene maps in Photoshop. You can edit these maps and update the model in Photoshop in either the 2D or the 3D layer. The Import Image Maps button lets you import the 3D scene maps as separate JPG files. Follow these steps to open a 3D scene map or groups of maps in Photoshop:

1. After importing the 3D scene to Photoshop using the previous steps, click Import Image Maps.
2. Choose one of the maps that is applied to the 3D scene. You can choose more than one map by holding the Shift key to select sequenced maps or the CTRL (CMD on the Mac) key to select separated maps, then clicking OK. The selected maps open in Photoshop to edit (Figure 16.5).

Export Image Maps

You can import the 3D scene maps to Photoshop; you then have the ability to edit the imported map and export it again to apply the changes to the 3D

Figure 16.5 Modifying the 3D scene map image.

scene. If the scene is imported to Photoshop as a 2D layer, the 2D layer is updated with the new map modifications.

Note: When you modify the map in Photoshop, the scene in DAZ Studio is updated with the modified map.

In the following exercise, we use the 3D scene previously imported into Photoshop, modify one of its maps, and update the model with the modified map:

1. In the DAZ Studio Bridge dialog box, select Export Scene as DAE.
2. Click the Import Image Maps button.
3. Select the file MPCycBeachM.jpg.
4. Chose Image > Adjustment > Desaturate, or press CTRL + Shift + U (CMD + Shift + U on the Mac).
5. Click the Export Image Maps button in DAZ Studio Bridge.
6. Choose the map MPCycBeachM.jpg and click OK.
7. Click Export Scene as DAE to update the 3D scene in Photoshop (Figure 16.6).

Figure 16.6 The 3D scene after modifying the background map.

In this overview of the DAZ Studio and its Photoshop plug-in, you've seen how to integrate 3D content in Photoshop and provide a fast and reliable workflow for transferring 3D files between both applications.

Strata 3D CX Suite

Strata is another complete package that provides 3D solutions for the different fields and industries that use 3D content, such as graphic design,

advertising, industrial design, and 3D games. Strata provides different 3D solutions, and its tools integrate directly with Photoshop and allow you to export your Strata 3D project to Photoshop easily. The Strata package lets you export the 3D project as either a 2D image or a 3D Photoshop layer that you can easily edit and modify through the 3D tools.

Unlike DAZ Studio, Strata provides 3D modeling tools and features similar to any other 3D applications, which allows you to start a modeling project from scratch. Strata provides four main 3D solutions that all integrate with Photoshop and other Adobe applications, such as Adobe Acrobat:

Note: You can download a 30-day trial version from the Strata website: http://www.strata.com/products/.

- Strata Foto 3D CX: This is one of the comprehensive tools that lets you build 3D models based on digital photographs that are taken from different angles and sides. Foto 3D builds a 3D mesh based on these images and markers, as you will see later.
- Strata Unfold 3D CX: Unfold 3D integrates with Adobe Illustrator and Photoshop to create 3D packages designed for industrial and advertising applications.
- Strata Design 3D CX: Design 3D creates 3D models and 3D content from scratch. Also, you can send the 3D content directly to Photoshop. Design 3D provides you with the tools to create 3D textures and lighting for the 3D content.
- Strata Live 3D CX: Live 3D provides a solution to create 3D interactive content for the web and Adobe Acrobat PDFs. It also provides 3D presentation that does not require plug-ins.

All of these applications provide integration with Adobe products, especially Adobe Photoshop; next up is an overview of two of these applications.

Strata Foto 3D CX

One of the 3D tasks that used to take much time and effort is creating 3D models of real-life models. It is even harder for Photoshop users who do not have much experience with 3D modeling. Foto 3D provides an easy method for turning real objects into 3D models. The concept behind Foto 3D is based on digital photos of the object taken from different views and angles and then translated into a 3D mesh that is textured with the real photos of the object.

In the following brief exercise, you will see how to send a 3D project from Strata Foto 3D to Photoshop based on one of the existing project examples in Strata:

1. Open Strata Foto 3D CX.
2. Choose File > Open and navigate in the Strata files for Examples > Horse.
3. When you load the Horse model, notice the digital photos that are used to form the model. Below the sequence images, you can see the generated 3D model. On the left side, choose the navigation tool from the Viewpoint area.

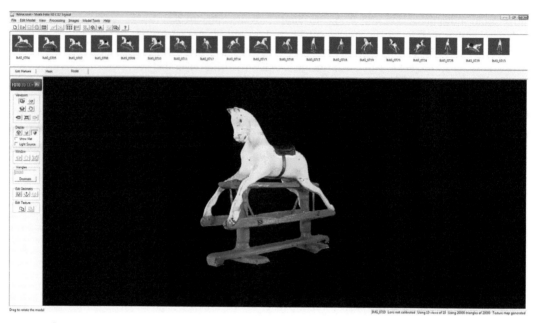

Figure 16.7 The 3D model in Strata Foto 3D CX.

4. In the display area under the control tools, set the display of the model to show the model mesh and wireframe structure (Figure 16.7).

5. At the top of the Tools area on the left side of the model preview area is a button that says Foto 3D CX > PS. Click this to send the model to Photoshop.

6. A dialog box appears to let you specify whether the model will be Texture Paint Ready. This option makes the model ready for 3D painting using the painting tools in Photoshop, such as the brush tool. Check this box and click OK.

7. Open Photoshop. You will see a dialog box appears to let you create a new document for the imported 3D model or select its destination if there are already open documents in Photoshop.

8. In the Document dialog box, choose the document that you would like to import the 3D model into. If you are creating a new document, choose the document name in the Name field and press OK.

9. The 3D model opens in a new document and appears in the Layer panel as a 3D layer that you can edit using the 3D tools. Open the 3D texture layers and notice that the 3D model has one diffuse texture applied to it, along with the other texture effects. This texture structure depends on the imported model.

Although the output mesh of this process is a low-polygon model and not as accurate as creating the model from scratch, it provides an easy method to

Figure 16.8 The imported model in Photoshop.

turn a real object into a 3D model that can be used in Photoshop designs, and you can use the resulting model in 3D animation in Photoshop.

Strata Design 3D CX

Strata Design 3D CX is another application from the Strata package, which provides a full modeling 3D tool. You can also use this program to add texture and light to the model. Although you can use other 3D applications to create 3D models and export to Photoshop, Strata Design 3D provides an easy method for direct integration with Photoshop.

The Strata Design 3D CX user interface is easy to navigate and is similar to the Adobe interface. It also provides extended 3D tools, such as the resources located in the Resources panel. This panel includes resources such as textures, shapes, and backgrounds. It can be a good resource for Photoshop users who are unfamiliar with 3D applications and would like to enhance their Photoshop 3D experience with extra resources and content.

In the following exercise, we will export a 3D model from the existing resources in Strata Design 3D and send it to Photoshop:

1. Open Strata Design 3D CX.
2. Select File > New.

Figure 16.9 The 3D model in Strata 3D CX.

3. Under the document window is the resources panel. Click the Shapes tab to view the available shapes in the resources panel.
4. Select the Chair-Director's model and drag it to the stage (Figure 16.9).

There are two methods to send the 3D model to Photoshop: the first is to send it as an image and the second is to send it as an editable 3D model. In both methods, the sent model is rendered in Photoshop either as an image or a 3D model.

Continue the previous exercise by sending the model to Photoshop:

1. In Strata Design 3D CX, choose Send Model to Photoshop.
2. A dialog box appears for you to choose the exported properties for the model. Check all the checkboxes and click OK.
3. In Photoshop, a dialog box appears to let you either create a new document for the imported model or import it into an existing document. Let's start with a new document.
4. The model starts to render in Photoshop and then appears as a new 3D layer (Figure 16.10). You can edit the model using 3D tools.

3DVIA

3DVIA is another 3D tool and model provider; it integrates with Adobe Photoshop through the 3DVIA for Adobe Photoshop plug-in. It allows you to

Figure 16.10 The Strata 3D model imported to Photoshop.

navigate the 3DVIA site for models (some free; some for purchase) on the website (http://www.3dvia.com/) and import them directly into Photoshop. The 3DVIA Photoshop plug-in provides an easy interface to search for models either in the 3DVIA store or the community submissions, where users upload their models to the site.

You can download and install the 3DVIA plugin for Photoshop CS5 from 3DVIA.com. Make sure that you have the Microsoft. NET Framework, which is only supported in Windows in order to continue the installation. Once the install process is done, you can use the 3DVIA plug-in:

Note: Some models aren't free; for these, you must purchase credits in order to be able to import them.

1. Open Photoshop or restart if it was already open.
2. Select File > Import > Search 3DVIA.
3. The Search 3DVIA window appears to let you search 3D models in the 3DVIA store or the community uploads. Choose either to search for models.
4. Select a 3D model and click the Import button to open it in Photoshop. The model is imported directly into a new Photoshop document.

You can use the 3DVIA plug-in to search for models through the Photoshop interface and import them directly with a click of your mouse. The 3DVIA store provides a variety of models from different categories.

Figure 16.11 The 3DVIA Photoshop CS5 plug-in search dialog box.

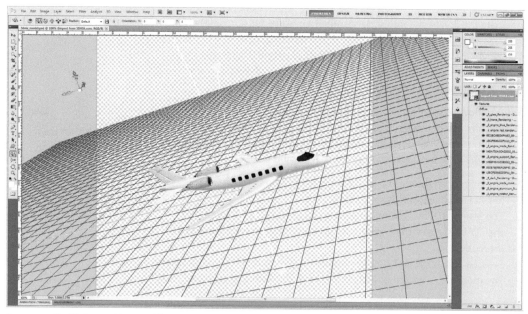

Figure 16.12 The 3D plane model imported from the 3DVIA store.

Summary

The third-party applications mentioned in this chapter are not the only applications that can integrate with Photoshop to extend your 3D experience in Photoshop. However, these are three of the most important applications that integrate with Photoshop. Now that Photoshop has a 3D feature of its own, it might seem like the end of the other tools that are designed to deliver 3D to Photoshop. But actually you can still make good use of these tools to enhance your 3D projects in Photoshop.

Index

T - #0506 - 071024 - C292 - 246/189/13 - PB - 9780240813493 - Gloss Lamination